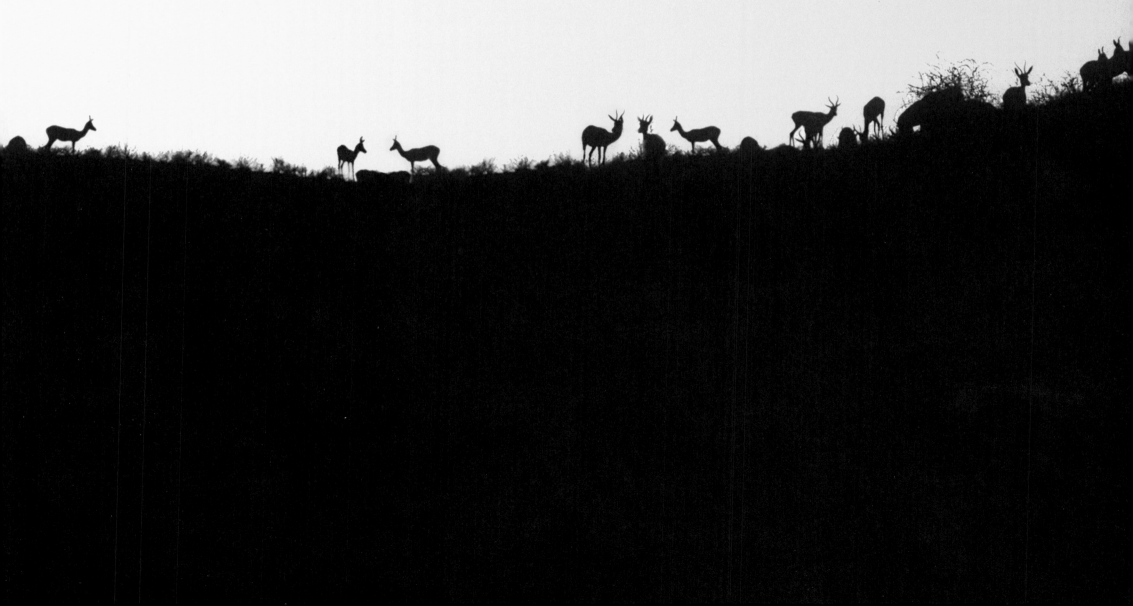

WILDLIFE

GERALD HOBERMAN

WILDLIFE
GERALD HOBERMAN

TEXT BY ROELIEN THERON

ADVENTURES IN THE WILD PHOTOGRAPHED AND RECOUNTED BY GERALD HOBERMAN

GERALD HOBERMAN PUBLICATIONS
CAPE TOWN

To future generations, custodians of the Earth

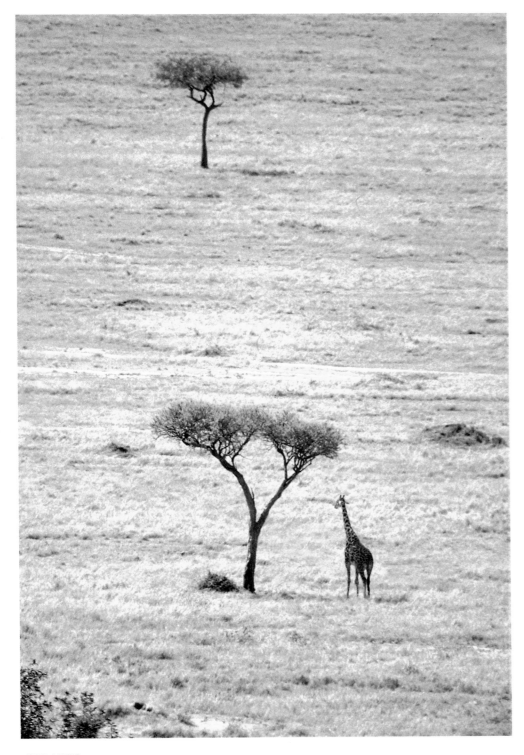

GIRAFFE

CONTENTS

Concept, design, photography and production control:
Gerald Hoberman
Cameras and lenses: **LEICA**
Cameras: R5 and R8; Lenses: 19mm f2.8; 28mm f2.8; 80mm f1.4; 100mm f2.8; 280mm f2.8; 800mm f6.3; 1 x 1:4 extender
Film: **KODAK**
Kodachrome Professional PKL 200; Ektachrome 100 Plus Professional; Ektachrome 100 S Professional
Colour processing: **CREATIVE COLOUR**
Ernest Methembu, Mervyn Moses, Dennis Sprong, Terry Wampach
Digital scanning and reproduction: **POSITIVE IMAGE**
Bongikaya Gobile, Kim Human, Thomas Mihal
Text reproduction: **MEGA PRE-PRESS**
Adrian Tromp, Duncan Henderson
Editorial management: **PAGE ARTS**
Fiona Adams, Roelien Theron
Text: Roelien Theron, Gerald Hoberman, Dr Phil Hockey
Editing: Fiona Adams, Hillary Bassett
Scientific editor: Dr Dave Gaynor
Proofreading and indexing: Sandie Vahl
Printing: **EDINA-GRIFFITHS**
Roger Austen, Neil Kay, Lionel Ramedies, Michael Ubsdell
UV spot varnishing: **UNITED VARNISH AND PRINT FINISHING**
Henry du Plessis, Paul Hastilow, Leon Kaimowitz
Binding: **GRAPHICRAFT**
Klaus Borgelt, Vida Fisher
Executive sales manager:
Charlotte Harmse

First edition 1998

Published by:
Gerald Hoberman Publications
PO Box 60044, Victoria Junction, 8005, Cape Town, South Africa
Phone: 27(021) 419–6657 Fax: 27(021) 418–5987 Cell: 082 560–2120
E-mail: hobercol@global.co.za

Printed with pride in South Africa

ACKNOWLEDGEMENTS

The preparation necessary in producing this particular book has been complex, multi-disciplined, challenging, sometimes arduous, but for all those people involved with it – very exciting!

I am most fortunate to have developed very valuable relationships with the people who have contributed to the production of this book. I refer to them all with much appreciation and affection as the 'A team'. Without them, this volume could not have existed in its present form.

Their perpetual enthusiasm for my work, the manifold input given by them to the publication, and their dedication transcends commercialism and is remarkable. I will be forever grateful to them.

Roelien Theron, editor and writer at Page Arts, is worthy of special mention. A Rhodes University journalism graduate, she has edited and written several publications during the last decade. With this book she has once again demonstrated her considerable expertise, dependability and enthusiasm in what was an exciting and challenging project. Her awesome responsiblity for ensuring the accuracy of this complex subject was handled with diligence and meticulous care.

I also want to thank Professor Phil Hockey of the Percy FitzPatrick Institute of African Ornithology at the University of Cape Town for his contribution to the book, and Dr Dave Gaynor, zoologist and scientific editor.

To those people listed below who have crossed my path and contributed to the project, I am deeply appreciative.

GERALD HOBERMAN

Tony and Dee Adams
Alpheus
MK Appayya
Randy Borman
Tony Brinkman
Bee Brummer
Sean and Ann Bryan
Marius Burger
Margie Cochran
Ken Cole
Charles Dickson
Dr AS Dippenaar
NR Durn
Max and Cecile Elstein
David Falconer
Arlene Fanaroff
Mel Goott
Randy Green

Robin and Berta Halse
Maureen Hargraves
Ted Harrison
Peter Herbert
Koti and Hanlie Herholdt
Lex Hess
Doris Jacobs
Karel Keinman
Brian Kirsch
Henri Kruger
Klaas Kruiper
Pat Lampi
Elias LeRiche
Peter le Roux
Miriam Meltzer
Renius Mhlongo
Nico Myburgh
Richard Randall

N Rangashamaiah
Krishna Murthy Satyanarayana Rao
David Rattray
Harold Sack
Sandros Sanhlamu
Sammy L. Seawell
Malaki Sithole
Arnold Swart
Michael Terry
Chris van der Linde
Joseph van Os
John Visser
Ravi T. Wadhwani
John Wakefield
Sharon Walleen
Jenny Walters
Frank and Brenda Watts
Daniel and Thorya Wheedon

INTRODUCTION

I have seen wondrous things.

I have visited the rarest spots on earth in pursuit of my vision, for I dreamed of building up – and sharing with the world – a collection of indelible images of wildlife, each one thought-provoking, enduring and magical.

In the course of this odyssey I discovered majesty in mountains, companionship in people and a deep need to celebrate nature. The wealth of the vast outdoors and its extraordinary animal kingdom, and their continuity over aeons, seem to me to represent our connection with infinity. It is a profoundly spiritual experience to stand in silent awe of creation, contemplating both our humble insignificance as human beings, and our triumph.

The purity of early morning air has intoxicated my spirit, as has the smell of dust as rain begins to fall on Africa. I have been exhilarated by journeys in every kind of transport, from hot air balloon to helicopter, sea plane and mokoro.

I have marvelled at the sound of silence, revelled in remoteness, peace and tranquillity – and learned to fear them too.

I have plodded through deep and steamy jungles on diverse continents; I have crossed parched and sculptured deserts. I have sailed the tempestuous Southern Ocean to the Antarctic with its fearsome winds, treacherous icepacks and indescribable beauty. I have been entranced by the atmospheric phenomenon of aurora borealis, the northern lights, sending sheets of colour dancing and

Gerald Hoberman in the Amazon River

shifting across the star-studded sky. I have had encounters with polar bears and Arctic foxes, and held out my hand to trusting creatures who, never having been hunted or harmed by man, have allowed me the rare privilege of approaching them in the wild.

On my journeys I have had several narrow escapes, and have only the grace of God to thank that I am here to tell the tale.

My photographs were taken over a period of some 20 years. On many occasions I had the joy of having family and friends accompany me, which has brought rich quality time into all our lives.

So with this collection, I bring you, with great delight, the summation of my dream – the very best of my wildlife photography. I hope the pictures and the stories behind them will encourage more people to feel connected with, and do their best to conserve, the fast-dwindling natural habitats of the world's diverse and extraordinary fauna and flora.

My ultimate dream is that we so appreciate this bounteous heritage that we do whatever is necessary to preserve it for future generations.

Gerald Hoberman

GERALD HOBERMAN
Cape Town 1998

WHAT IS MAN WITHOUT THE BEASTS?
IF ALL THE BEASTS WERE GONE, MAN WOULD DIE FROM A GREAT LONELINESS OF SPIRIT.
FOR WHATEVER HAPPENS TO THE BEAST ALSO HAPPENS TO THE MAN.
ALL THINGS ARE CONNECTED.
WHATEVER BEFALLS THE EARTH BEFALLS THE SONS OF THE EARTH.

CHIEF SEATTLE, CHIEF OF THE DWAMISH
STATEMENT ON SURRENDERING TRIBAL LANDS ON THE SITE OF SEATTLE, GOVERNOR OF WASHINGTON TERRITORY (1854)

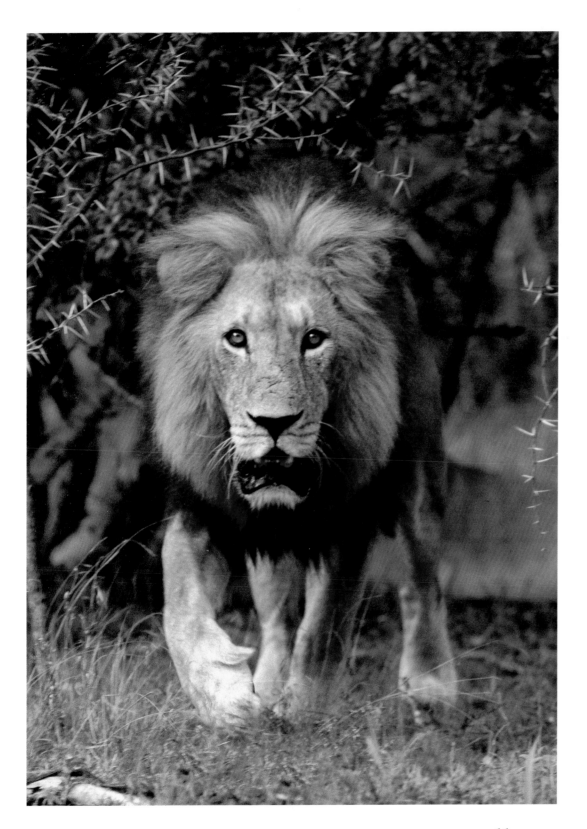

Africa

THE LION

The mighty, reverberating, blood-curdling roar of the lion (*Panthera leo*) is but one reason for its epithet, 'king of the wild'. The magnificent beast epitomises African wildlife, being the largest, fiercest and some say the most noble of all its carnivores. The only species of cat that could be dubbed social, lions live in prides, typically averaging 13 animals, but sometimes numbering as many as 50. Larger prides divide into sub-groups within the home range.

The lionesses, often sisters, half-sisters and their female offspring, form the nucleus of a pride, while their cubs, reared collectively, remain dependent for at least 16 months. Life for male offspring is harsher than for their female siblings. Ousted from the natal pride before the age of three, groups of sub-adult males are forced to range nomadically, biding their time until they are able to mount a challenge for an older lion's territory and its residents – a pride of unrelated lionesses. The contest for ownership is usually vicious, leading to serious injury and even death.

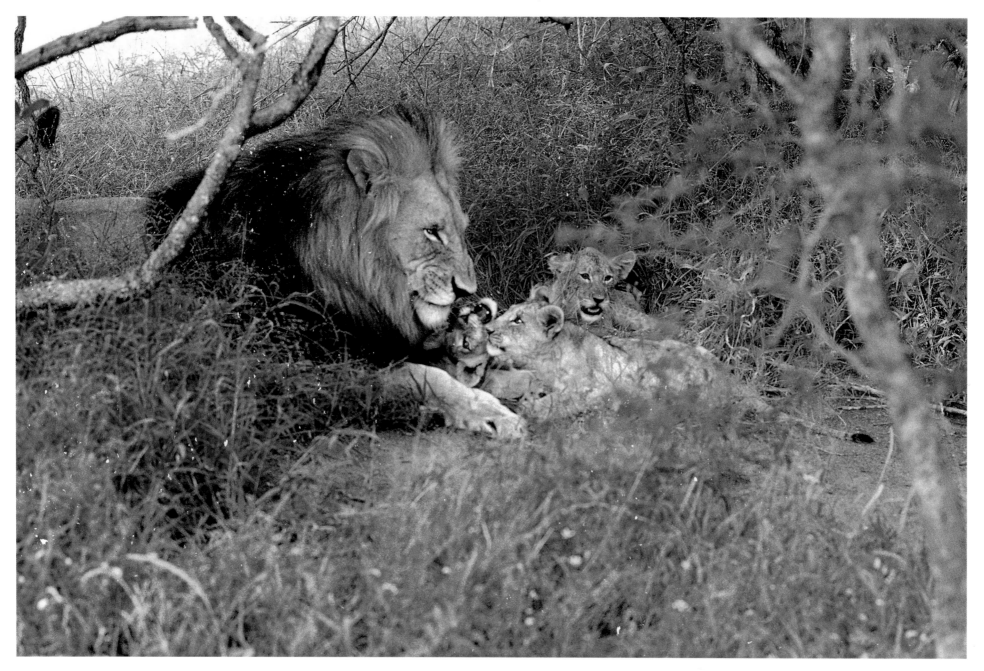

LION AND CUBS

"This apparent smile belies the ferocity of moments earlier, when this young male had tried to kill the cubs of his newly conquered pride. This survivor of the battle of the fittest probably sought to propagate his own genes in this attempted act of infanticide – lactating lionesses can't conceive. Two of the lionesses leapt fiercely to the cubs' defence. The trio, muscles bristling with raw power, braced for a fight. After a short but serious altercation the lion, suitably corrected by the lionesses, engaged the cubs in a gentle, tender interaction but with a malevolent smile on his face."

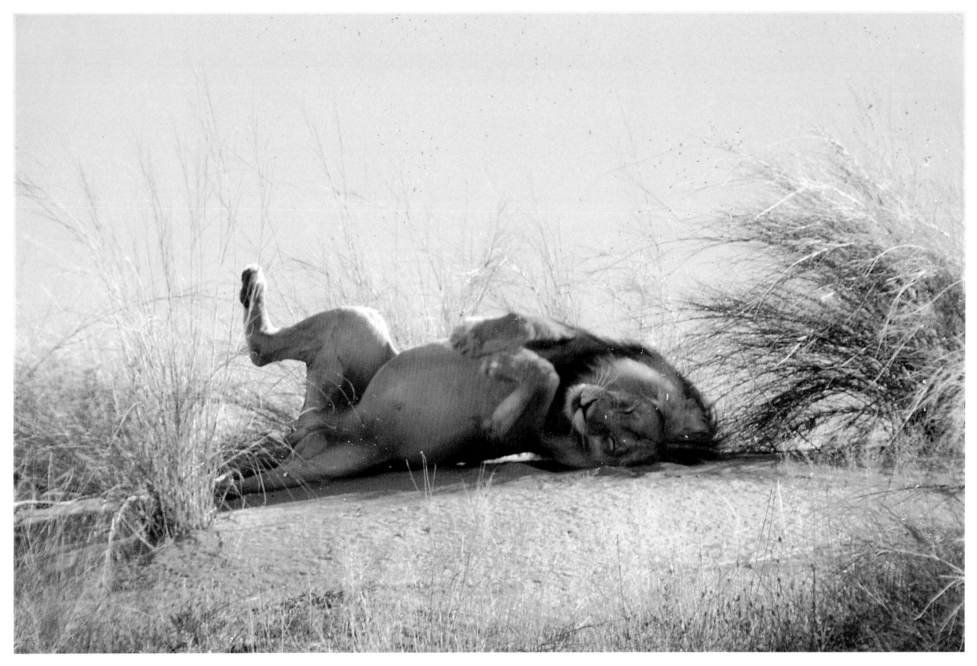

KALAHARI CATNAP

A black-maned lion, belying its reputation for fierceness, enjoys a catnap on a grass-tufted Kalahari sand-dune. These tawny cats spend most of the day dozing, hunting at night except when prey is scarce. However, when there's a pride of lionesses in thrall male lions rely instead on the females' prowess. Hunting either individually or collectively to catch their prey, lionesses use up to 50 distinct sounds to communicate with each other while coordinating an ambush. After the kill, males are the first to eat their fill, and are then joined by the lionesses and cubs. Lions also scavenge, and don't hesitate to appropriate another predator's kill. Generalist feeders, lions eat anything from wildebeest to insects.

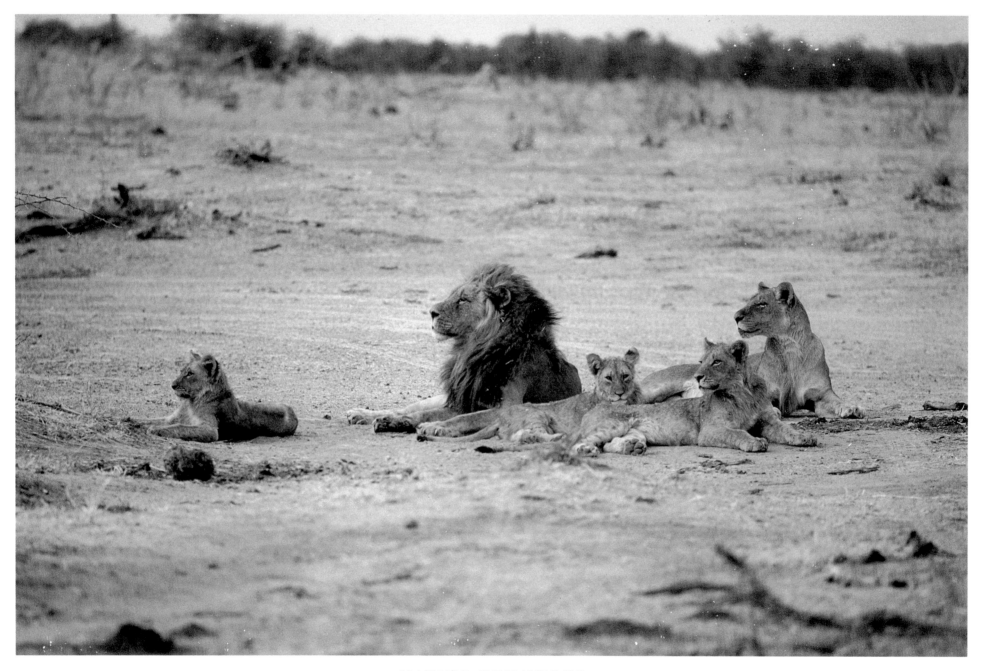

MATING BEHAVIOUR

To produce a litter of cubs such as this one, a lion and lioness would have performed several hundred acts of copulation as not all matings result in progeny. The mating ritual can continue over three days and ovulation is induced by this orgy of repeated matings. In this time the pair may copulate up to 50 times in 24 hours, with actual copulation lasting for 20–60 seconds. Either males or females can initiate the courtship ritual. While the distant presence of lions belonging to the pride is tolerated, strangers are driven off ferociously.

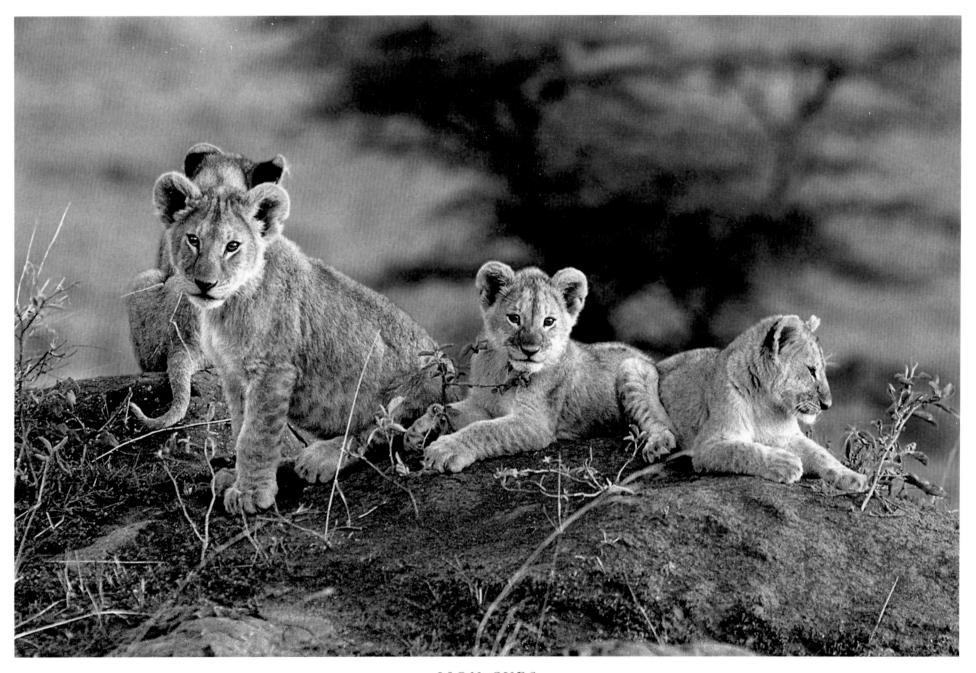

LION CUBS

Life for a young lion cub is precarious – only one in five may survive to the age of two. Lionesses of the same pride often give birth around the same time, each helping to raise, defend and suckle the others' young. This promotes survival since cubs can turn to any of the lionesses in their pride for food, grooming, protection or play. Their male parent's only contribution to childraising is to defend the territory against younger males in search of a pride to dominate. Cubs are particularly vulnerable when prey is scarce: too weak to fight for their share of the kill, they may starve to death.

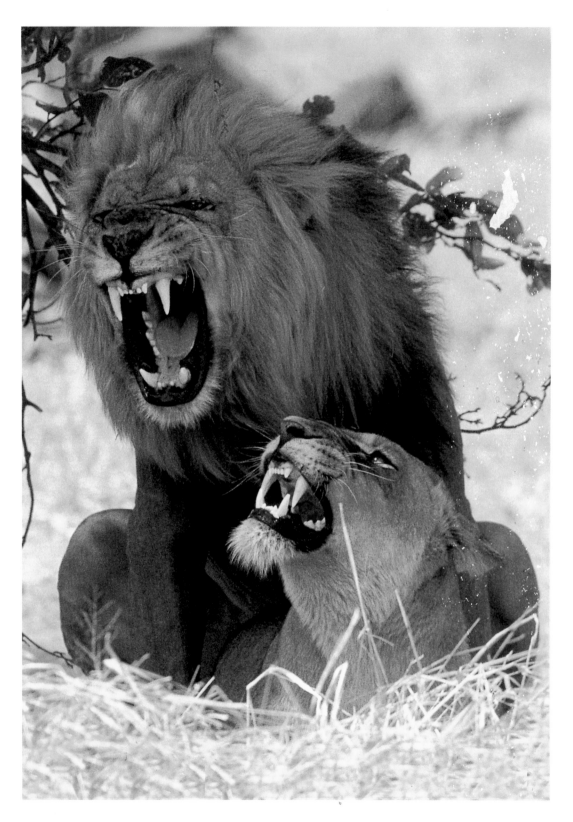

AN INTIMATE MOMENT

"Late one afternoon in the Chobe National Park in the Okavango Delta, Botswana, we suddenly came across a lion and lioness, lying close together under a shady tree. We quietly approached in our vehicle and then waited. The lioness rose and languidly moved ahead of the lion into the clearing. When he stopped walking, she then sauntered over. He positioned himself behind her. He snarled, wrinkled his nose, bared his fearsome teeth and then nuzzled her neck. Then began his frenzied thrusting; the lioness snarled and purred in apparent ecstasy. Copulation lasted a mere 60 seconds."

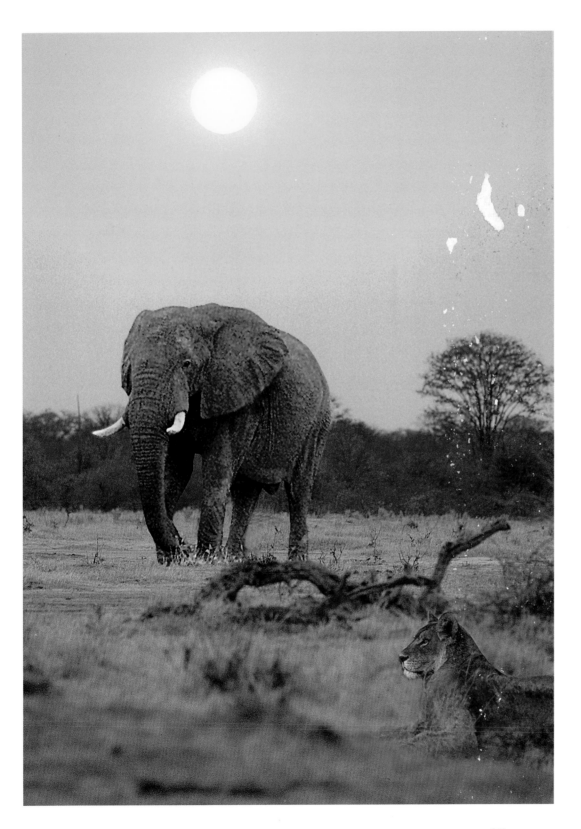

LIONESS AND ELEPHANT

"The elephant (Loxodonta africana) *and lioness cross paths as the sun's fierce rays, diffused by a raging veld fire in Savuti, Botswana, casts a pinkish hue. In my view, the elephant is the real king of beasts. Fully-grown elephants know no threat from other animals, not even the lion, although lions will occasionally attack baby elephants. Its only real threat is human greed and encroachment."*

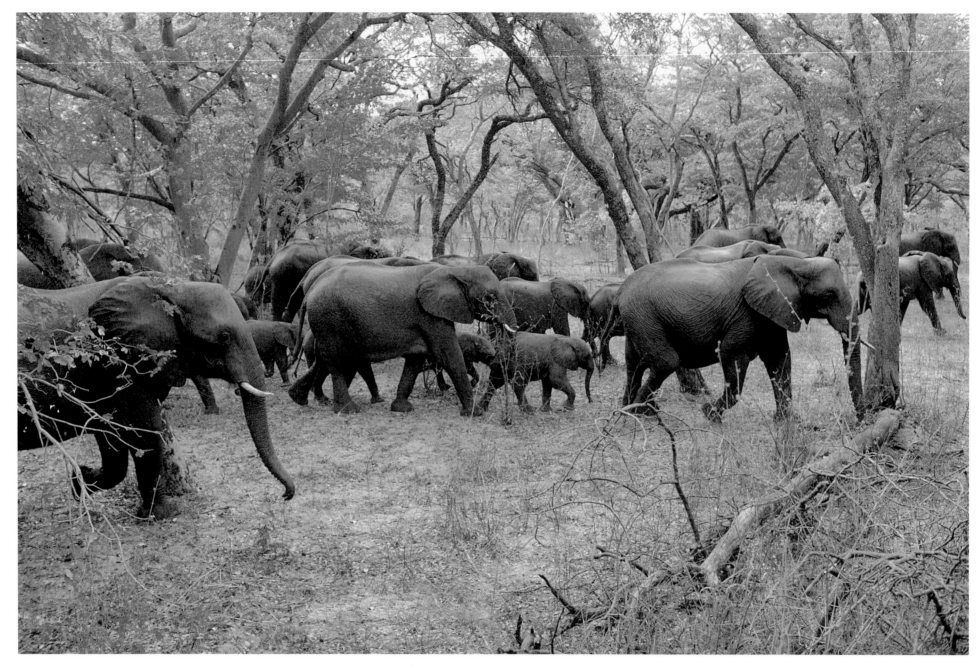

ELEPHANT HERD, ZIMBABWE

The basic unit of the elephant family is the female herd, comprising an average of 11 cows and calves led by the oldest cow. The matriarch is influential, providing guidance to the rest of the herd in all its activities. From her the young learn about the home territory, predators, and good sources of food and water. Large herds may separate into smaller family units in the same home range and communicate through low-frequency sounds that are inaudible to the human ear. Bulls wander in temporary bachelor herds or alone, only joining the cows to mate during musth, a period of heightened sexual activity.

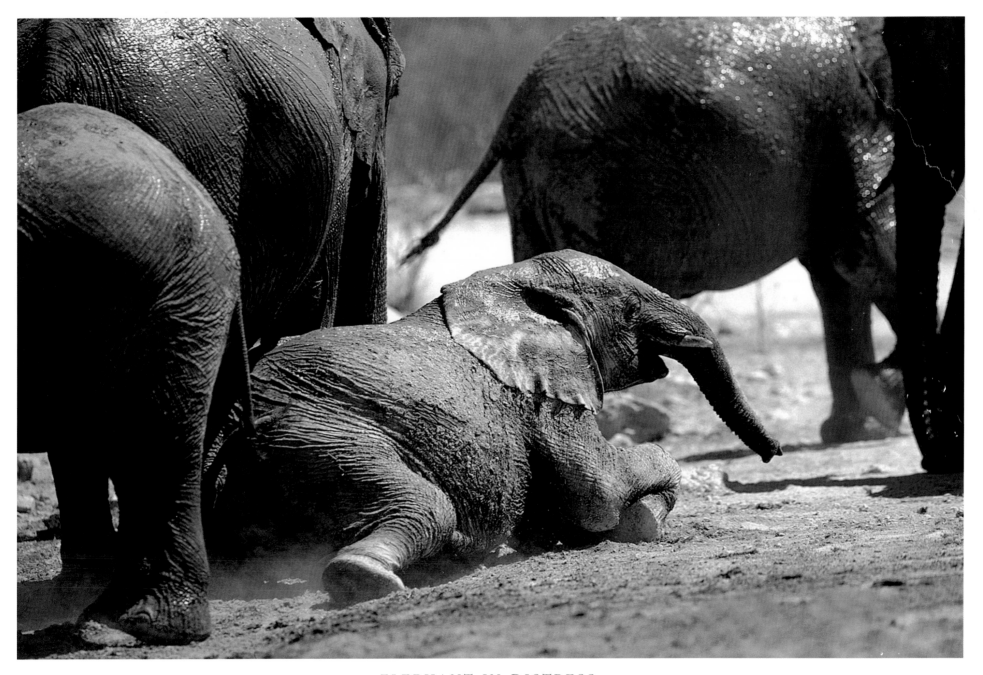

ELEPHANT IN DISTRESS

"We watched helplessly as a lone elephant tried to lift itself out of a cement gully in the Etosha Pan, Namibia. These gullies are built to serve as waterholes during periods of drought, but inexplicably this elephant got stuck. Unable to dislodge itself, the elephant became increasingly distressed. A while later some elephants ambled up, appearing as if from nowhere. They stood around, appearing to assess the situation and then one nudged the distressed pachyderm in a three-quarter turn and backwards, helping it out of the gully to freedom. Elephants are able to communicate over long distances, using low-frequency sounds."

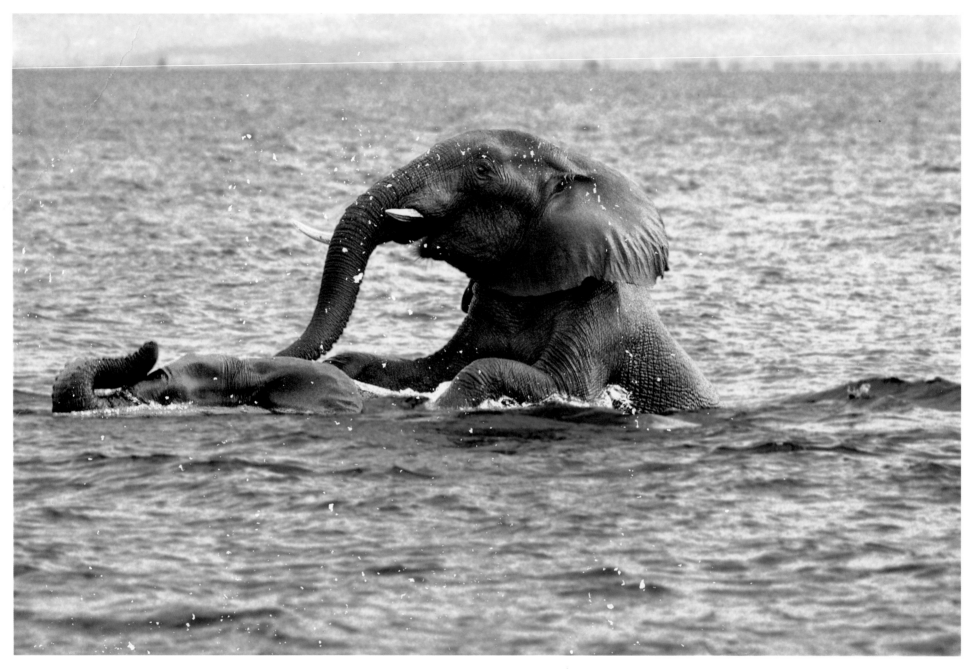

LAKE KARIBA, ZIMBABWE

Water is an essential element of elephants' habitat as they can only exist without it for short periods. While they depend on water to slake their enormous thirst, it also has unlimited recreational possibilities, as these two elephants in Lake Kariba demonstrate. Elephants have also been spotted crossing the Zambezi River, using their trunks as snorkels while en route to the islands in search of food. Elephants and their association with water are well represented in the rock paintings of the San (Bushmen) of southern Africa. Their paintings depict elephants with white raindrops on their skin, symbolising the rain beast which has the power to coax rain from the sky.

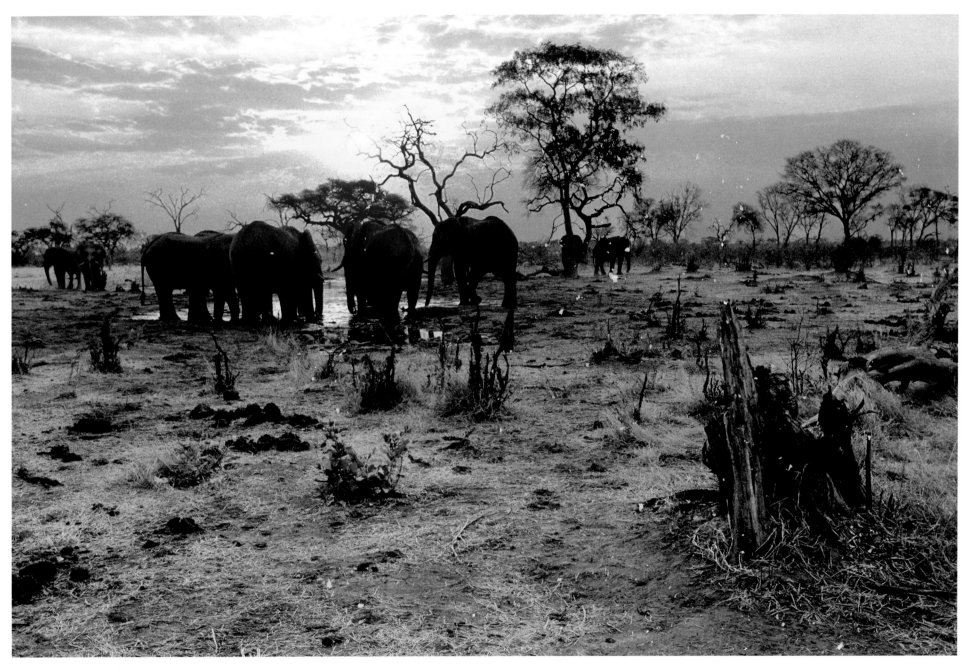

SUNDOWNERS, BOTSWANA-STYLE

Elephants gather at a waterhole to quench their thirst. Using their trunks to suck up as much as 220 litres a day, they squirt water into their mouths in eight-litre bursts. The multipurpose trunks are also used for washing down the day's dust, and, in times of drought, to dig for water. A stop at a waterhole is an opportunity, if the pool is deep enough, to submerge their six-ton bodies. The giant herbivores spend most of the day consuming a hearty 150–200kg of vegetation, which they may wander over 80km to find. The trunk, which has an astonishing 50,000 muscles, is used to reach the highest foliage or to graze on short sweet grasses.

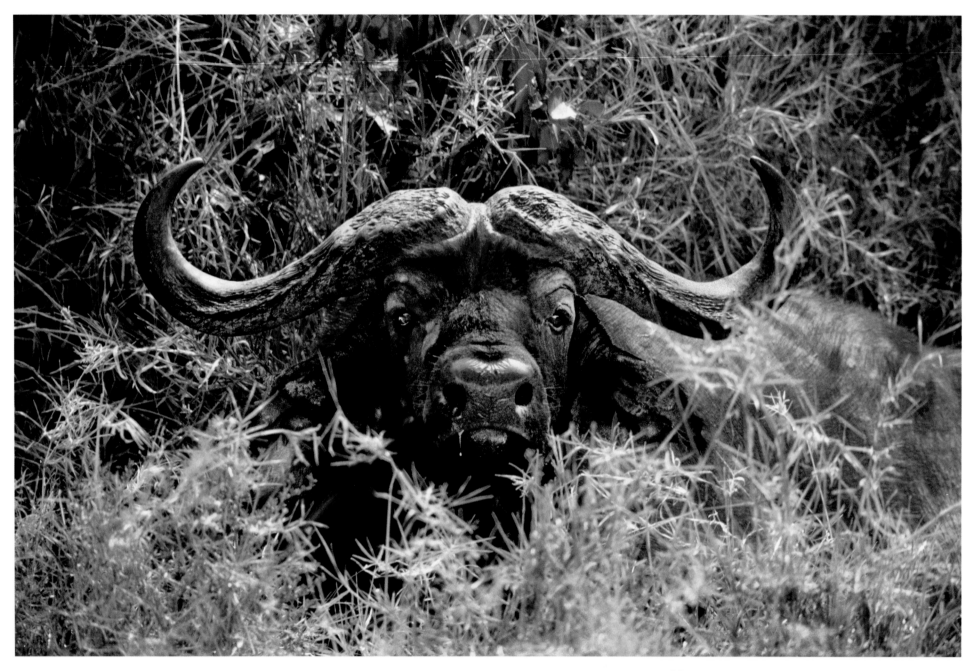

AFRICAN OR CAPE BUFFALO, *Syncerus caffer*

Though seemingly docile, the African or Cape buffalo is the most feared member of Africa's 'big five'. While quite placid if unprovoked, it is savage in attack, using its flamboyantly curved horns to hook, toss or gore an assailant. Normally, however, buffalo browse together peacefully in herds of up to 2,000 individuals. Such huge herds need an effective communication and coordination system to maintain the same direction, to defend against predators and to respond to calves' distress calls. The buffalo's communication system encompasses varied postures and low-pitched calls. When threatened they launch a thunderous, impressive and deadly effective stampede.

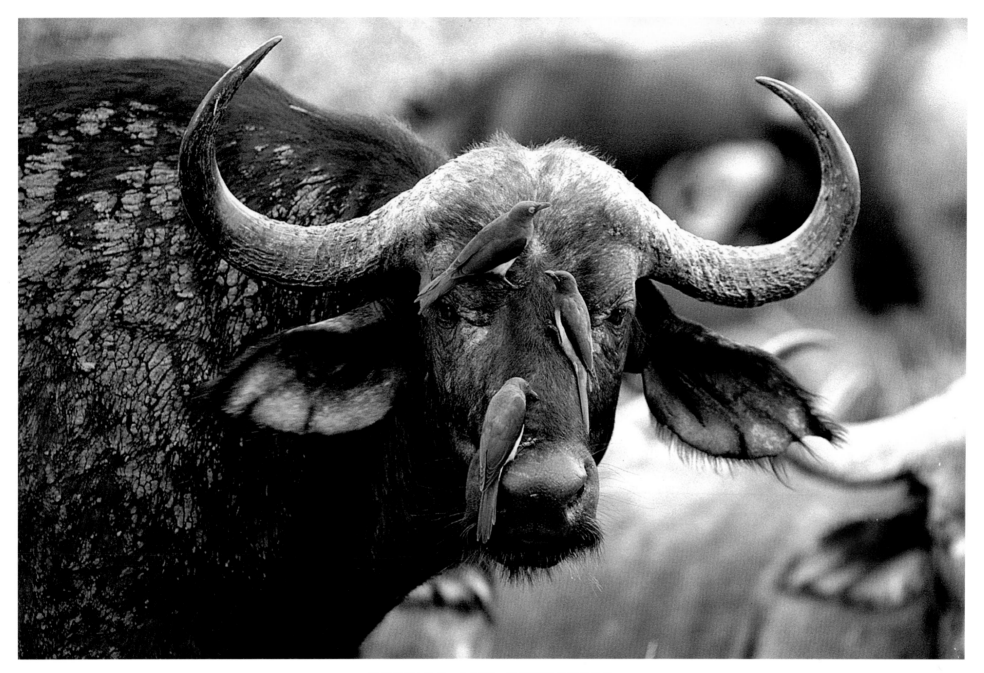

BUFFALO AND OXPECKERS

This diligent team of oxpeckers is feasting on the ticks, larvae and other parasites that nestle in the buffalo's hide. The birds' strong, flattened bills scissor away continuously, picking at ticks and larvae. The symbiotic relationship between bird and mammal extends to surveillance: the chittering alarm calls of the yellow-billed oxpecker *(Buphagus africanus)* and the hissing of its red-billed cousin *(Buphagus erythrorhynchus)* alert the buffalo to approaching danger. The oxpeckers, on the other hand, get food and a free lift everywhere, including a ride to the water bath. Oxpecker hosts include antelope, kudu and giraffe.

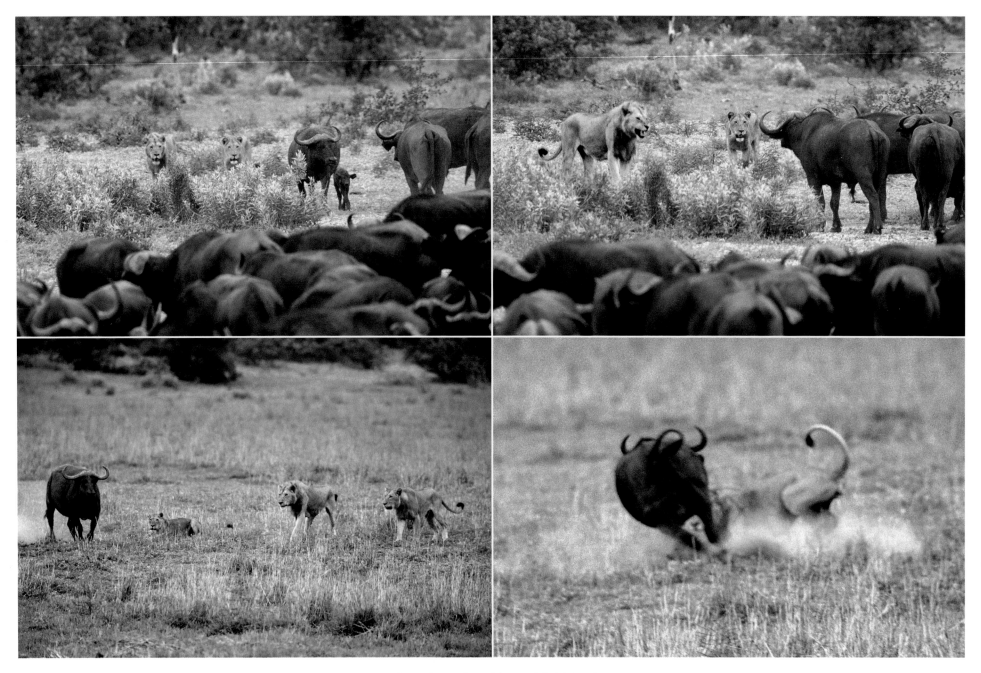

CLASH OF THE TITANS

"In the wild I have often encountered situations so extraordinary that, if I had been told about them by someone else, I would have probably dismissed them as tall stories. One such event took place on a blistering hot day in the Kruger National Park in South Africa. I was driving in a remote part of the reserve to see if I could find any sign of animal activity. It was not a particularly good time for viewing game: at midday most animals rest up in shady spots to escape the heat and conserve their energy. Noon is not the best time for taking photographs either; the sun casts harsh, unphotogenic shadows.

Despite this I was optimistic about seeing some action that afternoon. I decided to park my car on the side of the gravel road I was on. Scanning the environment with my binoculars, I saw an extraordinary event unfold. A huge herd of African buffalo had gathered in a clearing, some 300 metres away. I didn't go off the designated roads, as, for good reason, the authorities at most game reserves demand that visitors keep to the established network of roads and paths, both for their own safety and for the protection of the animals. Expecting to see a kill, I hauled my camera and telephoto lens through the roof hatch of my vehicle. I then rested the equipment on my special polypropylene-filled bag (which serves as a tripod) on the vehicle roof, and waited.

(I have on occasion been in the middle of a buffalo herd, but always as a passenger in the four-by-four vehicle of a game ranger.

During those times the buffalo appeared to be almost as docile as cows, but when provoked, they are extremely volatile and dangerous. Buffalo are known for their persistence: stories abound of them chasing hunters up trees, and still waiting for them to descend the next morning.)

On this particular afternoon some lionesses were attempting to seize a newly born buffalo calf. What then unfolded was extraordinary. The cow moved between her calf and the lionesses, while the rest of the herd formed a solid phalanx to prevent any of the cats from snatching the calf. The herd seemed to be following a cohesive and coordinated game plan, as the juveniles, babies and nursing mothers sat down close together. They were surrounded by sub-adult bulls and, on each flank, angry bulls with formidable horns stood their ground. As the skirmish continued, one of the bulls lowered its large, horned head and charged an approaching lioness, kicking clouds of dust and clumps of grass into the air. The ferocious charge paid off: the lioness stopped dead in her tracks.

The battle was over. In the face of such an organised and impenetrable defence, the lions capitulated and slunk away. More awesome, though, was the sight of the herd moving off as a large, cohesive body, maintaining its defensive formation."

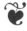

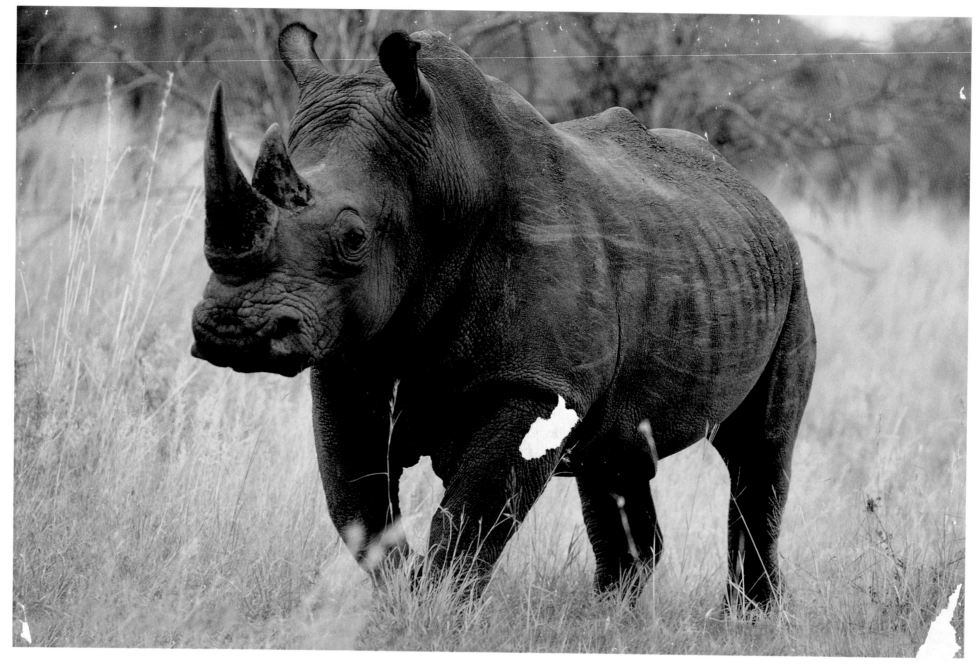

WHITE RHINOCEROS, *Ceratotherium simum*

The white rhino takes its name from the Dutch word *widj,* meaning 'wide'. This aptly describes the colossal mammal's muscular, square-lipped jaw. In fact, neither of the species' colloquial names matches their colour: both are grey and tend to display the colour of the mud in which they wallow. Such a bath not only keeps the rhino cool but also creates a mud barrier on the skin's surface that helps suffocate ticks and prevents insects from laying eggs. The white rhino has been saved from extinction by successful conservation efforts, particularly in South Africa's Umfolozi-Hluhluwe Game Reserve, where a quarter of the world's white rhino population lives.

BLACK RHINOCEROS, *Diceros bicornis*

Conservationists went on full alert in the 1970s when evidence mounted that Kenya's black rhino population was in rapid decline. Illicit rhino horn was found in North Yemen, where it is used for the ornately carved handles of ceremonial daggers, called *jambiyyas*. The horn, consisting of keratin and gelatin fibres similar to nails and hair, was also illegally exported to the East for use in traditional Chinese medicine. But despite the efforts of conservationists, numbers have declined dramatically from about 65,000 in the 1970s to a mere 2,400 today. The remaining black rhino can be seen in Tanzania, Kenya, Zimbabwe, Namibia and South Africa.

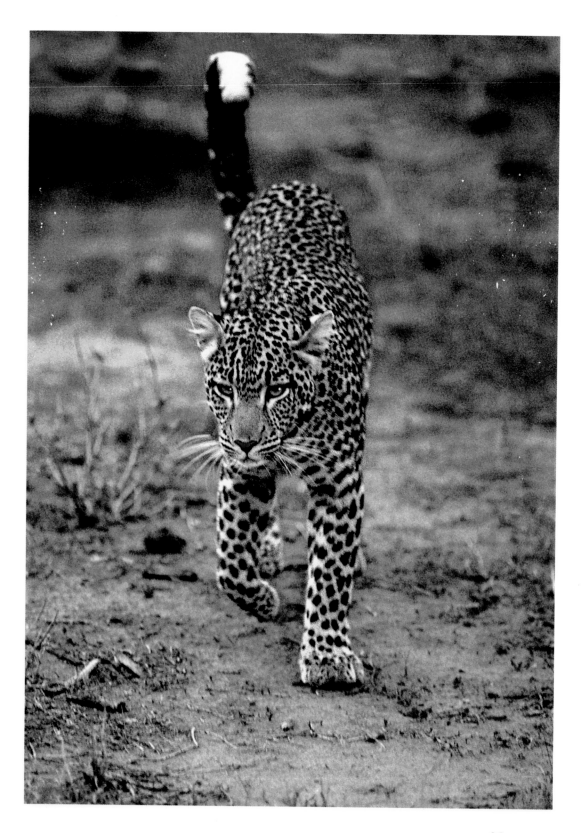

LEOPARD,
Panthera pardus

Graceful and striking, cunning and powerful, the leopard is one of the cat family's most successful members. It is the least specialised of the cats, and therefore also the most adaptable to its habitat, living in regions as diverse as low-lying rain forests, rocky hills, and semi-desert areas in both sub-Saharan Africa and southern Asia. Its diet, too, is varied: dung beetles, hares, antelope, buffalo and young giraffe are all preyed upon. Leopards can regulate their drinking habits, and those in desert regions can survive on moisture from their prey. A striking aberrant, the 'black panther', occurs mainly in the forests and mountains of Asia. Its black coat marked with barely visible rosette-shaped spots is the result of a recessive gene.

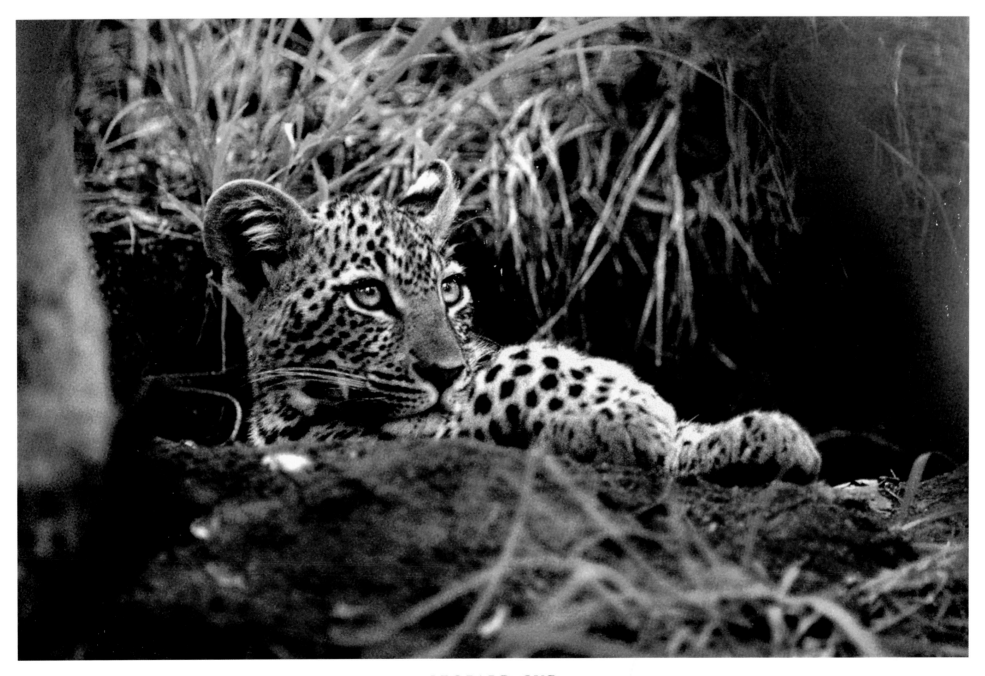

LEOPARD CUB

Leopard cubs are born in secluded places, usually in dense bush, caverns or rocky outcrops. Kept hidden by the mother for the first six weeks, they are moved around frequently to a new lair to protect them from predators. Extremely vulnerable during the early months, they are easy prey for hyenas or lions. For three months the mother nurses the cubs, up to three in a litter, before weaning them. At the age of a year cubs may be independent, but they frequently stay with the mother until they are two years old. Cubs' playful behaviour – swinging their paws through the air, stalking, climbing trees and play-fighting – develops skills that will form part of their hunting repertoire as adults.

"Our light aircraft bumped along the dusty, makeshift runway in the Botswana bush and coughed to a halt just as the sun dropped below the horizon, painting the wide grassland plains vivid reddish-gold. After weeks of planning, I had arrived at Mashatu Game Reserve and was eagerly awaiting the chance to photograph leopards.

I didn't expect it to be easy – these cats are elusive, especially during daytime. My host, zoologist Peter le Roux's research entailed darting the leopards, and fitting them with collars emitting a radio signal. It was hoped that when I accompanied him in the tracker jeep, the bleeps would lead us to a sighting. But as day succeeded day, I grew increasingly frustrated. I had come a long way.

Peter was sympathetic, and invited me to accompany him at night instead. I joined him on one of his nocturnal research expeditions. As word got around, a few more people asked to be included, and our party left base camp one evening after dinner.

Our vehicle lurched along for a while. Then a ghostly pair of tusks suddenly showed up in the headlights. We halted, hearts pounding. But the elephant, which had been dangerously close, slowly turned and with the snap of a dead branch, disappeared into the night. We drove on towards a dry river bed, sweeping the trees with a searchlight in the hope of spotting a leopard.

In the middle of the river bed the four-by-four's engine spluttered and died, and with it the radio. We were stuck, with little hope of being rescued. It became bitterly cold in the open vehicle. All we could do was sit it out until morning.

Our cold discomfort was tempered by elation, however, when we spotted, not two metres away, a leopard burrowed in the soft river sand, presumably for warmth.

In the freezing early hours, our endurance was rewarded by another amazing experience. On the other side of the vehicle and close to it, another leopard arrived, dragging the carcass of an impala. Suddenly a hyena challenged the cat for the kill, and a fierce altercation ensued. We sat there, awed by the savage, primeval sounds of these rival predators. The leopard grabbed the heavy carcass – several times its own weight – in its vice-like jaws and hauled it up the tree. The display of strength was astonishing. We watched as he laid the limp, lifeless impala across a branch, a gaping, bloody void where one eye had been.

In the early hours of the morning Peter was able to coax the radio to life and transmit a crackling message back to base. We were rescued, and thawed out with steaming hot coffee, sandwiches and blankets."

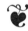

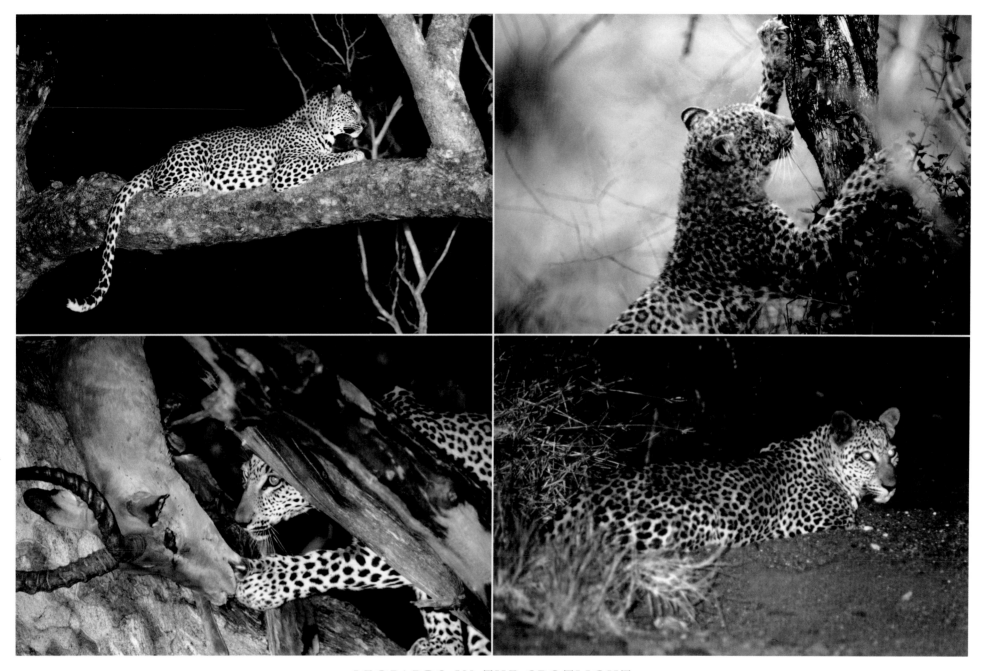

LEOPARDS IN THE SPOTLIGHT

31

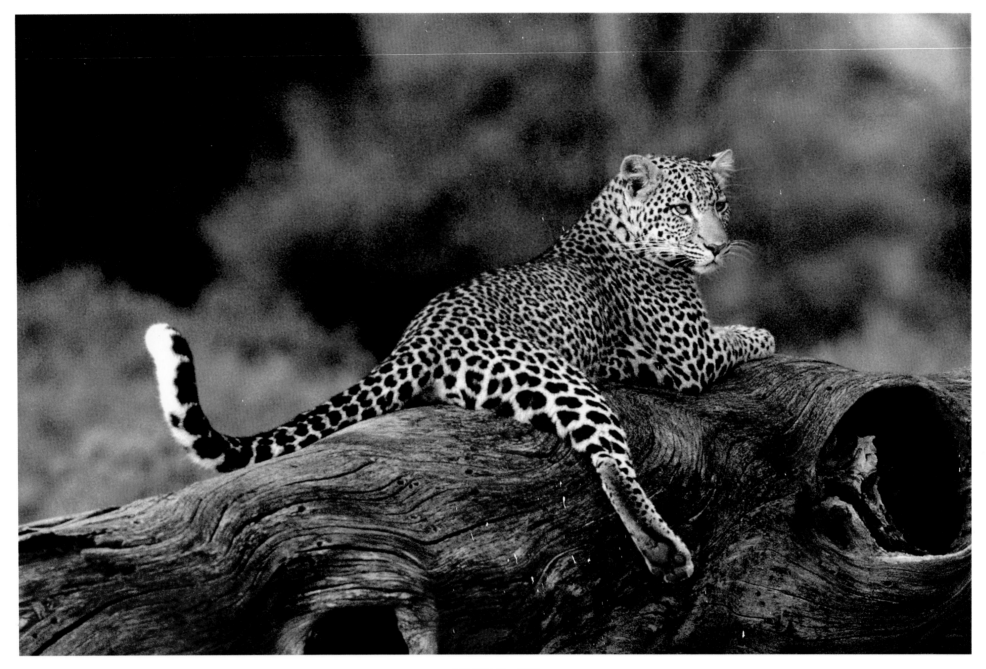

LYING UP

An accomplished stalker, the leopard displays endless patience and supreme stealth during the hunt. A solitary, silent killer, it stalks to within close range of its victim before pouncing with lightning speed. Although leopards consume some of their quarry immediately after the kill, they then drag the carcass hundreds of metres to store it in dense bush. At times, they may use their immense strength and agility to cache their prey in a tree, out of reach of scavengers such as lions, hyenas and wild dogs. Leopards hunt at night, lazing around for most of the day, their handsome, spotted coats providing good camouflage in the dappled shade of treetops or in dense undergrowth.

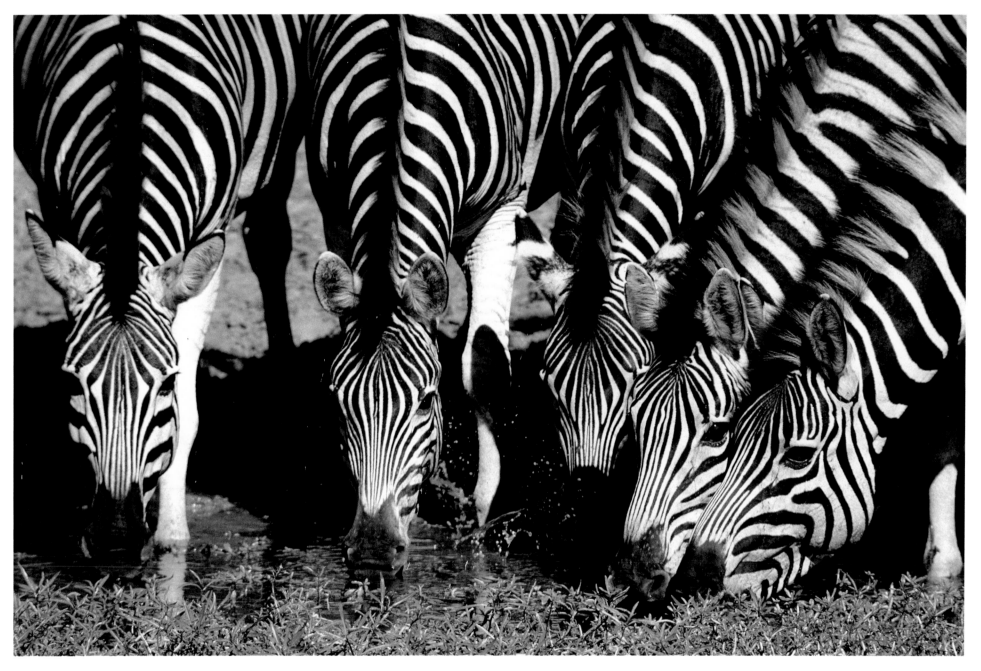

BURCHELL'S ZEBRA, *Equus burchelli*

Questions about the wondrous striped hide of the zebra continue to confound scientists. What is its purpose? Chief among evolutionary theories is that the stripes confuse predators who see only a random pattern and are therefore unable to single out an individual. Another suggestion is that the vertical markings serve as camouflage – but zebra herds are startlingly visible as they range in open grassland, so that seems doubtful. Other suggestions are that the stripes may create a 'feeling' of belonging among herd members, and that pattern variations help individuals recognise their own species.

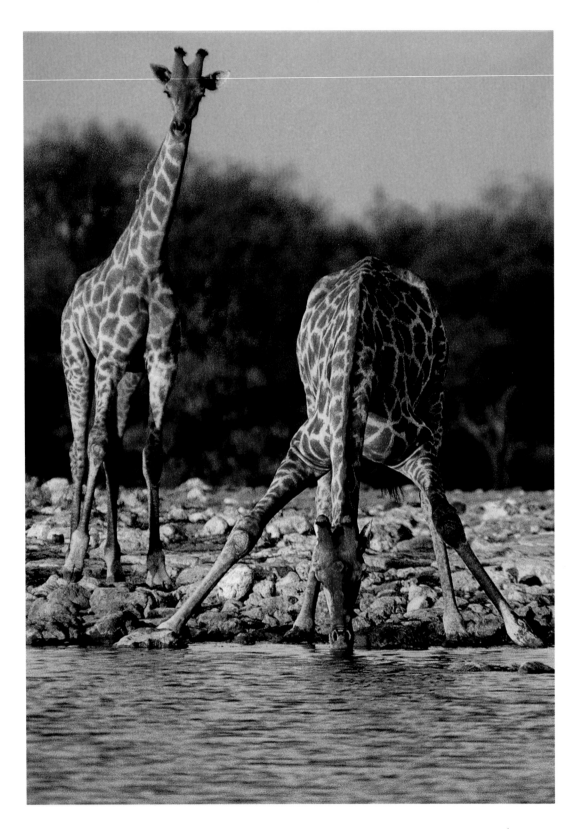

GIRAFFE,
Giraffa camelopardalis

Even after splaying its legs and bending its knees, the giraffe must lower its neck five metres in order to quench its thirst. It is very vulnerable when drinking and constantly has to jerk its head up to check the environment for predators. The sudden rush of blood either way would cause a blackout were it not for the giraffe's unusual circulatory system. Blood flow to the brain is maintained by means of elastic blood vessels and special valves which open and close in the carotid artery and jugular vein, controlling the back-flow of blood.

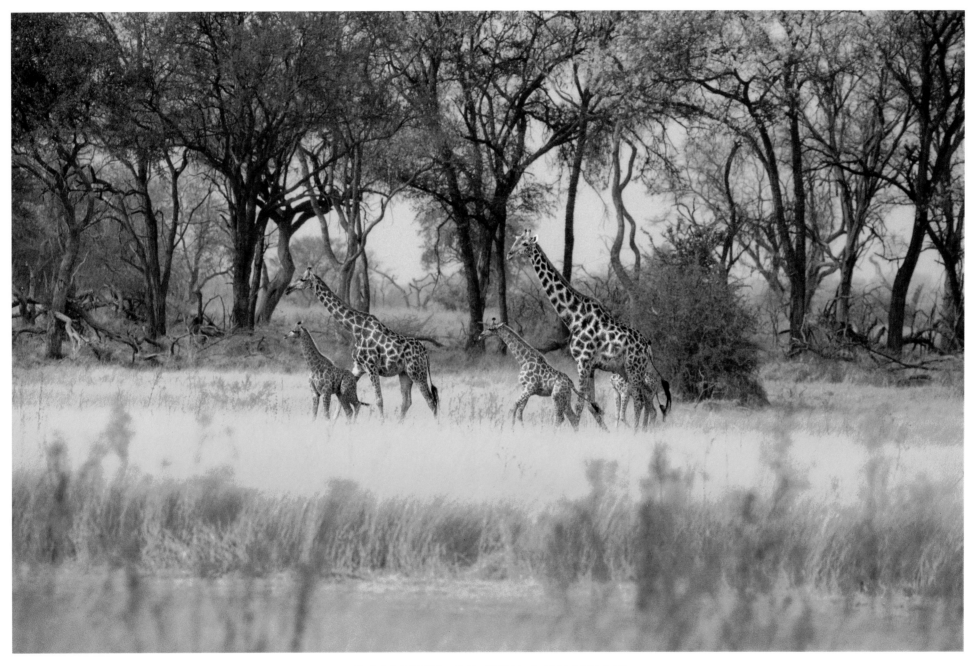

GOLIATHS OF THE SAVANNAH

These strange, loping giants of the African savannah, with their unique, honeycomb-patterned hides, are the world's tallest creatures, reaching nearly six metres in height. To sustain their 1,900kg bodies, their daily diet consists of up to 34kg of leaves and tender shoots, plucked from trees such as *Acacia* and *Combretum*. The giraffe uses its long, prehensile tongue and sensitive lips to manoeuvre the food into its mouth. Thorny vegetation is made more digestible by compressing it against the grooved upper palate, before swallowing it with viscous saliva. Giraffes spend over half the day feeding and part of the night chewing the cud.

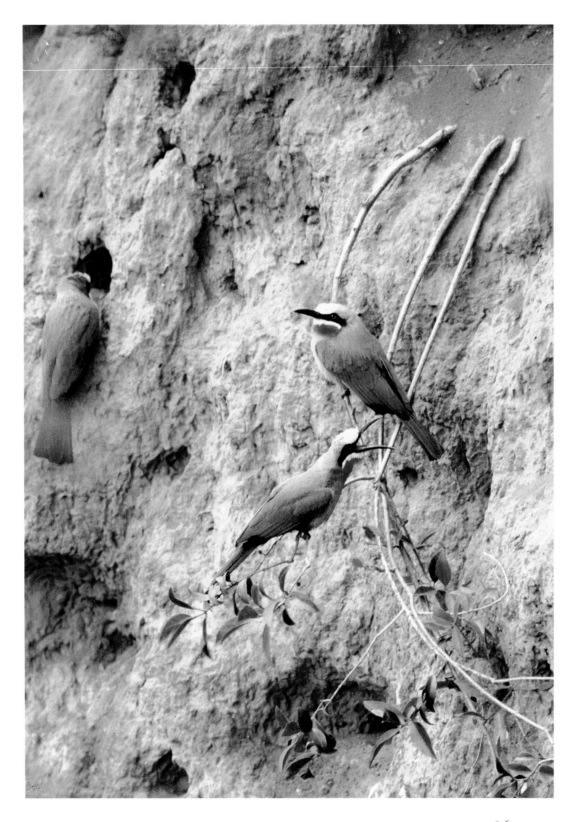

WHITEFRONTED BEE-EATERS,
Merops bullockoides

Whitefronted bee-eaters breed colonially in burrows which they excavate themselves in steep, muddy banks. Single colonies contain as many as 150 breeding pairs of bee-eaters, but birds called 'helpers' supplement their numbers. These birds assist by feeding youngsters in the nests of close relatives. As many as five helpers can be active at a single nest. Several bird species have helpers at the nest – a strategy termed 'cooperative breeding'. In most cases, the assistants are young birds that are waiting to attain breeding status. The whitefronted bee-eaters are unusual in that a bird that has been a breeder one year will sometimes revert to being a helper in the following year. Another unusual feature of their breeding biology is that three or four nearby nest-owners combine to form a 'clan'. Clan members move freely between each others' nests, but will not tolerate the presence of non-clan birds.

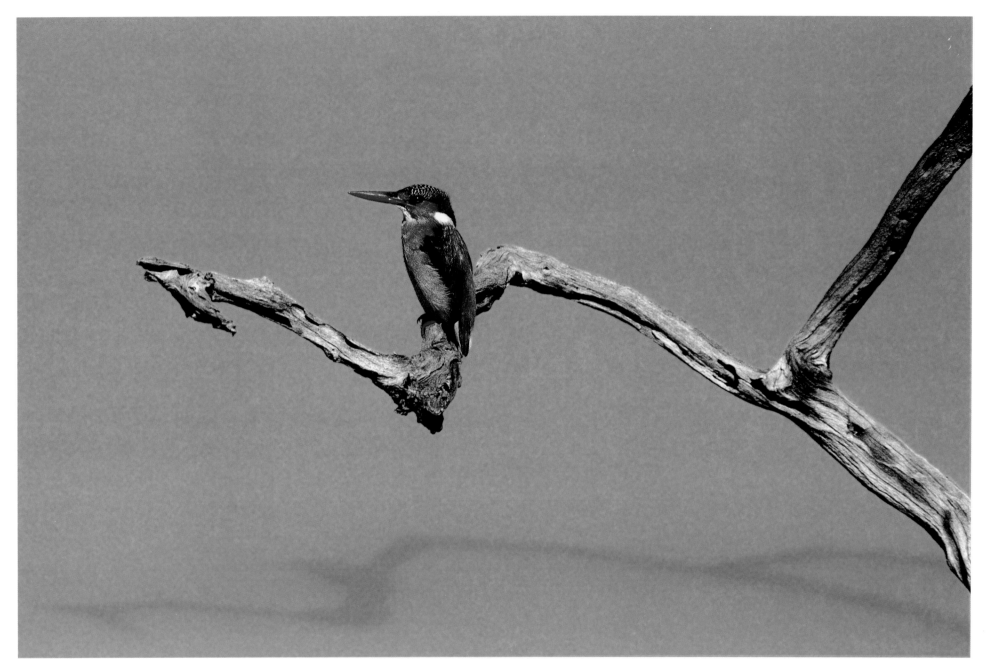

MALACHITE KINGFISHER, *Alcedo cristata*

The waterways, lakes and swamps of sub-Saharan Africa are home to the malachite kingfisher. When perched out in the open like this, its electric coloration hardly seems the perfect adaptation for a stealthy hunter. But, when the bird perches motionless in the dappled edges of a reedbed, it blends beautifully into the background. From its vantage point it dives steeply downwards onto its prey of fish, frogs, crabs or water insects, returning to its perch to stun the prey before swallowing it whole. Malachite kingfishers can breed for the first time when only six months old, and, during their long breeding season of up to six months, can rear three or four broods of youngsters in rapid succession.

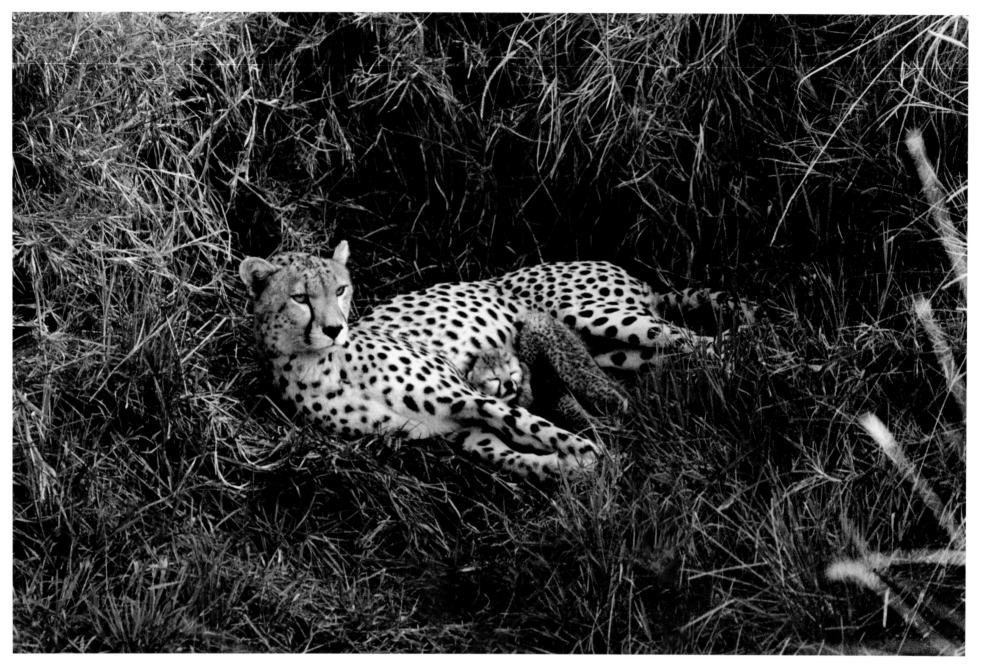

MOTHER CHEETAH AND CUBS, *Acinonyx jubatus*

This cheetah takes motherhood seriously, and works hard in the 18 months it takes to train her young. By five weeks the cubs accompany their mother on hunts, studying her supreme sprinting skills and partaking of the spoils. They practise stalking, chasing and killing in play, emitting shrill calls if in danger, bringing their mother racing home. Weaned at three months, by six the long-legged youngsters are making their first kill, practising on small live rodents which their mother brings back for them. By nine months they're hunting fawns, hares and other small mammals. By 15 months practice has made perfect; the young cheetahs are worthy of the title 'greyhound of the cats'.

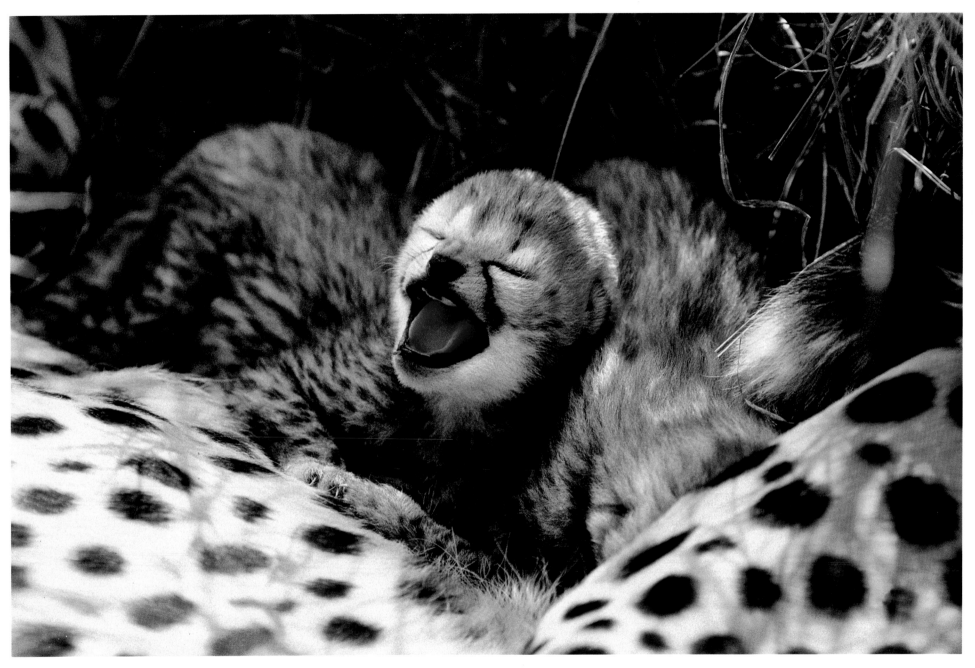

CHEETAH CUBS

The cheetah gives birth to three cubs on average, although she may have as many as eight, gestating for some three months. Like the leopard, cheetahs hide away among rocks and scrub to have their litter, and are strongly protective. A cheetah may hide her cubs somewhere new every other day at first. Already the little ones have the characteristic facial 'tear lines' running from eye to mouth, yet their coat is quite different to that of the adult, being blue-grey. This gives them some protection against predators such as lion, leopard and hyena, to which they are extremely vulnerable. That's why only about a third of the litter survives to adulthood.

"The morning was crisp and cool as we set off on a game drive from Kichwa Tembo camp in the Masai Mara National Park. Our guide had come across a litter of newly born cheetah cubs earlier that week. We headed for the overgrown gully in which their mother had concealed them.

Still blind, the cubs were crawling, drinking, suckling, slipping and squabbling little fluffy balls of grey fur. The infants' fur mantle helps conceal them from predators.

After having fed her young, the mother stood up, stretched her long limbs, displayed her formidable teeth in a cavernous yawn, and took off to hunt.

I stayed behind, making the most of this rare opportunity to photograph the cubs interacting with each other. Leaning out of the window, I was able to get so close to them that I was able to use my macro lens (see page 39).

Some 15 minutes after the mother's departure, a dramatic situation developed. A large herd of buffalo came walking in the direction of the cubs who would almost certainly be trampled to death. Cheetah mothers do what they can to keep their offspring out of danger, but even the most vigilant cat could not have anticipated an advancing phalanx of gigantic buffaloes.

By this stage, we had been joined by a French photographer, also making the most of this opportunity to photograph the cubs. Together we hatched a plan to save the helpless animals. We drove towards the advancing buffalo and parked our off-road

vehicles in a V-shaped formation to divert the herd away from the cubs, saving them from being trampled to death.

Mother and litter were reunited and remained oblivious to the drama.

Her cubs were soon positioning themselves competitively to suckle again."

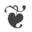

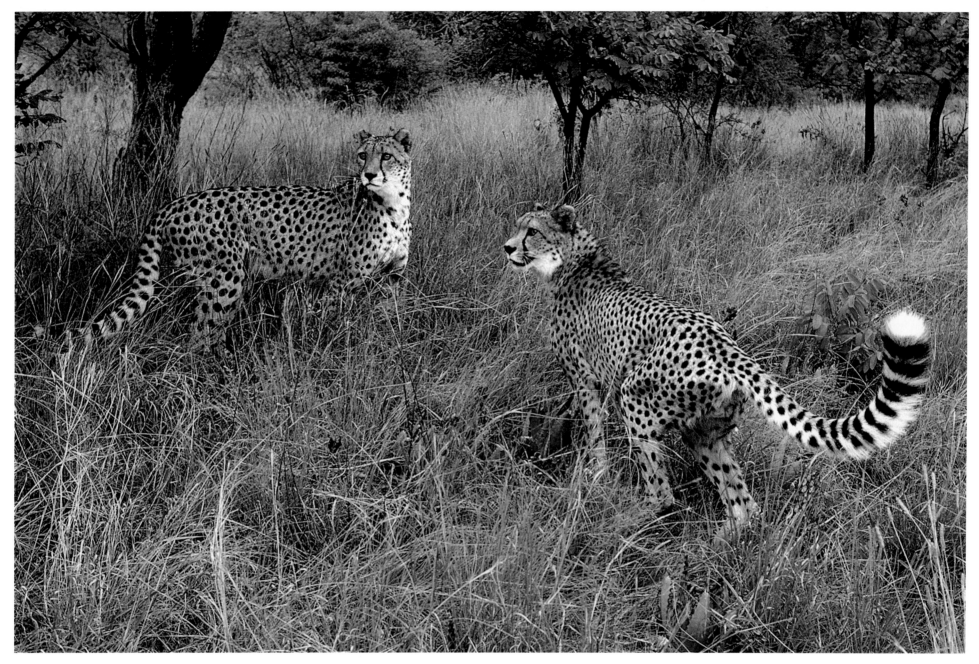

STEALTH, STYLE AND SPEED

The graceful cheetah combines stealth and supreme speed to capture its many varieties of prey, ranging from small rats to huge wildebeest. It's the fastest living quadruped, reaching speeds of up to 112km/h over 300m. Its style is to stalk its prey to within striking distance, then to make an all-out sprint. If any victim stays the course, overheating forces the cheetah to give up. Generally, however, the chase ends with a sideswipe of the paw that bowls the animal over. Then the cheetah seizes its throat, severing the jugular vein with one swift *coup de grace*. It takes only a moment to draw breath before tearing the carcass apart, as lions and hyenas await their chance to rob them of their kill.

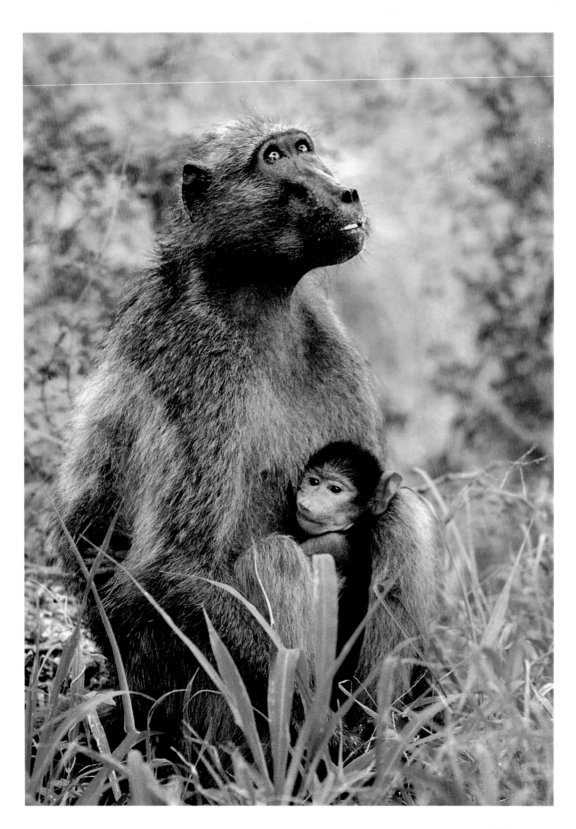

CHACMA BABOON,
Papio hamadrayas ursinus

Baboons, which occur only in southern Africa, are highly social animals and range in troops of 10 to 100 individuals. They often groom each other, which not only keeps them clean, but also promotes harmony in the troop. There is a strong bond between mother and offspring: newborns soon learn to cling to the mother's belly and, when older, to swap position and ride piggyback. The troop's juveniles and other females eagerly play with the young, and help groom and ferry them; but the mother only permits this after the infant is two weeks old.

SERVAL,
Felis serval

The slender, long-legged serval, with its spotted and barred coat, is one of Africa's most elegant small cats. Seldom seen, it makes its home among the tall grasses of the African savannah, preferring to live near water and hunting mainly at night. The serval is well adapted to its habitat. With a shoulder height of just over half a metre, it is able to survey the landscape over the top of tall grasses. Its long limbs help it leap to great heights when pouncing, often landing ahead of its prey. Servals hunt for vlei rats and other rodents, and sometimes wade to catch frogs and fish. Birds also form part of the servals' diet, and the cats have been seen lurching into the air to catch birds in flight. They occasionally hunt larger prey, including flamingos and small antelope, silently swooping down before pouncing. Though absent from forest and desert areas, servals occur across Africa south of the Sahara, with a relict population living in the Tunisian and Moroccan mountains.

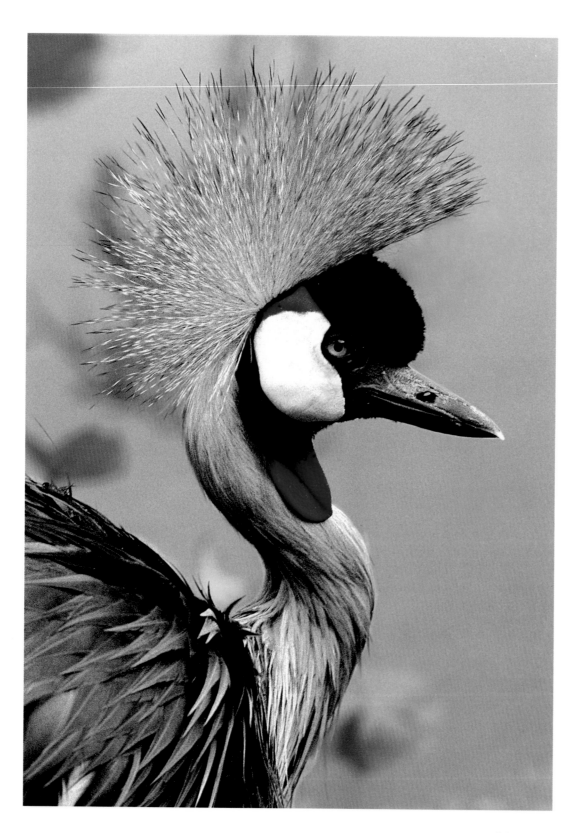

CROWNED CRANE,
Balearica regulorum

A member of the stately crane family, the crowned crane is distinguished by its unusual crest of erect, straw-coloured feathers, its striking facial markings and the bright red wattle down its throat. Crowned cranes are gregarious: 30–150 birds may flock together in marshes, along vleis and swamps, and in grassland areas. Breeding pairs build their nests from flattened reeds and grass in marshy areas or may occasionally nest in trees. They eat insects, frogs, lizards and grass seeds and can sometimes be seen feeding in freshly ploughed fields.

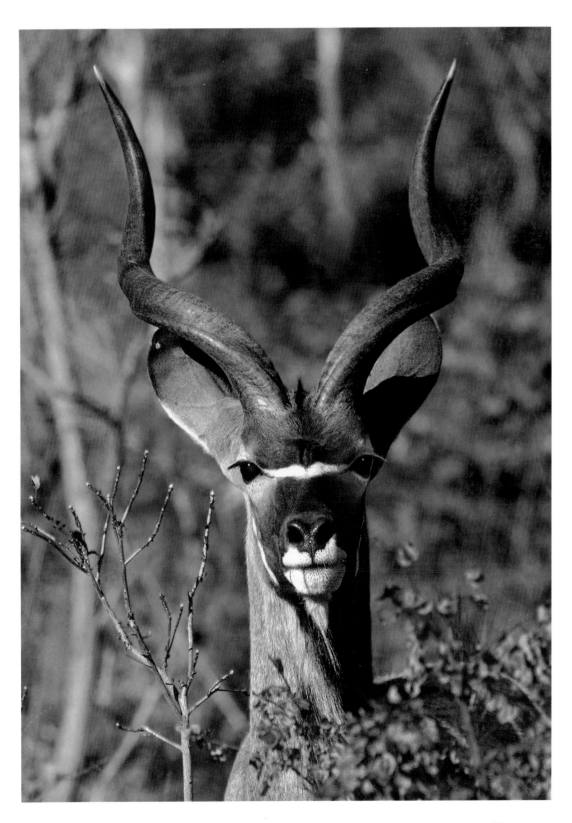

GREATER KUDU,
Tragelaphus strepsiceros

This magnificent antelope, with its delicate face and elegant white-on-grey striped flanks, is particularly fine looking. Tall and resplendent, the male sports a beard as well as his splendid horns, which continue to grow throughout his life from their first, spiky appearance at five months, and their first inward curve by the age of two. Kudu are gentle, amiable animals who seldom fight although it has been known for two rival bulls to be found dead, horns still locked. Like all antelope, their digestive system is complex and efficient, allowing them to swallow large amounts of unchewed grass in the open and retire to safety to pass it through their four-chambered stomachs twice.

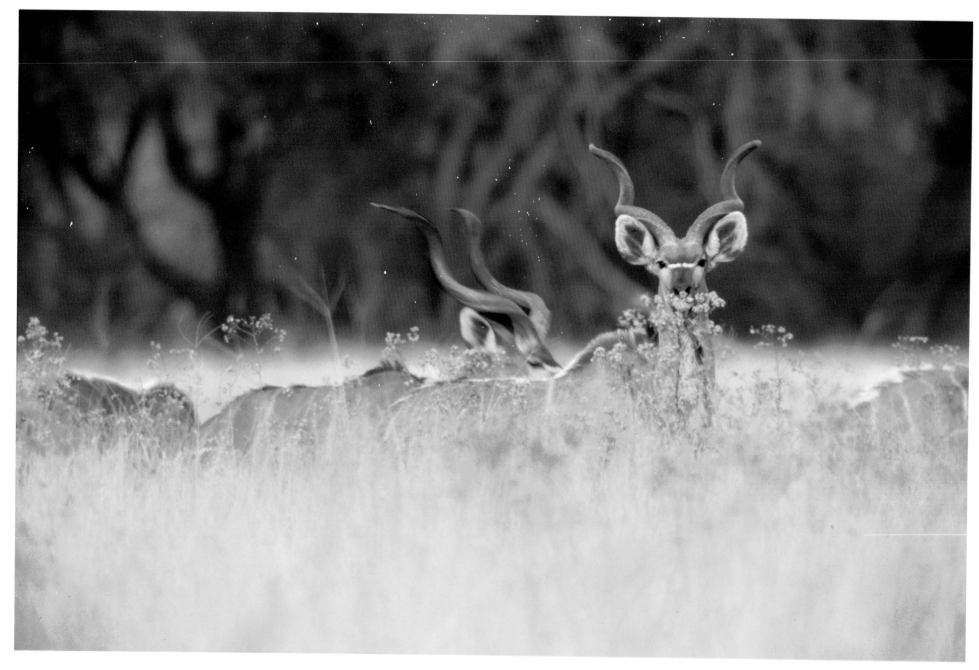

KUDU HERD

Kudu are a savannah woodland antelope, needing both cover and water to survive. They gather in tiny herds – average size four – sometimes consisting of cows and their young, sometimes mature and sub-adult bachelors. These herds usually overlap during the rut and the wet season, when food is abundant. Kudu have an indiscriminate palate, browsing on a variety of leaves, fruits and herbs. When alarmed they use their slim, long-boned feet and anklebones to make a swift retreat, a vital defence for animals that inhabit open spaces. The male throws his head up, laying his horns back on his body so they don't snag on branches. They lift their tails, exposing the white underside as a warning of danger.

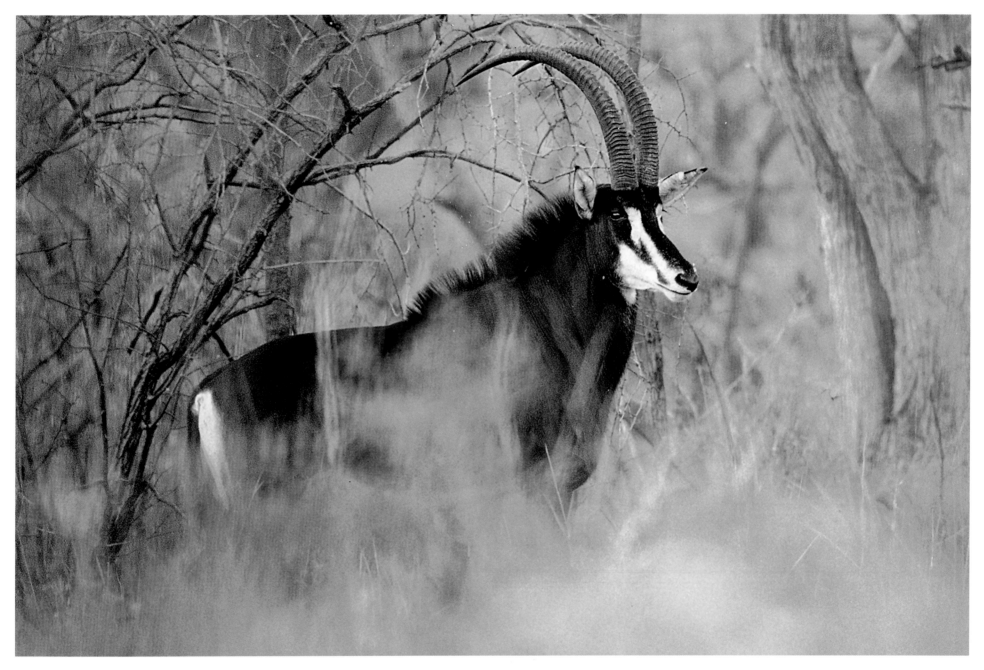

SABLE ANTELOPE, *Hippotragus niger*

The sable antelope is probably the most striking of all African antelopes. Other animals, even lions, are wary of the damage that can be done by a sable antelope's sharp, scythe-shaped horns, and few attack it. The largest of its species, it lives in small herds of about 30, aggregating into larger ones during the dry season when grazing fields are diminished. A strict hierarchy regulates social relations in the herd, with mating bulls in supreme authority. But the real power lies with the dominant females, whose ranking is determined by their age. It is the older ones who lead the herd to greener pastures and drinking holes, and alert it to danger.

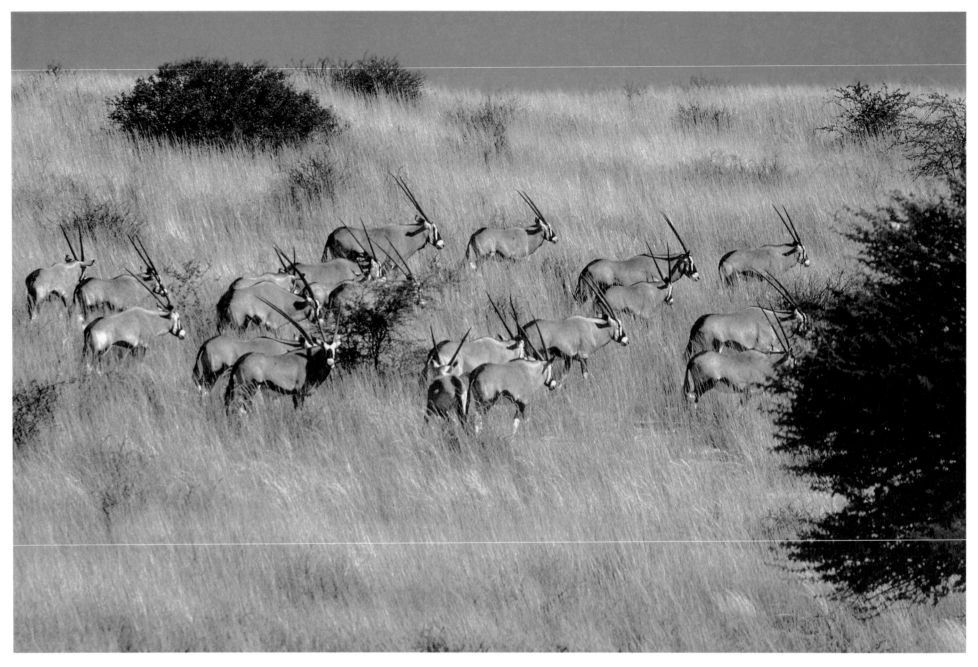

GEMSBOK, *Oryx gazella*, KALAHARI GEMSBOK NATIONAL PARK

Gemsbok, among the most regal of antelope with their distinctive black and white faces and rapier-sharp, V-shaped horns, are also the most quarrelsome. They live in mixed herds averaging about 14 antelope in the driest parts of southern and northeastern Africa. Herds are strictly hierarchical, the ranks being topped by the territorial male, followed by a senior cow, who is also the herd leader, and a mix of submissive females and non-breeding bachelors. Bulls mark their territorial boundaries with dung pellets dropped in small piles – a warning that the owner will defend his property to the death, as even lions have found. The buck also scent-mark their territories by pawing the ground.

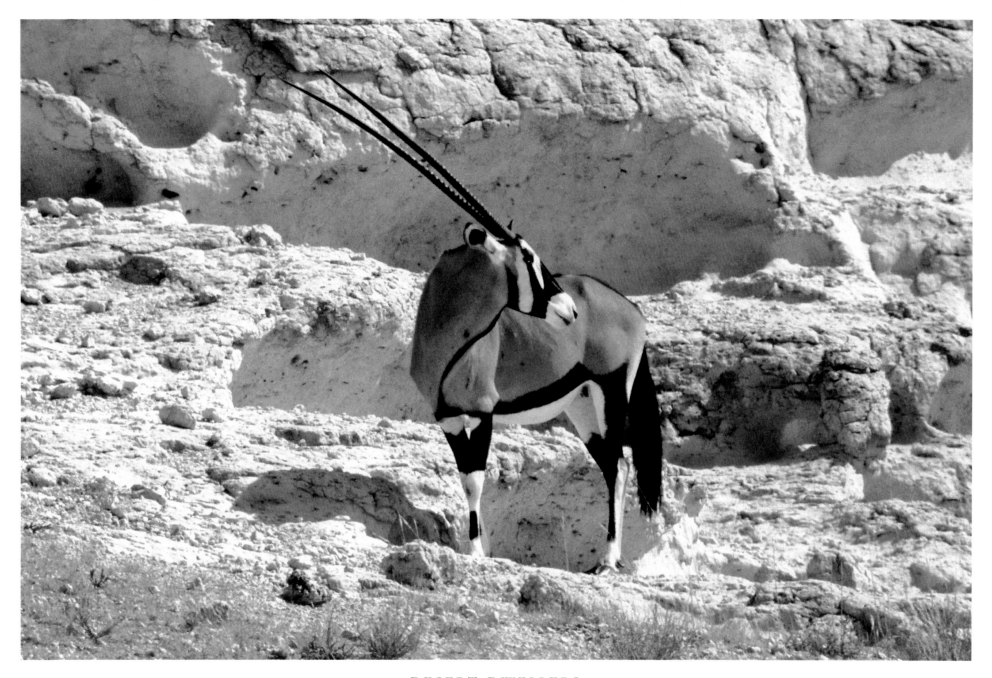

DESERT DWELLERS

The statuesque gemsbok, seen here at a salt-lick, lives a life of remarkable adaptation to an environment in which the sun beats down mercilessly for most of the year, vegetation is sparse and water may not be seen for days. Its body temperature may rise by as much as 6°C to 45°C, thus preventing sweating, and enabling it to store excess heat, which it uses in the cool evenings. When the animal needs to cool down, it pants through the nose with the mouth closed, which increases the airflow over surface capillaries. Other behavioural adaptations include digging for water-rich roots, tubers and tsamma melons, and grazing at sunrise and sunset, when plants have absorbed maximum moisture.

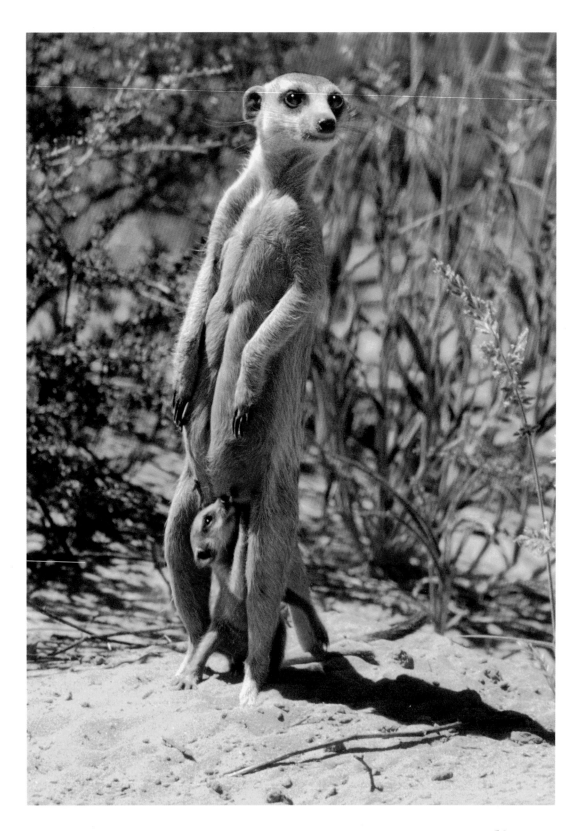

SURICATES,
Suricata suricatta

The arid Kalahari Desert is home to the lively suricate or meerkat, a member of the mongoose family. These highly social animals live in burrows, in colonies of up to 30 animals in the Kalahari. They are communicative, always keeping eye contact with foraging family members while simultaneously making murmuring sounds. A sentry, who keeps watch for predators such as birds of prey, uses distinctive alarm calls to alert the foragers to danger. While the mother searches for food, the young are cared for by males and by non-breeding females.

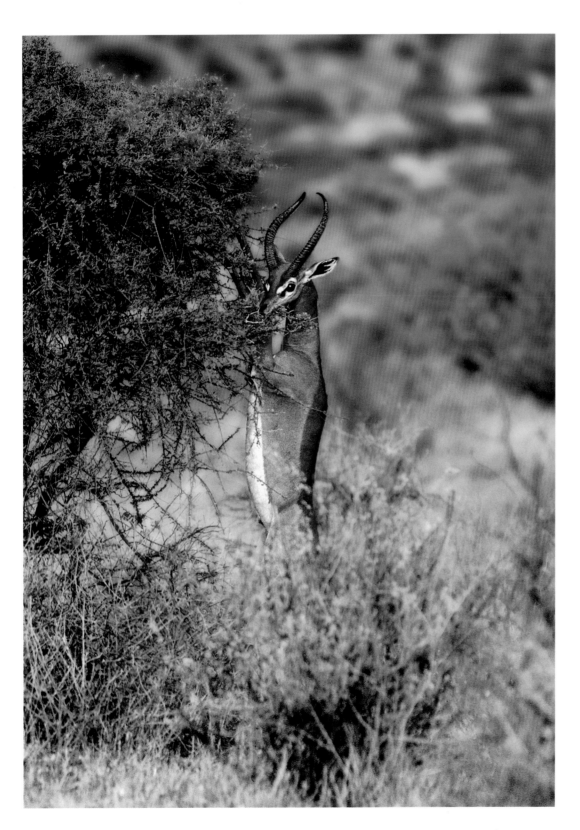

GERENUK,
Litocranius walleri

The graceful and rare gerenuk, with its elongated neck and long, slender limbs, is perfectly adapted to feeding in its natural habitat. Standing on strong hind legs, it can selectively feast on succulent leaves, shoots, flowers and fruits in the higher reaches of thorn trees and bushes. When feeding it reaches up with its forelegs to bring higher branches within range. Gerenuks can survive for extended periods without water, obtaining most of their moisture from trees and shrubs. They are found in small, semi-social herds in the dry savannah regions of the Horn of Africa, from Ethiopia to Tanzania.

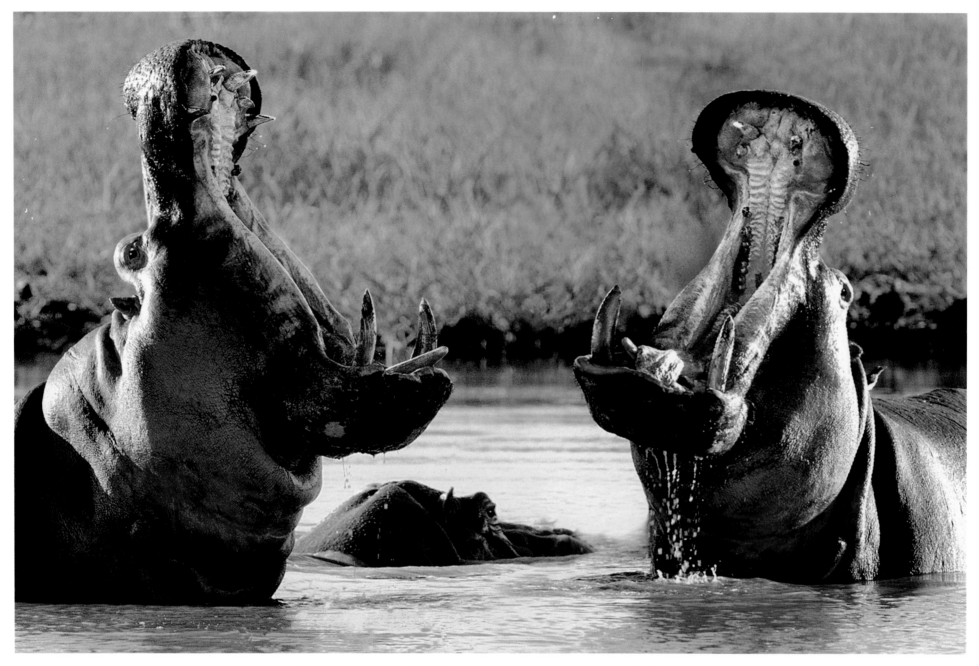

HIPPOPOTAMUS, *Hippopotamus amphibius*

A territorial male hippo will defend his river home and status as dominant herd bull to the hilt. Where populations are small, dominant males can maintain their territories for several years. Fights, though, are kept to a minimum by ritualised threat displays (including dung-showering, lunging, throwing water scooped into the mouth, and grunting). When fights do happen, they can be fatal. Hippos' jaws can open to 150 degrees, and their tusk-like canines, kept razor-sharp by constant whetting of the incisors on the lower teeth, can cause serious damage. Herds usually number up to 15 animals but can increase to as many as 200 when there is sufficient water space.

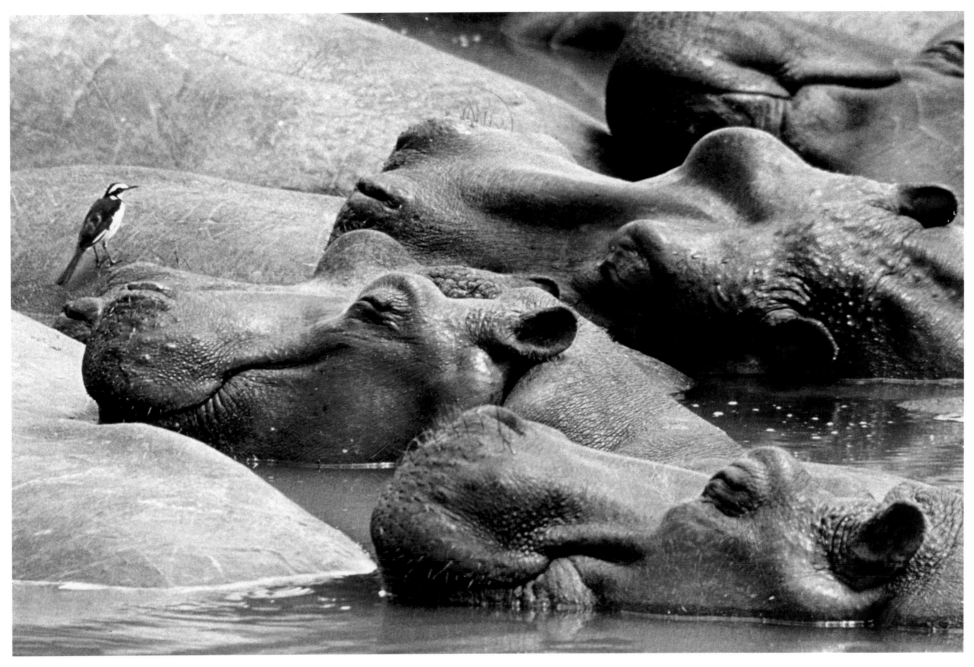

'SMILING' HIPPOS

Aquatic by day and terrestrial by night, hippos loll around in water and wallow in mud-pools to protect their sun-sensitive skins from dehydration and sunburn. After sunset, herds journey to adjoining grasslands to graze. Hippos generally feed alone, although mothers and calves feed together. During the five or six hours of supper time, adult hippos can walk up to 10km while foraging and consume 40kg of grass at one sitting. Creatures of habit, hippos traverse the same paths to and from their pasture every night and won't hesitate to attack any animal or human which comes between them and the water. Despite their bulk, they are remarkably fast, reaching maximum speeds of 30km/h.

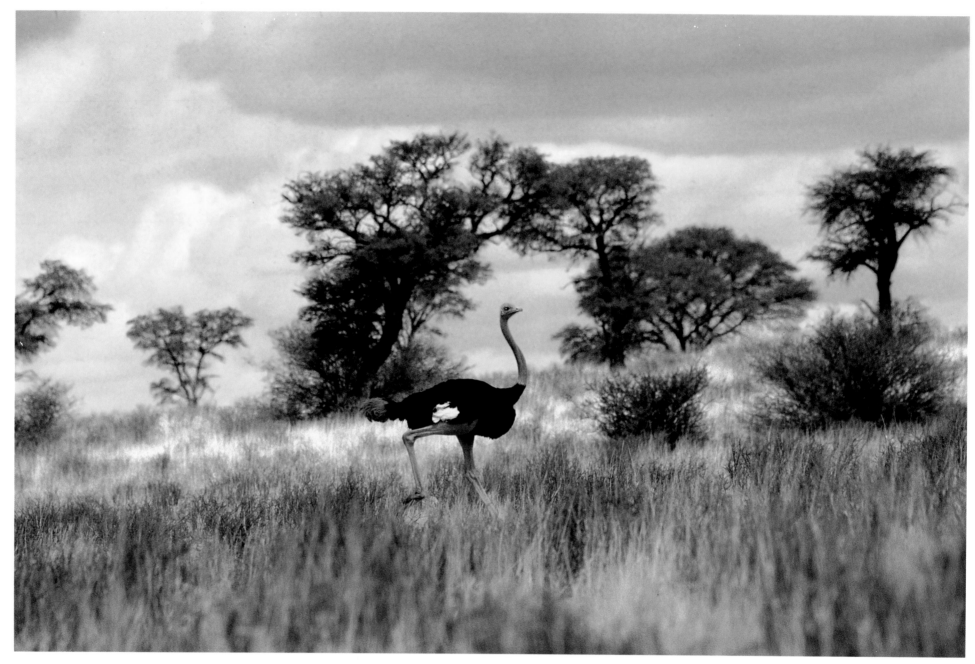

OSTRICH, *Struthio camelus*

The ostrich is the largest living bird: males can stand almost three metres high and weigh up to 150kg. The ostrich also has the largest eye of any terrestrial vertebrate. Their relatives are found in South America (the rheas) and Australasia (emus, cassowaries and kiwis). Other relatives, the moas of New Zealand and elephant birds of Madagascar, are extinct. Although ostriches are now confined to Africa, they had a wider range in the past. Fossils have been found from southern Europe to Mongolia, some of which are about 12 million years old. Modern ostrich farming was started in South Africa in the 1830s and, in recent years, has spread to other parts of the globe.

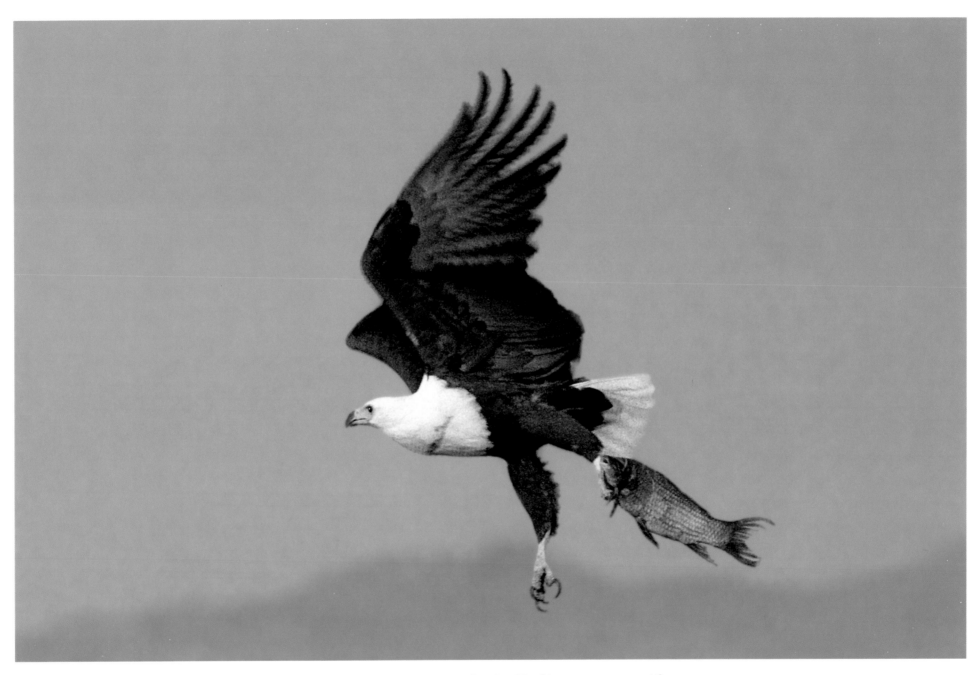

AFRICAN FISH EAGLE, *Haliaeetus vocifer*

"No sound better captures the essence of Africa than the cry of the fish eagle. Its call evokes the ancient plains of the African continent, slow, somnolent afternoons, the secretive rustle of savannah grasses under sunset skies, the jackal's bark echoing across moonlit valleys. No other sound is so paradoxical: haunting and forlorn, yet filled with the infinite possibilities of the unknown and the unexplored. It's a cry that resonates with that spiritual place in all of us where sorrow and hope coexist."

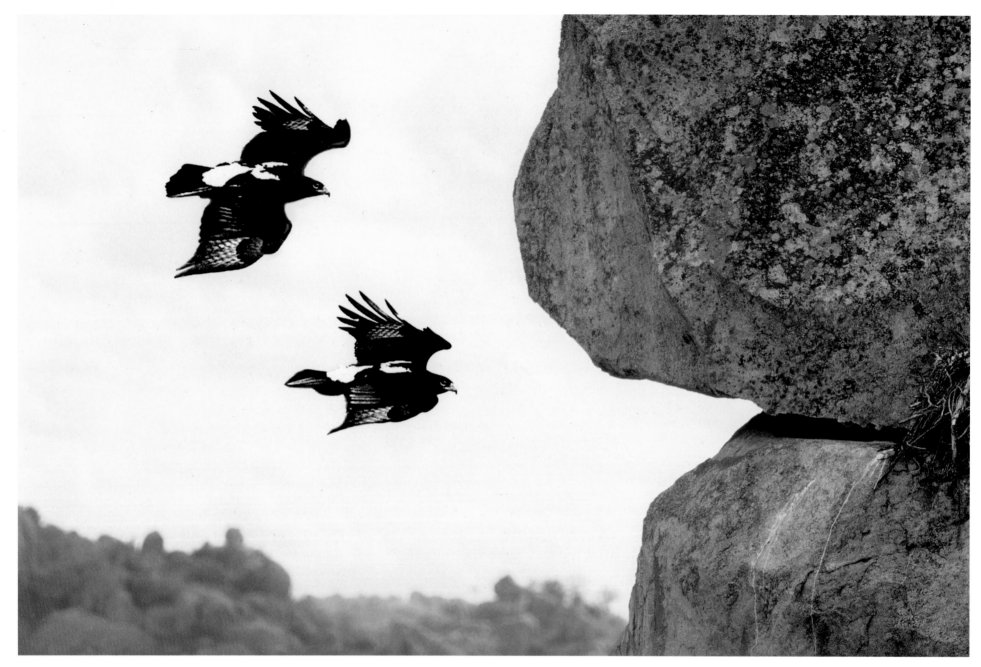

BLACK EAGLES, *Aquila verreauxii*

"The largest congregation of black eagles in the world is found in the Motobo Hills, Zimbabwe. It is a spiritual place, where ancient African chiefs lie buried. So too does Cecil Rhodes. To the Ndebele people it is Malindidzimu – 'the dwelling place of benevolent spirits'. I visited this intriguing place with my son Marc, to take photographs of these beautiful birds of prey.

Many birdwatchers are happy if they can identify birds as tiny specks in the sky, but I don't consider it a sighting for my photographic purposes unless I can see and record the bird's fine details. Since black eagles inhabit inaccessible rock faces and craggy heights where their favourite food, the dassie or rock hyrax, frolic, photographing them in this way presents a difficult challenge.

On arrival in the Motobo Valley, I was introduced to a Matabele tribesman, Malaki Sithole, who told me he knew a perfect spot for viewing a black eagle's nest. So, before sun-up the next morning, Malaki, Marc and I set out to climb the Khalanyoni Mountain. This was not easy as I was carrying heavy photographic equipment, including a huge lens (Leica 800mm/f6.3 with a 2x extender), which stores in sections like an assassin's rifle but resembles a bazooka when assembled, as well as my special 'tripod sandbag'.

We were awed by the precariously balanced, giant granite boulders around us, reminiscent of modern sculptures. Hours later, after an arduous hike up the mountain, we reached an ideal vantage point – a natural crevice with commanding views of the pristine valley below. Most exciting, we were within 500 metres of a spectacular rocky monolith. Perched on a sheer rockface near the top was an eagle's nest, an extraordinary structure of stout twigs built on successive older black eagle nests. In a contemplative atmosphere of brooding silence, broken only by the whispering breezes that blow at these lofty heights, we waited for the birds to take flight. I focused my lens on the nest, but the female seemed reluctant to leave her eggs, no doubt aware of our presence.

Hanging above the nest I noticed something astonishing. Ropes! They dangled from a remote pinnacle which I gauged no human could scale. I asked Malaki how on earth they had got there? 'Poachers,' he told me. They had apparently clattered into the area in a helicopter, greedy for the rare birds' eggs that would fetch good money from collectors in Europe. The perpetrators were caught, prosecuted and fined, we were told.

Suddenly the pair of eagles flew over us to investigate. Dropping like stones from a great height, they banked steeply, their shrill cries echoing across the valley, and alighted on a nearby hill, probably to evaluate our presence. Eventually they both flew past us to the nest. Then the female settled on the eggs while her partner, some 15 minutes later, soared off to join another pair of eagles, specks against the sunset sky. We were stunned by the magic of it all and our spirits soared with the eagles."

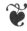

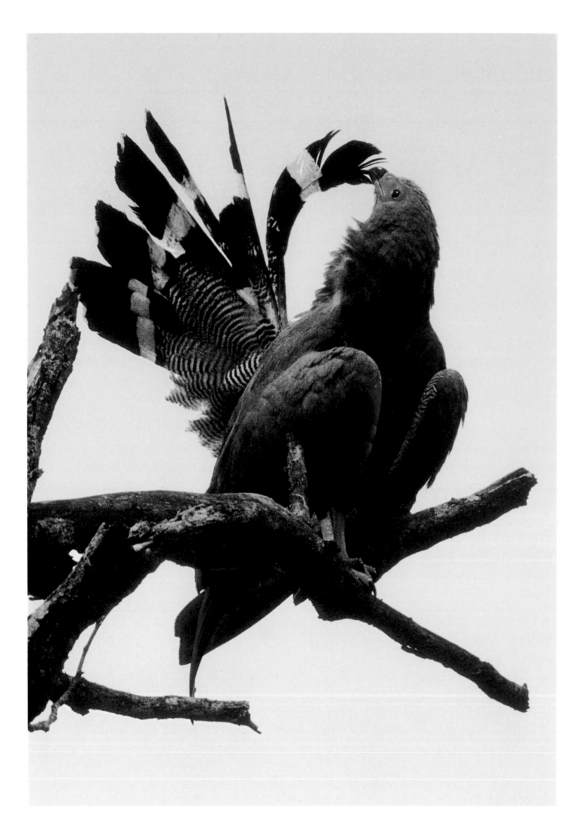

RAPTOR'S RAPTURES

"While driving in the Kruger National Park one morning with park ranger, Chris van der Linde, we noticed a solitary gymnogene perched on a branch. Unfortunately the raptor was in un-photogenic light. I needed the sun at my back, so after taking a reference shot I asked Chris to reposition the vehicle. Somewhat incredulously, he warned that the raptor would fly away if he started up the engine. As predicted, the bird took off as soon as he turned on the engine. Together, we watched as it flew off. Then suddenly it soared, circled in the air and unexpectedly alighted on a nearby branch. This time the light was perfect. The gymnogene ruffled its feathers and preened itself with panache, fanning its feathers through its beak. Within moments a male gymnogene alighted, literally out of the blue, and a dramatic, tender 'love scene' ensued. Gymnogenes have legs that are uniquely jointed to assist them in raiding other birds' nests. Their heart-shaped faces are normally yellow, but turn red when they become sexually excited."

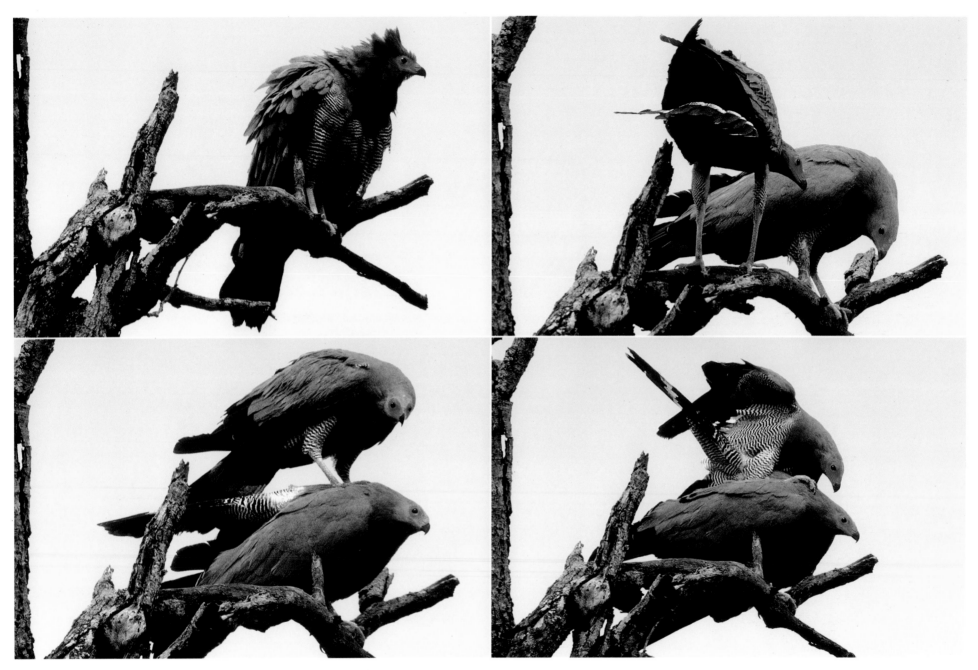

MATING GYMNOGENES, *Polyboroides typus*

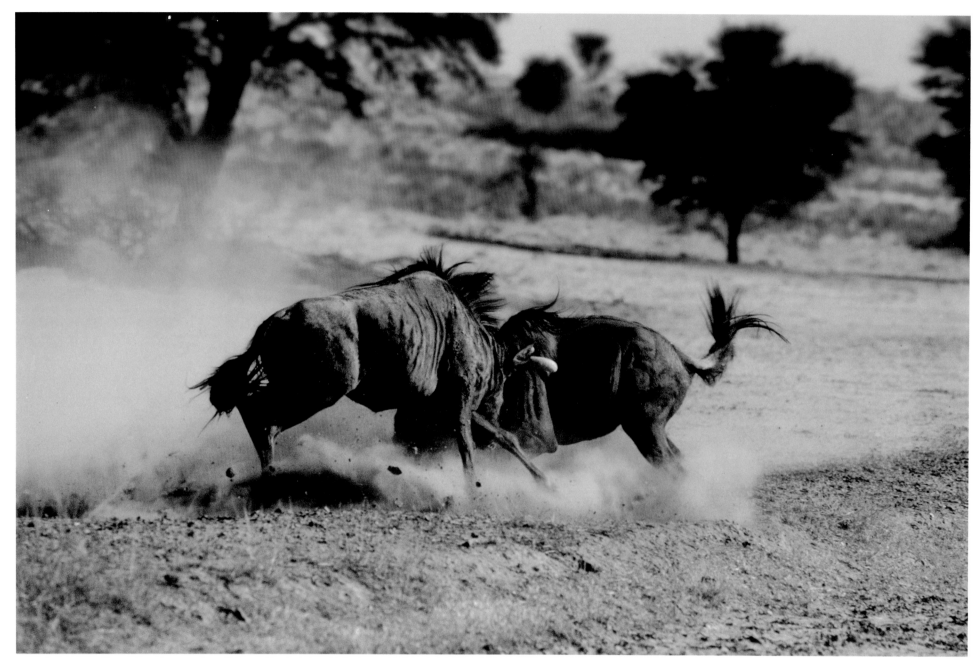

BLUE WILDEBEEST, *Connochaetes taurinus*

Unless cornered or injured, wildebeest are peaceable and usually shy away from confrontation. However, male territorial disputes during the rut may sometimes lead to a brief period of boss butting and horn clashing, though serious injury is seldom inflicted. Wildebeest occur in stable formations, typically numbering around 30 individuals. Yet large congregations of thousands of animals mark the dramatic seasonal migrations across the vast plains of the Serengeti in Tanzania. Calves, born on the open plains, are extremely vulnerable to predators, but their precocious behaviour – they are able to stand and then run with their mothers a few minutes after birth – improves their chances of survival.

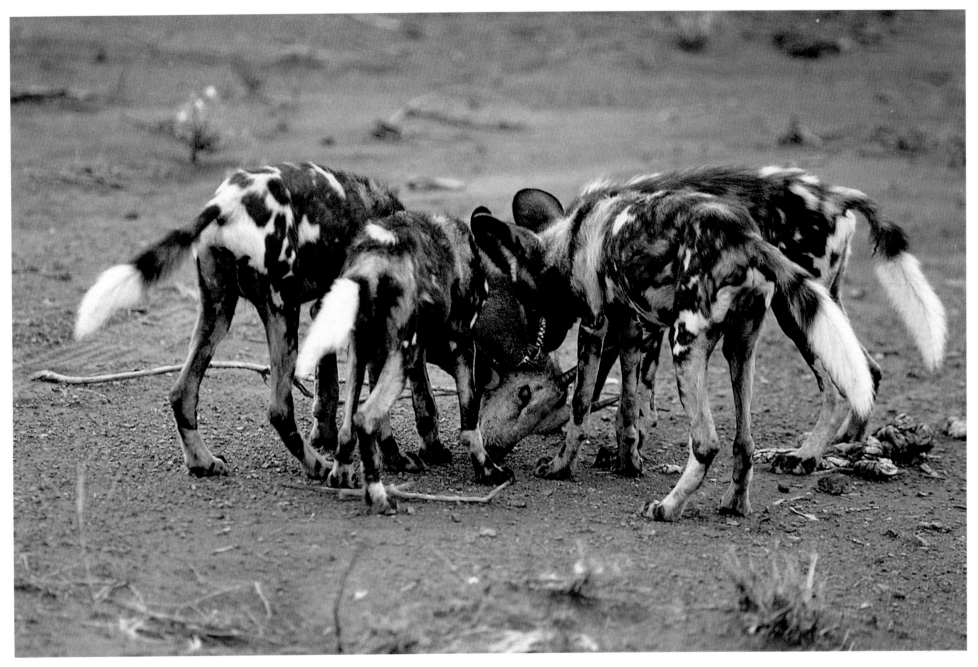

AFRICAN WILD DOGS, *Lycaon pictus*

"I have witnessed a pack of wild dogs on the hunt in what was reminiscent of a disciplined military formation. They are very efficient hunters indeed. On this occasion they ran down an impala and bit chunks out of the animal as it ran, then tore it limb from limb. The dogs then ran off with the bones and, in minutes, it was as if the impala had never existed. On another occasion I came across a pack of wild dogs that, at 5.30am, were running around with the heads and limbs of a baby impala in their mouths. I was able to park my vehicle among them and observe them for about an hour."

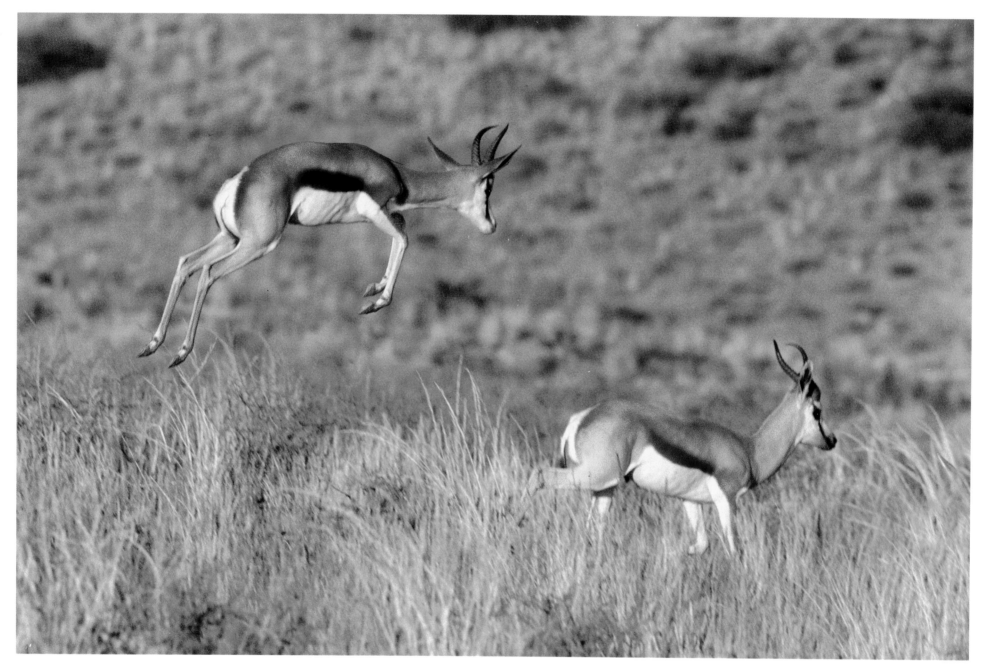

PRONKING SPRINGBOK, *Antidorcas marsupialis*

In a characteristic mid-air display of predator avoidance, springbok give a characteristic stiff-legged leap, known as 'pronking' (a form of stotting). Triggered by fear or danger, in one smooth movement the buck extends its legs, arches its back, and propels its body upwards, sometimes leaping two metres high before landing. The action is repeated again and again as the buck leaps and bounds towards safety. This leaping movement lends the springbok its common name – its specific name, *marsupialis*, refers to the crest of white hair which fans out during pronking, possibly signalling to the predator that it has been noticed. Normally the fan is hidden in a 'pouch' beneath the buck's hair.

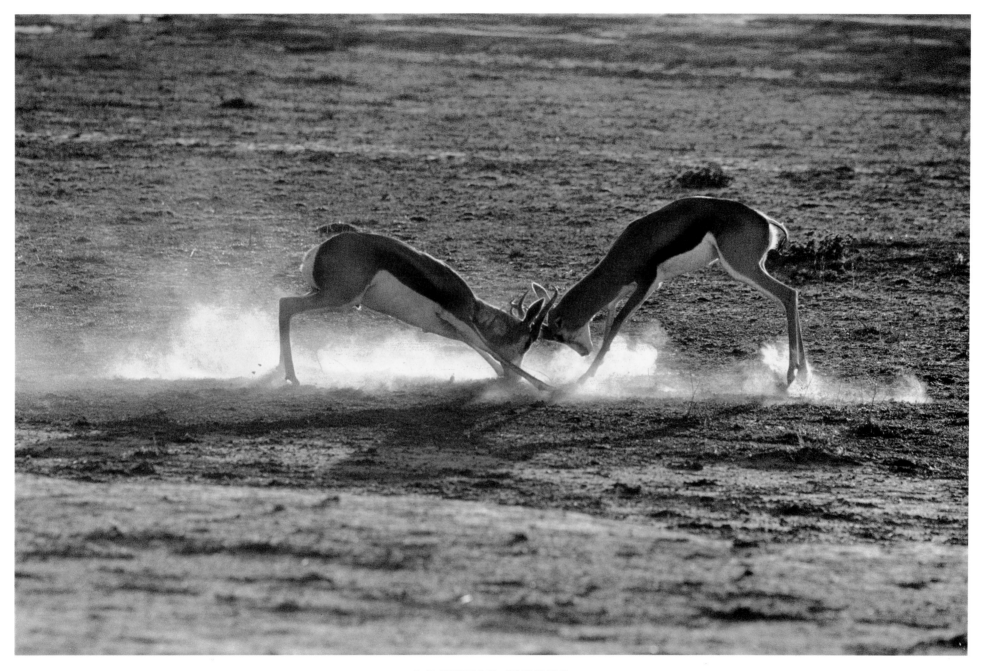

LOCKING HORNS

Springbok lock horns only occasionally, and more in fun than fury – it's generally just a case of play-sparring among young males, ending without injury. Yet springbok rams are as territorially fierce in the mating season as any other animal, and search their domain for a female herd which they noisily round up. However they are quite gentlemanly about it – if a breeding herd chooses to move on, the rams rarely resist. During the rut, the male chases a female on heat, announcing his intentions in a continuous cacophony of loud, deep grunts. Rivals are chased away, horns threatening. However, when mating is over all is forgiven, and rams form bachelor herds.

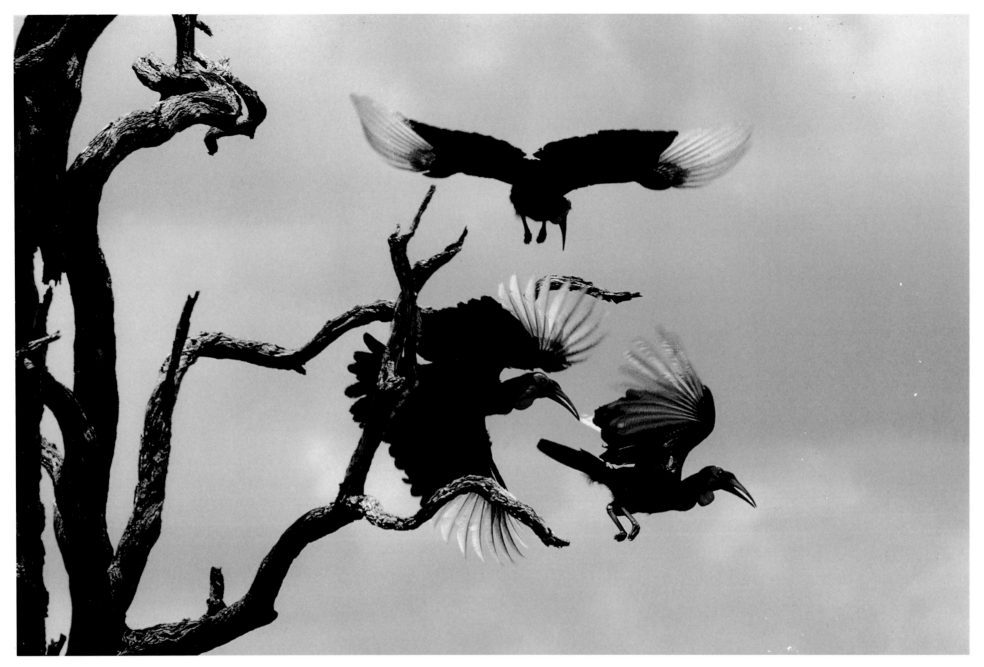

SOUTHERN GROUND HORNBILLS, *Bucorvus leadbeateri*

Some male southern ground hornbills weigh more than six kilograms, making this the largest hornbill species in the world. These birds live in family groups, and their deep, booming, territorial calls, usually given just before first light, can be heard over four kilometres away. Within the family group, only the dominant male and female breed – other group members help to feed the incubating female and, subsequently, her chicks. Despite the presence of these helpers, family groups do not breed every year, and when they do breed their success is low – a group may successfully rear chicks only once every six years. For the population to remain stable, the average lifespan needs to be almost 30 years.

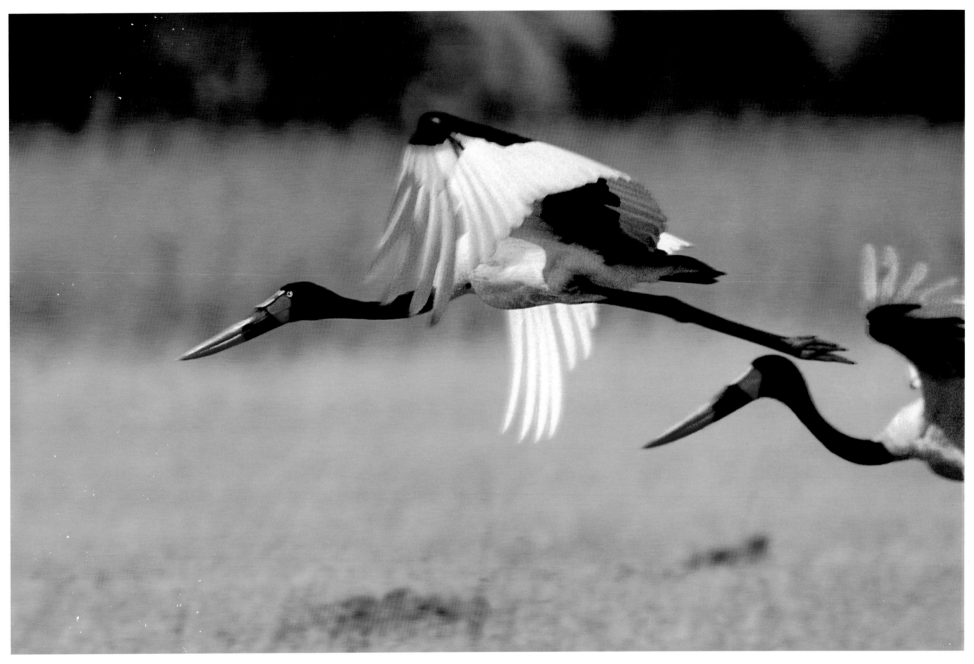

SADDLEBILLED STORKS, *Ephippiorhynchus senegalensis*

The saddlebilled stork is one of only two stork species in the world in which the male and female can be distinguished in the field. The eye of the female (the leading bird above) is yellow, whereas that of the male is dark. These striking, stately birds are widespread in the warmer regions of sub-Saharan Africa, but generally are uncommon. They prefer wetland habitats, where they hunt mostly for fish, including catfish. Catfish have large spines, which could become lodged in the throat or digestive tract. To avoid this risk, the storks neatly snip off the spines before washing and swallowing the fish.

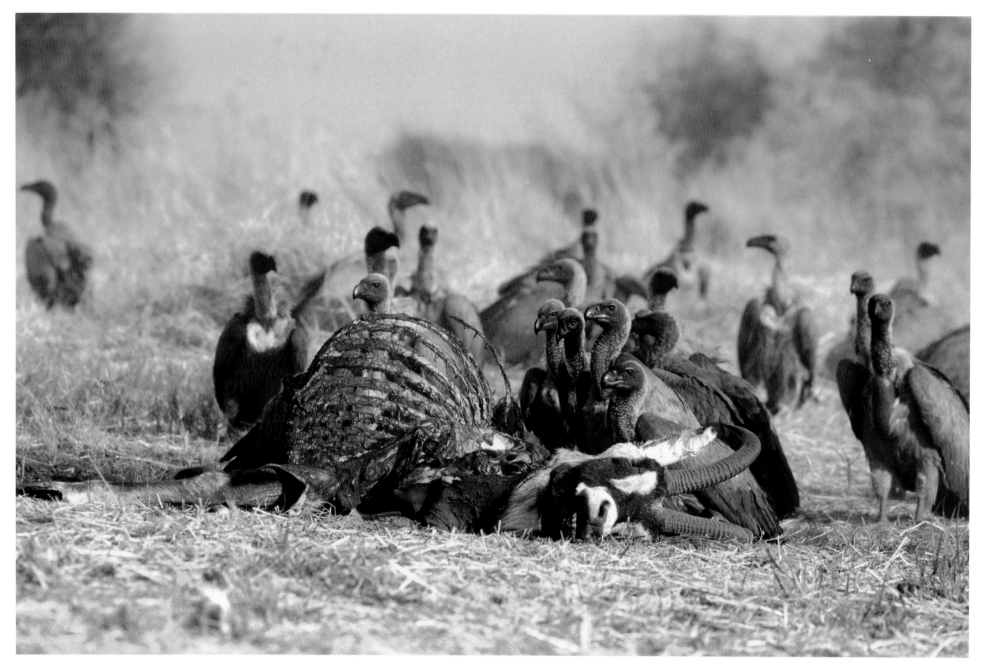

WHITEBACKED VULTURES, *Gyps africanus*

Whitebacked vultures are common in much of sub-Saharan Africa. These scavengers rely on other vultures and predators to tear the skin of a dead animal before they swoop down to devour the intestines and pick the carcasses clean. Parents carry shards of bone, crushed by larger animals at the kill, back to the nest for their chicks, for whom the shards are an important source of calcium. Some farmers have erroneously regarded vultures as a threat to their livestock and consequently many have been shot or poisoned. But this is changing: some farmers now opt to set up vulture 'restaurants' – feeding grounds with a regular meat supply – in an effort to preserve these powerful yet graceful birds.

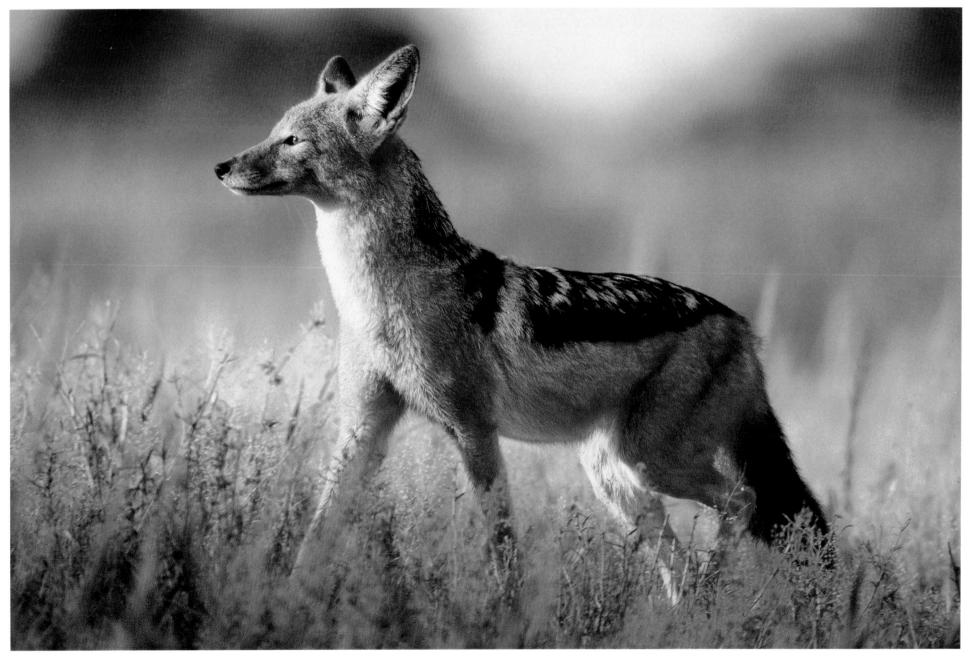

BLACK-BACKED JACKAL, *Canis mesomelas*

The dog family has been evolving for some 54 million years. At its peak, some 26 million years ago, there were 42 genera extant. Now there are only 10, of which the jackal is one. For the sharp-witted and elegant black-backed jackal, the chances of species survival are increased by the presence of 'helpers' – juveniles who remain behind to look after newborn siblings. They babysit the pups, which not only protects them from hungry predators, but also allows the adults to forage as a pack and go after larger prey. They also help feed lactating mothers and their litters by disgorging food. The more helpers there are, research shows, the more young survive.

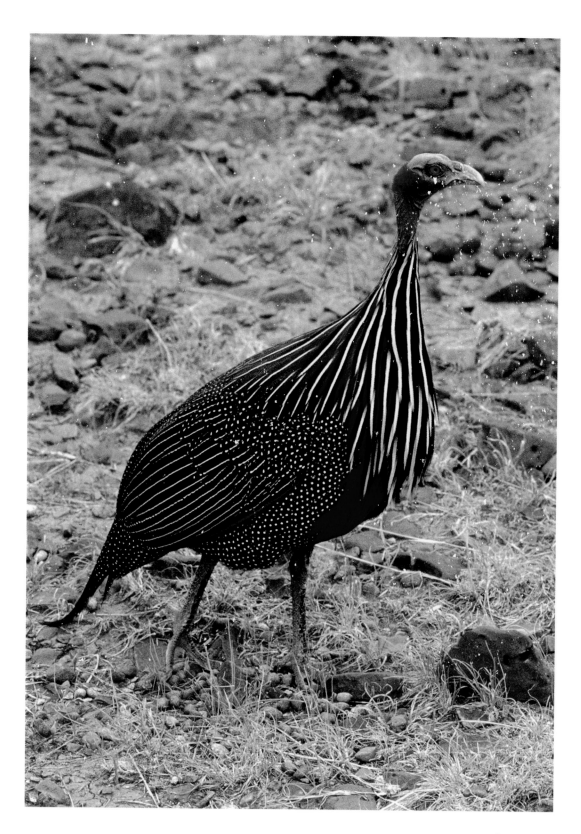

VULTURINE GUINEAFOWL,
Acryllium vulturinum

The drylands of northeastern Africa, from northern Uganda to Somalia and southern Ethiopia, are the home of the strikingly coloured vulturine guineafowl. For most of the year these birds live in flocks of 20 to 30 birds, but with the onset of the rains they pair up to breed. Seeds, leaves, berries and buds make up the vegetable component of their diet, which is supplemented with spiders, scorpions and insects. They are well adapted to a semi-desert existence as they derive all the moisture they need from their food. Even at the height of the dry season, they do not visit waterholes to drink.

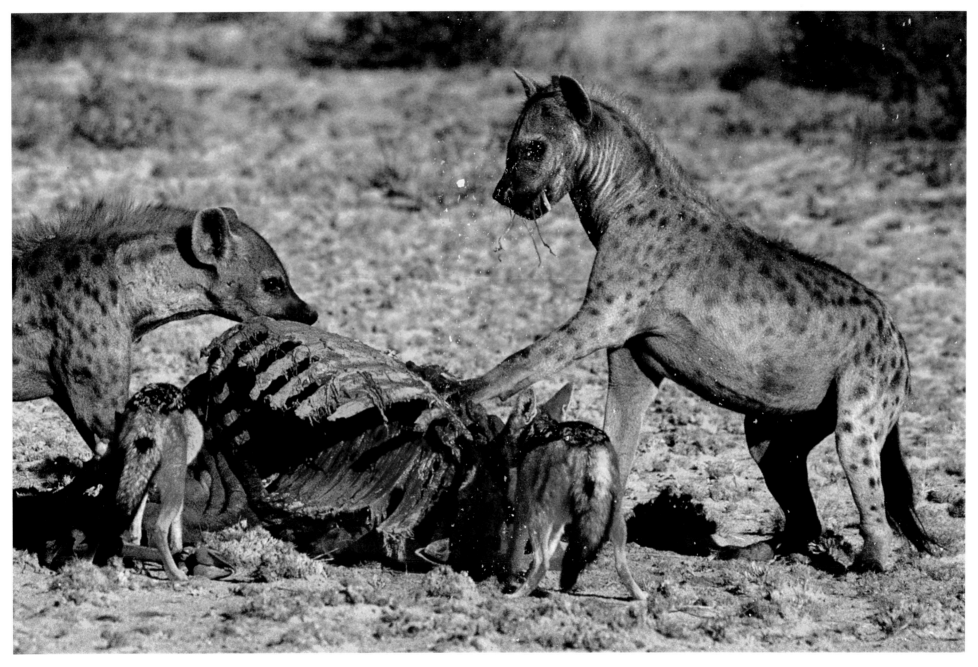

SPOTTED HYENAS, *Crocuta crocuta*, AND BLACK-BACKED JACKALS, *Canis mesomelas*

"While driving in the Kalahari Gemsbok National Park, my son Marc and I came across two scrawny lionesses feeding on a kill. Then, out of nowhere, three hyenas came storming towards the wildebeest carcass. Strong, powerful and menacing, they drove the lionesses away and, salivating, began tearing at the flesh of the carcass, taking turns to keep guard. Hyenas and lions are serious adversaries: they compete ferociously for each other's kills. The hyena's muscular forequarters and powerful jaws – more powerful than a lion's – make it a formidable predator, able to bring down a wildebeest nearly three times its weight."

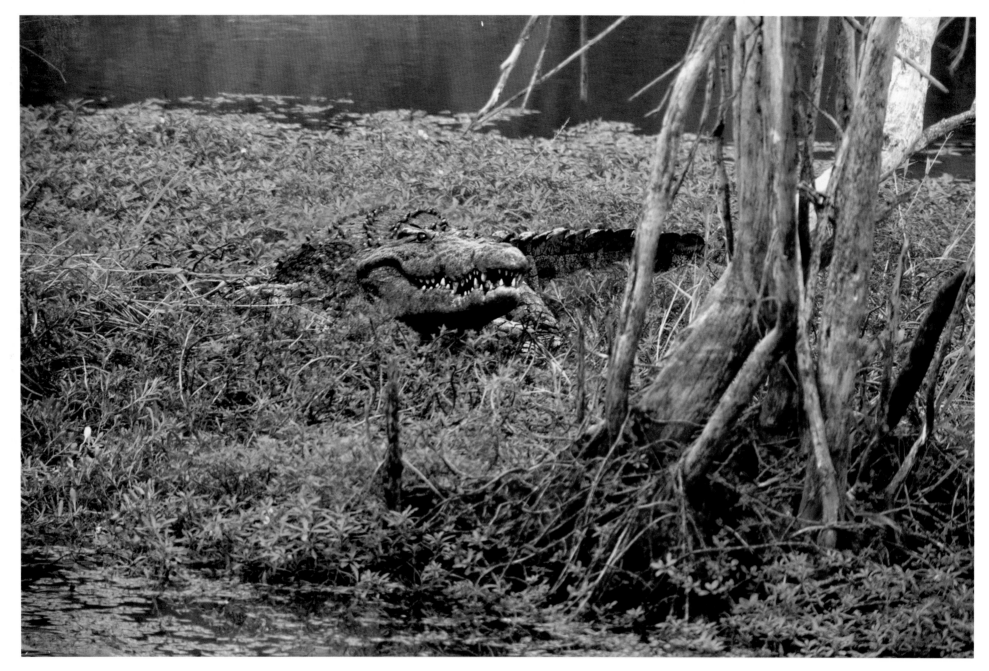

NILE CROCODILE, *Crocodylus niloticus*

The Nile crocodile masterfully uses the element of surprise when hunting. It lies patiently in wait, motionless as a log, its scaly body submerged in the water, with its head, identified only by a pair of menacing olive-green eyes, appearing just on the surface. At the right moment it hurls its massive body out of the water, closes its enormous jaws over its prey's muzzle, and drags it underwater to drown it. A valve at the back of its throat closes off the crocodile's respiratory throat and alimentary canal, enabling it to open its mouth under water but forcing it to surface to feed. A highly efficient metabolism allows the crocodile to survive for up to a year without food, if need be.

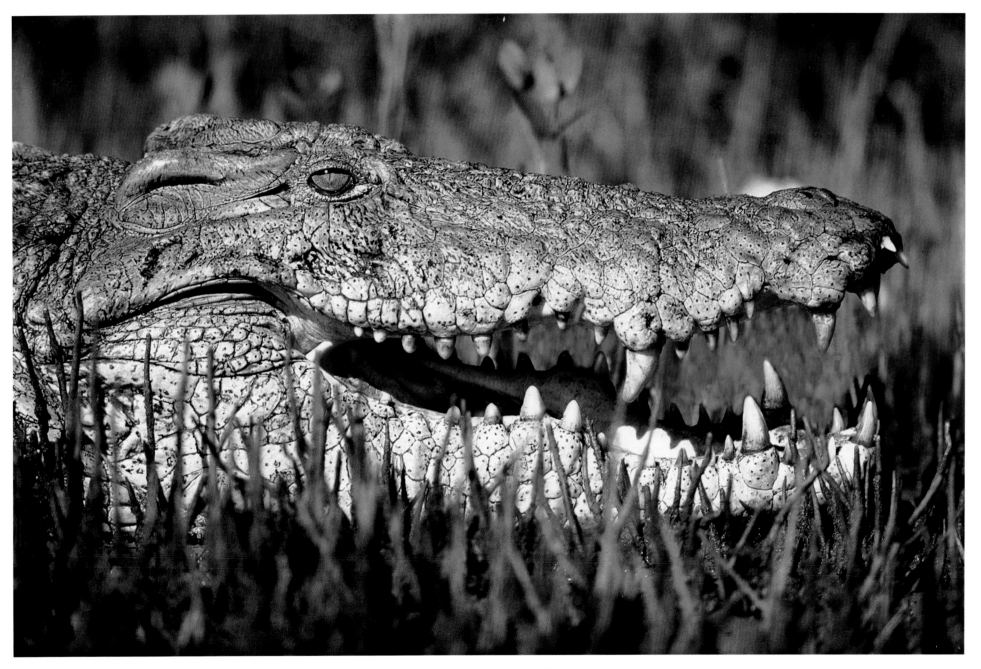

TAKING A BREATHER

A large, lizard-shaped reptile, the Nile crocodile is the most common of its kind in Africa. Gregarious animals, crocodiles live together in rivers, lakes, estuaries and marshes. The scaly reptiles, although poikilothermic (or cold-blooded) animals, are able to reduce their body temperature to some extent by propping open their jaws when basking in the sun – an action which helps them cool off. When this is not sufficient and their temperature rises too much, they return to the cool water. They may also dig dens to which they retreat in response to temperature extremes.

GOLDEN ORB-WEB SPIDER,
Nephila sp.

The vivid red- and black-banded legs of the female of this species handsomely complement her intricately patterned blue body. The male is both drab and minute by comparison, with a body mass only a thousandth that of its partner. Once the two have mated, the female devours the male. The spider's golden web – sometimes a metre wide – is usually spun between shrubs or trees. It is deceptively strong – its fragile-looking high-tensile threads are capable of ensnaring small birds. Though timid, the gold orb-web spider can inflict a painful, mildly venomous bite.

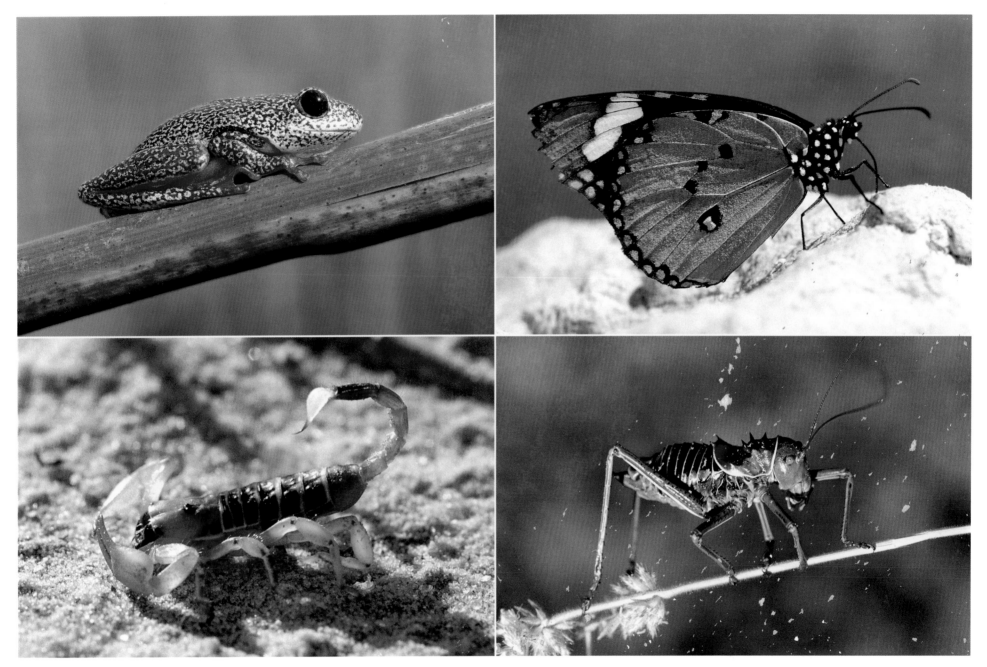

INSECTS, ARACHNIDS AND AMPHIBIANS

The parched Kalahari Desert may seem inhospitable, yet a remarkable variety of creatures, both large and small, live there. The delicate African monarch butterfly *(Danaus chrysippus)*, like most butterflies, enjoys only a few brief weeks of life (top right). Uniquely African, the ferocious-looking armoured ground cricket (bottom right) of the *Tettigoniidae* family is a nocturnal omnivore. The thin-tailed, less poisonous scorpions (bottom left) of the *Scorpionidae* family are also nocturnal, hiding under stones during the day. Further away, in the Okavango Delta, the thimble-sized painted reed frog *Hyperolius marmoratus* (top left) clings effortlessly to grasses swaying in the breeze.

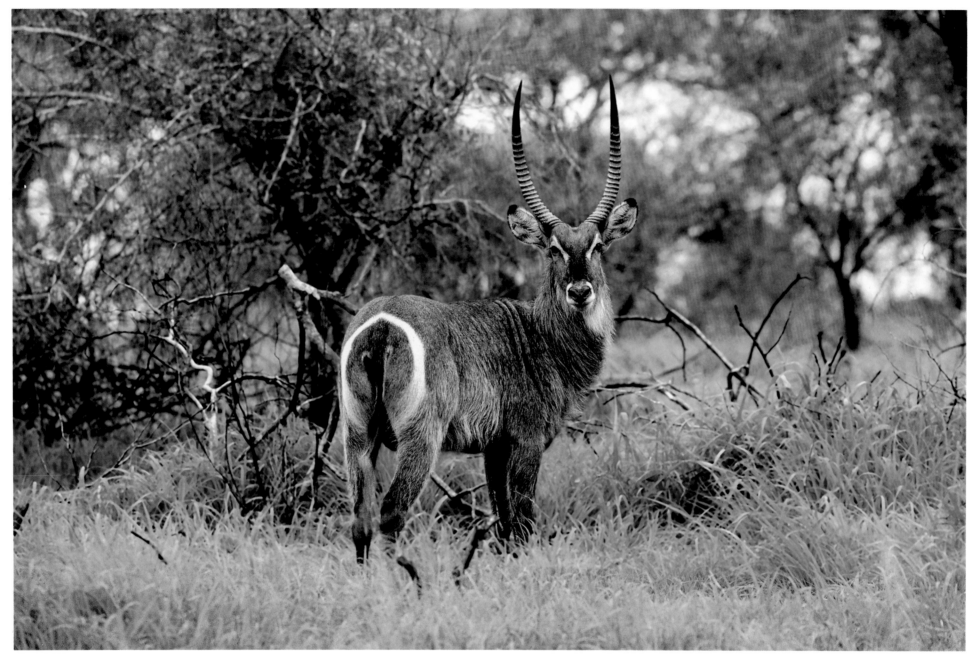

WATERBUCK, *Kobus ellipsiprymnus*

Water provides this handsome antelope with both sustenance and protection. Needing to drink nearly every day limits its range to a kilometre or two from a river or vlei. Though it is unpalatable to some predators, the waterbuck represents a good meal to others – these it avoids by the simple expedient of plunging into the depths. Bull waterbuck, especially, are well able to defend themselves, even mid-stream, using their magnificent, forward-curving, deeply ridged horns. Clearly visible here are the buck's extraordinary white-ringed rump, the shaggy mane along its supple neck, and the white markings on its face and throat. Skin glands secrete an oily fluid, releasing a distinctive musky odour.

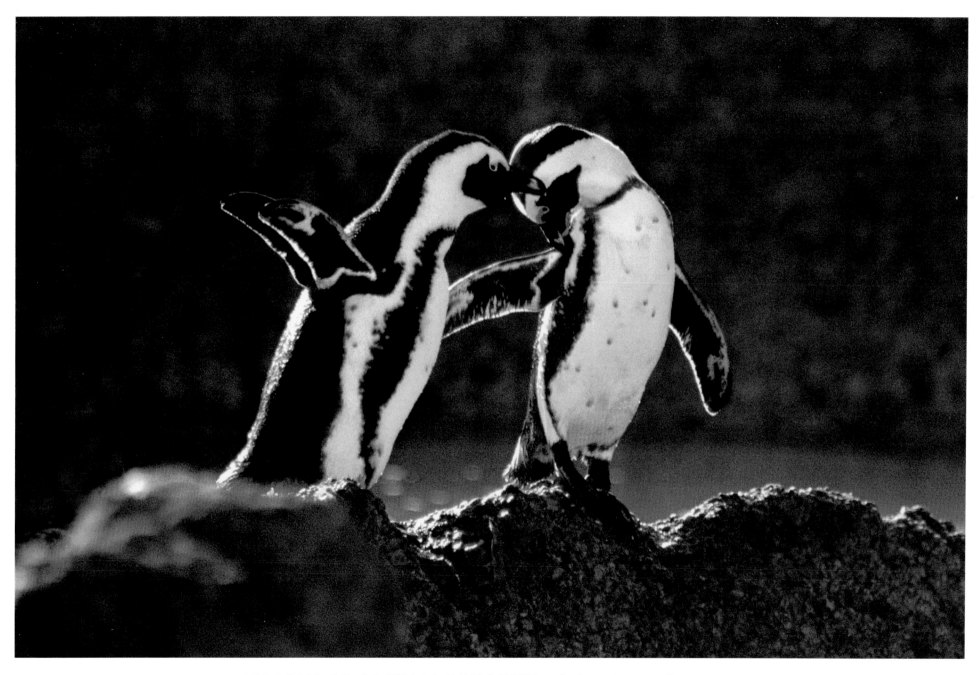

AFRICAN OR JACKASS PENGUINS, *Spheniscus demersus*

The jackass penguin is the only penguin species that breeds in Africa but numbers have been severely reduced by man's activities. Until the 1980s, guano removal from offshore islands along the Namibian coast destroyed their prime burrow-nesting habitat, forcing them to breed on the surface at the mercy of gulls and the hot sun. The annual collection of hundreds of thousands of penguin eggs, over-exploitation of pelagic fish stocks, and localised effects of oil spills reduced numbers still further. Fortunately improved marine conservation measures are benefiting some populations of jackass penguins. Among these is the mainland breeding colony in Cape Town, which now contains more than 1,500 birds.

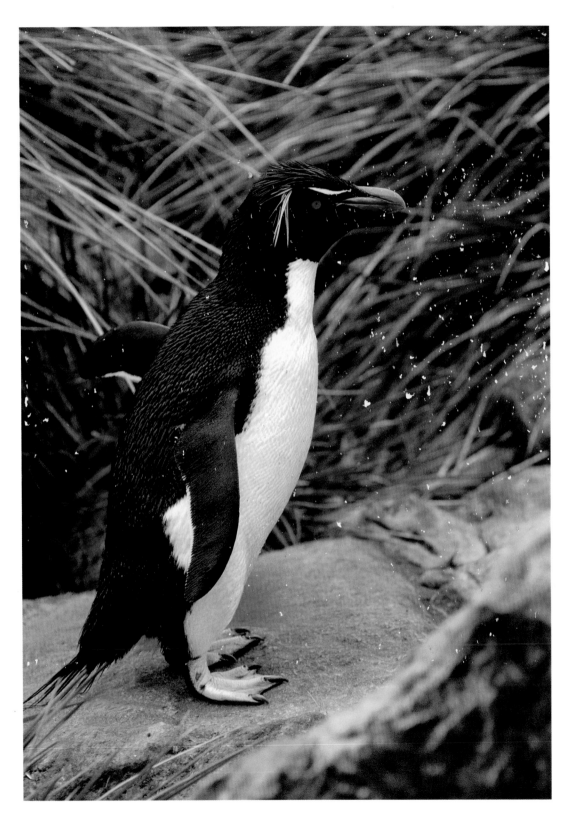

Falkland Islands & Antarctica

ROCKHOPPER PENGUIN,
Eudyptes chrysocome

"West Point Island in the Falklands was our last stop before crossing the tempestuous Southern Ocean to reach the Antarctic Peninsula, 1,200km away. The island is a birdlover's paradise: rockhopper penguins breed in pungent abundance, cheek by jowl with albatrosses, amid a cacophony of squawking. The colourful and delightfully comical penguins – named for their ability to hop with ease over craggy rocks, and even to scale high cliffs – display no fear of man. They waddled right past my legs, down metre-deep, hidden paths, on their way to the ocean for a meal of squid or lobster krill. The diminutive birds, 33–35cm high, are screened from possible predation by tough tussock grass, which I found useful to grab hold of to haul myself up out of the deep, furrowed paths."

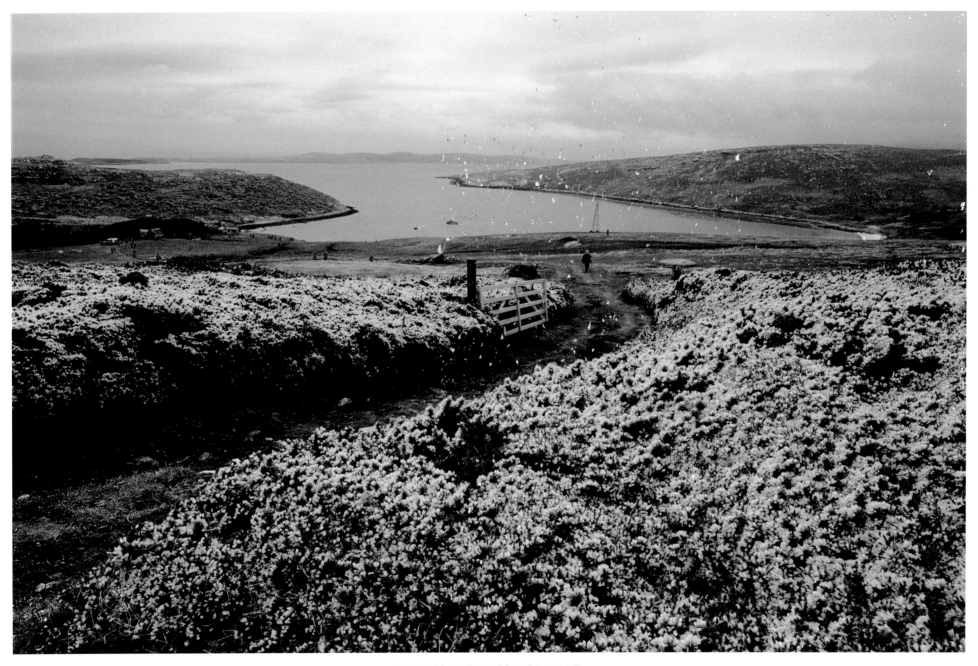

WEST POINT ISLAND

"West Point Island's sole inhabitants, Roddy and Lily Napier and their young granddaughter, invited us to tea around a crackling peat fire in their rustic farmhouse, set against verdant hills reminiscent of the Scottish Highlands. They share their magnificent island, bathed in a profusion of golden gorse (Ulex europaea), with several bird species. These include the striated caracara, one of the world's rarest birds of prey, rockhopper penguins, blackbrowed albatrosses, Turkey vultures and the elusive Magellanic penguins. As if in a time warp, the Napiers – without television, computers, fax machines and the like – seemed blissfully happy in their island utopia."

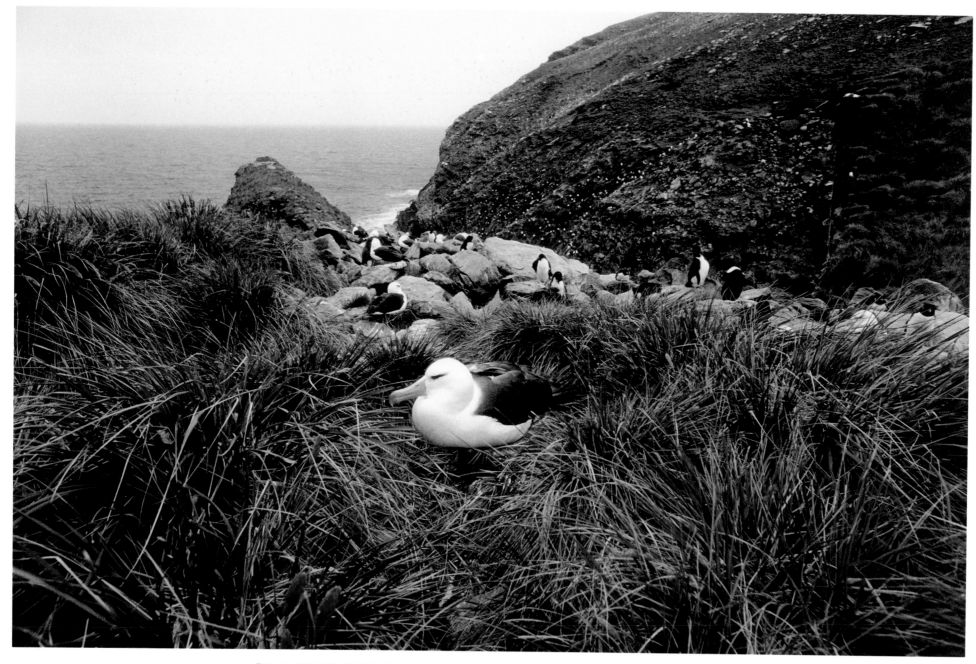

BLACKBROWED ALBATROSS, *Diomedea melanophris*

The blackbrowed albatross breeds colonially on remote islands in the Southern Ocean. Some of these colonies are enormous, containing up to 100,000 pairs. Only a single egg is laid and is incubated for just over 10 weeks before the chick hatches. Both parents share in the incubation of the egg, and single incubation shifts can last for up to two weeks. If the egg is lost during incubation, the adults do not re-lay, but wait for the following year before attempting to breed again.

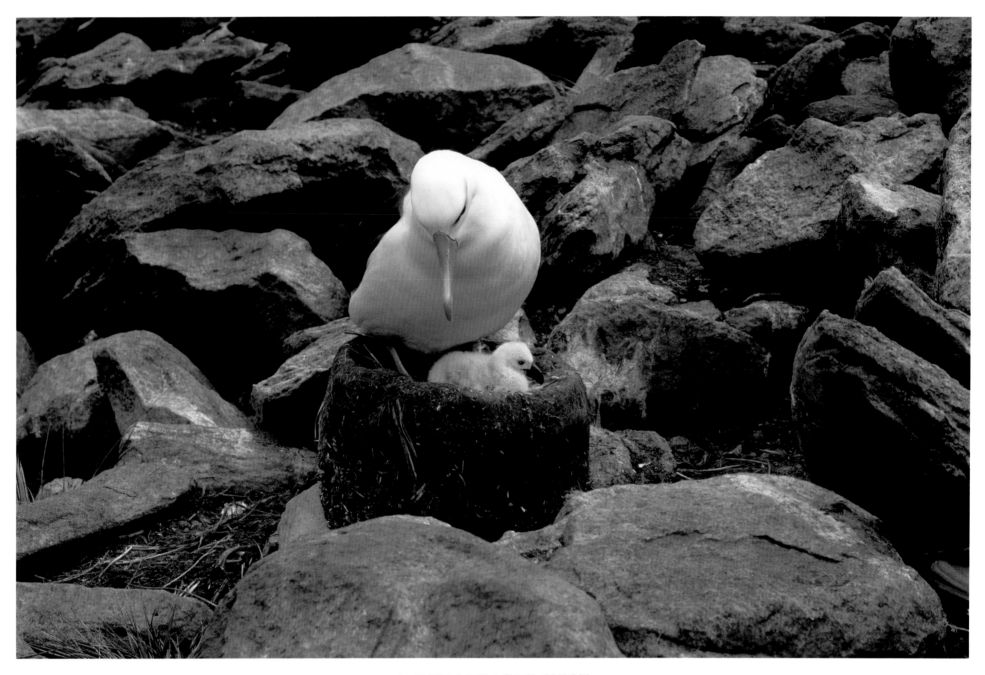

A REMARKABLE NEST

This newly born blackbrowed albatross chick will spend the next four months at this remarkable nest being fed and cared for by its parents. At three months old it will weigh more than either parent, after which it loses weight until it takes its first flight to independence. Once it has left the breeding colony, it will spend several years at sea before returning to seek a mate. Although a few birds succeed in breeding for the first time when they are six years old, some will wait for as long as 13 years before they join the breeding population.

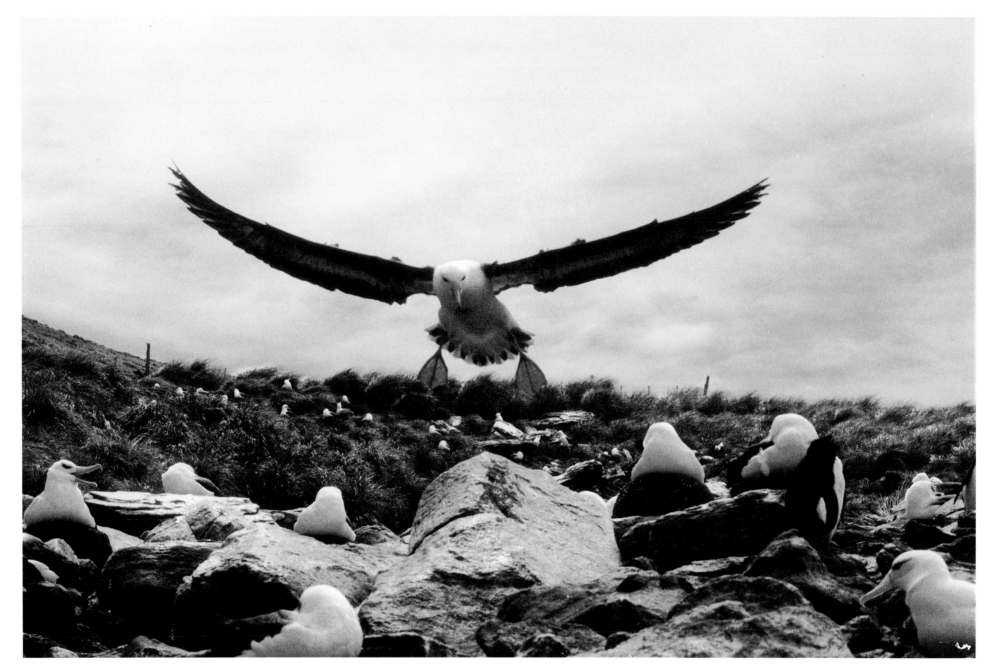

FREQUENT FLYER

The long narrow wings of the blackbrowed albatross are superbly adapted for life in the windswept and stormy Southern Ocean. These birds glide and wheel over wave crests and troughs in search of their seafood prey, mostly krill, fish and squid. Their seemingly effortless flight allows them to travel large distances without landing, sleeping on the wing – tens of thousands of these birds travel annually from breeding islands around southern South America to spend the non-breeding season in the rich feeding grounds provided by the Benguela Current off the west coast of southern Africa. Accomplished hunters, they are also voracious scavengers, gathering in huge flocks around fishing trawlers.

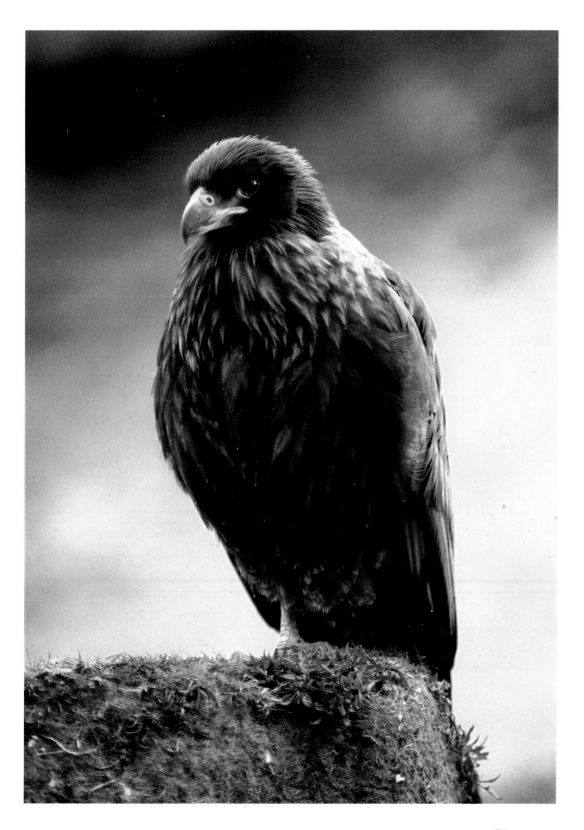

STRIATED CARACARA,
Phalcoboenus australis

"At West Point Island I met one of the world's rarest birds of prey, the striated caracara, or 'Johnny Rook'. The imposing bird, about 56–61cm long, stood near the water. As I inched closer on my haunches, camera in hand, the raptor appeared unusually tame – I think we were mutually curious. After a while it flew off, displaying white striations on its main primaries and light brown tail feathers. The striated caracara seldom takes prey on the wing. Fleet-footed, it uses its powerful feet and talons to snatch penguin chicks, eggs and young petrel. Carrion, molluscs and insects augment its diet. To survive the harsh winter, it eats penguin and fur seal excreta."

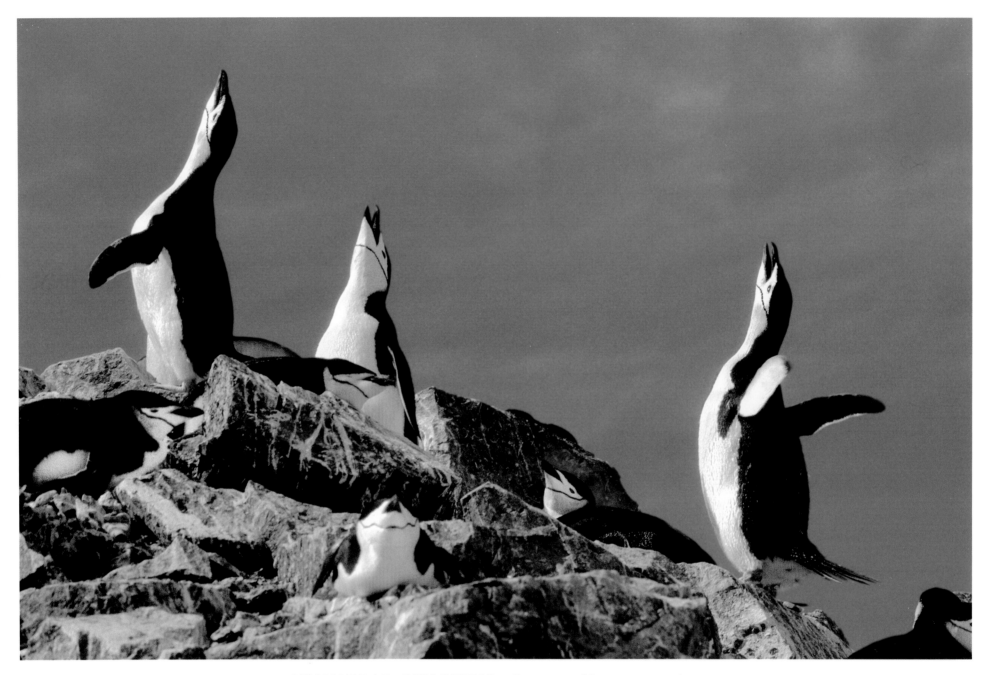

CHINSTRAP PENGUINS, *Pygoscelis antarctica*

"My family and I travelled to the coldest, highest, deepest and most tempestuous place on earth – Antarctica, a wondrous, pristine world of high, snow-capped mountains and centuries-old glaciers. This is home to the chinstrap penguin, aptly named for its thin black chinstrap-like band. Of necessity these bold and aggressive birds build their nests on large, angular rocks, using rounded pebbles as a substitute for grasses and twigs, while small groups keep watch. An assertive, repetitious cacophony of sh-kak-kuak *and skywards 'snake-necking' is the order of the day. Inbound chinstraps hurry forward in a subservient posture called a 'slender walk', to avoid an aggressive confrontation."*

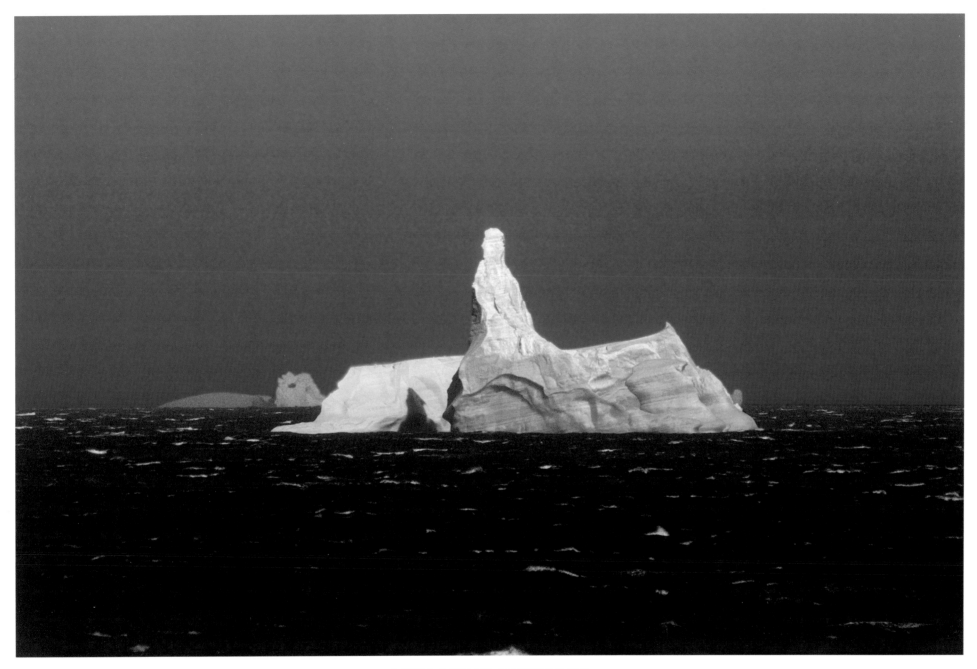

ANTARCTIC ICEBERGS

Balancing precariously in a restless sea, a wind-sculpted iceberg rises and falls imperceptibly with the tides. These freshwater monoliths are formed during spring and summer when glaciers and ice shelves, having reached the end of their seaward journey, 'calve' or shed enormous icebergs into the very saline Antarctic Ocean. Spurred on by currents and fierce winds, the icebergs – accompanied by dramatic groans and gunshot-like sounds of the ice stressing and fracturing – sometimes travel up to 1,600km before melting or breaking up in the warmer northern seas. Their icy sojourn can last 10 years before they finally disintegrate.

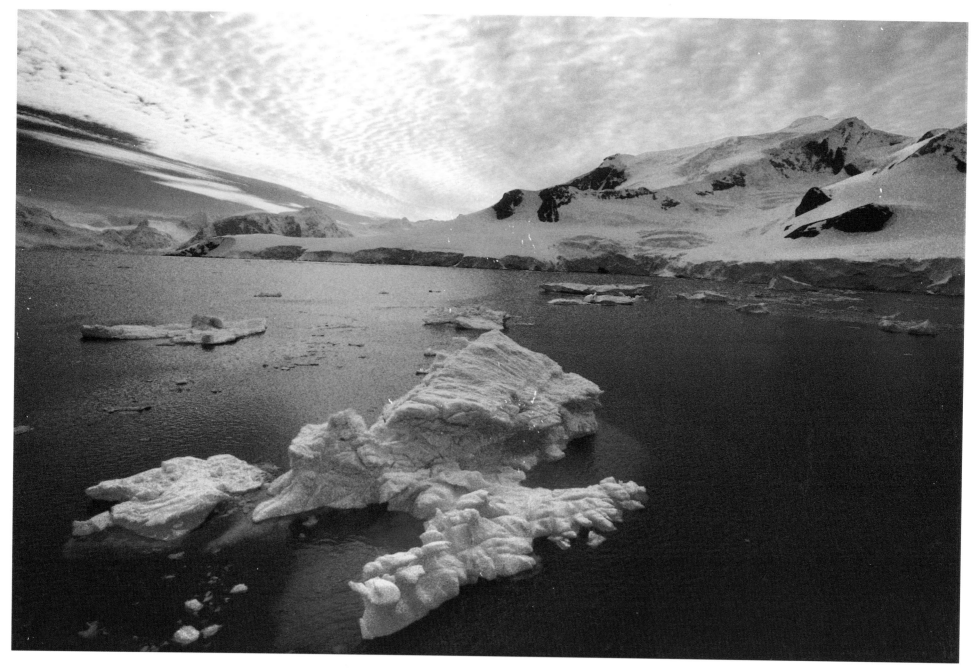

ANTARCTIC PENINSULA

In the short polar summer, the ice releases its freezing grip on the Antarctic Peninsula, freeing a chain of islands and inlets and exposing rocky outcrops to the 24-hour sun. The relatively ice-free waters are the summer refuge of whales and seals, while a multitude of birds, including several species of penguin, take advantage of the warmer weather to mate and breed. Vegetation is sparse, but for a short while yellow, red and orange lichens, mosses and Antarctic hairgrass cover exposed boulders along the shoreline. Winter soon arrives again and the ice begins its inexorable march across the sea, eventually covering 20 million square kilometres (57%) of the Southern Ocean.

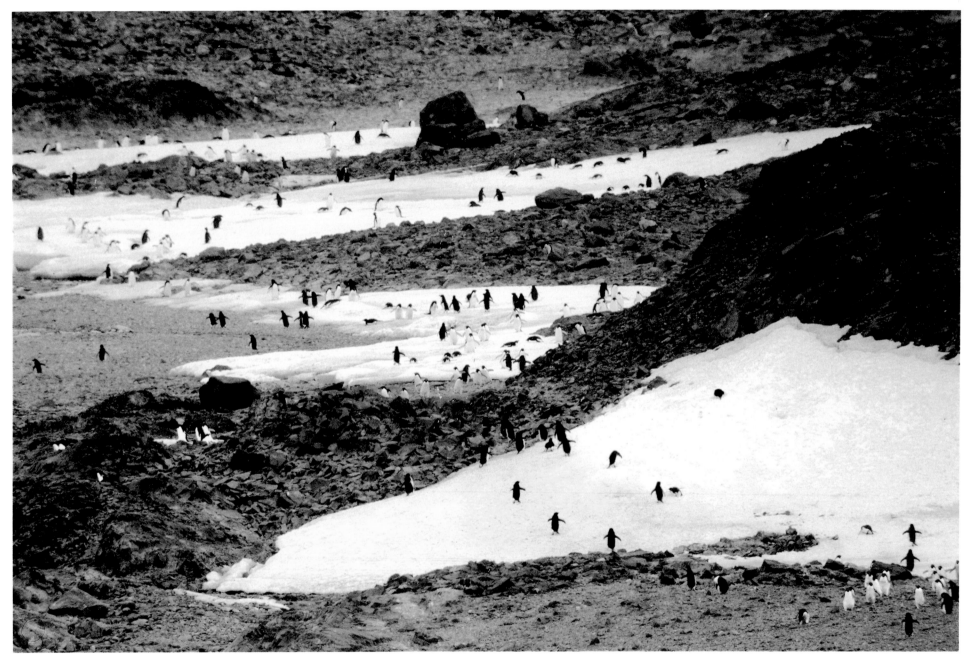

ADÉLIE PENGUINS, *Pygoscelis adeliae*

"In typical Antarctic conditions, fierce winds dragged our ship's anchor and made going ashore dangerous when we reached the vast Adélie penguin colony at Hope Bay. But my disappointment turned to elation when I brought my gigantic lens (800mm 6.3/eps with 2x extender, ie 1,600mm) on deck, and peered through the camera's viewfinder. The crisp, dry air, devoid of pollution or terrestrial heat waves, was crystal clear for miles. What a sight! Thousands of dinner-jacketed Adélie penguins dotted the landscape. I worked in dangerous wind, using every technique I could muster, while holding onto my equipment, the ship and the moment."

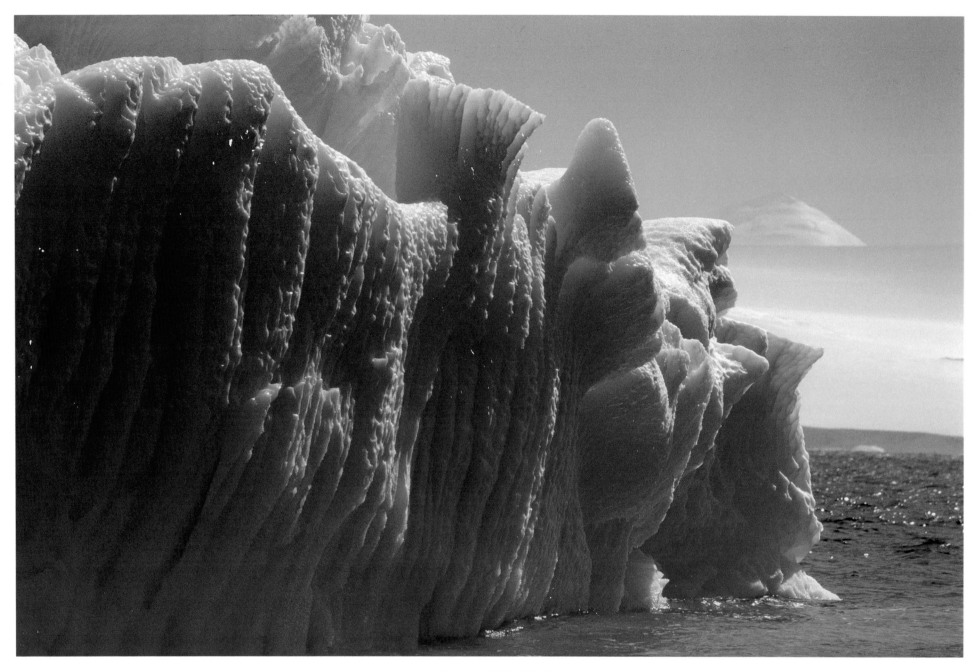

SEA ODYSSEY

Playful swirls and arcs of gleaming ice temper the cobalt-blue furrows along the sheer cliffs of this iceberg. Icebergs are sculpted by capricious winds and lashing waves, while the heat from the sun erodes the surface, causing freshwater rivulets to trickle down the abraded cliffs. Most of the iceberg remains some 90% submerged. As the voyage towards the equator progresses, the bottom of the iceberg might melt faster than the top, eventually causing it to keel over.

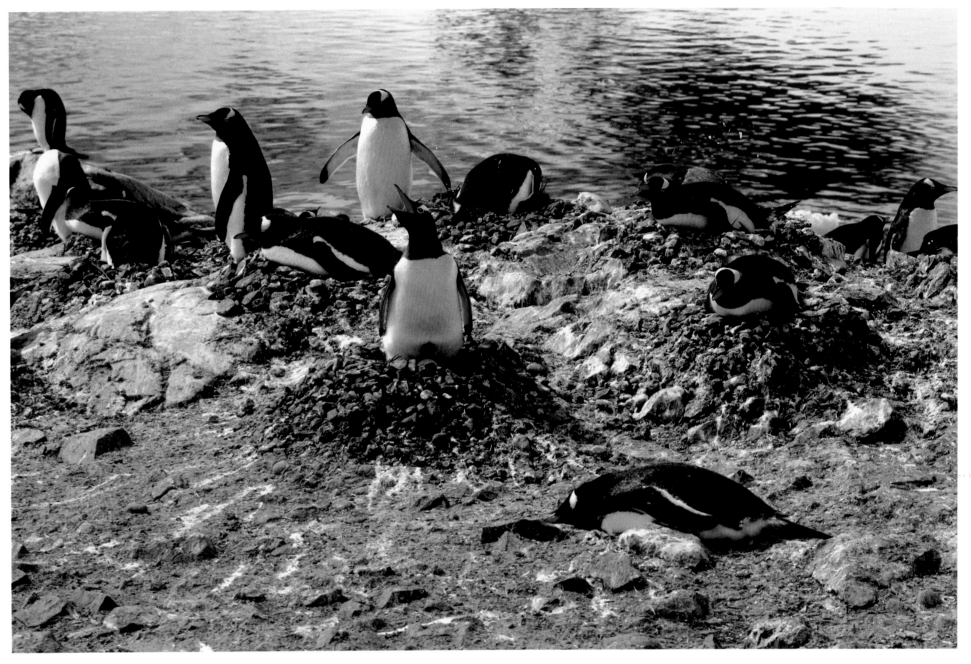

GENTOO PENGUINS, *Pygoscelis papua*

"Paradise Bay on the Antarctic Peninsula coast is aptly named. The rare Antarctic sun reflecting off the snow of the surrounding mountains made it feel great to be alive and there was nowhere else I'd rather have been at that moment. On our arrival at Paradise Harbour we were greeted not only by excited gentoo and chinstrap penguins, but also by two excited, lonely staff members from the Chilean research station. A gentoo on a craggy rock basked in the brief sunshine, flippers elevated and displayed. Standing sentinel over the rookery of pebble mound nests, it faced the snow-covered mountains beyond, and, like its fellow pinnipeds, it appeared unperturbed by a predatory leopard seal on a rock below."

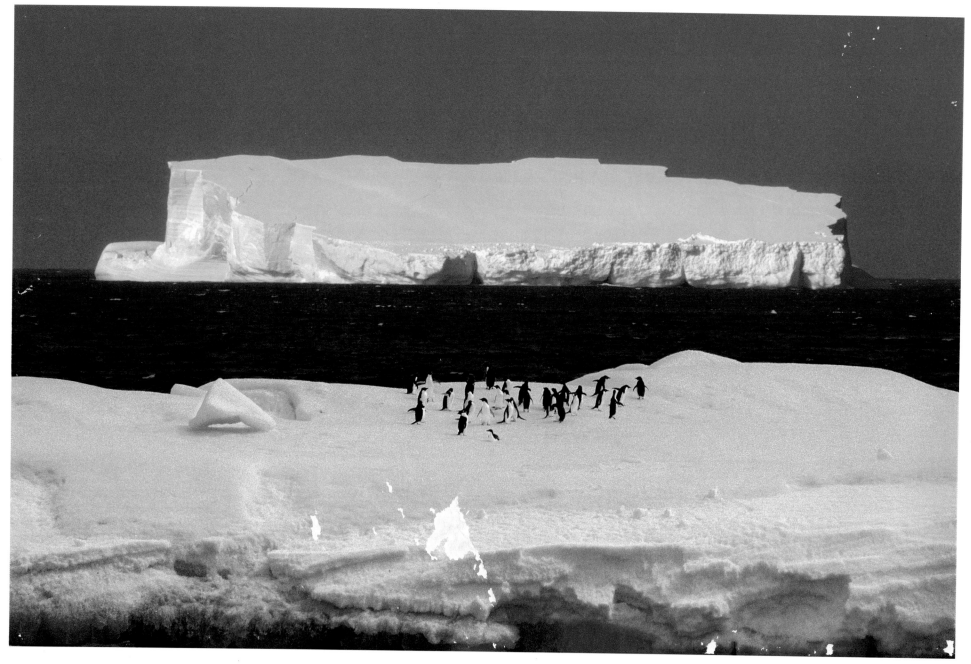

PORTLY PINNIPEDS

A small band of Adélie penguins crowd together on the edge of an iceberg. Soon they will be forced to brave the icy sea, and the predators that inhabit its freezing depths, to search for edibles such as fish, squid and krill. These portly, flightless birds have become one of the world's best-studied seabirds, and a recent discovery has been that males woo females with a 'gift', usually a small pebble, in exchange for the chance to mate. A colony of Adélie penguins was first encountered in the early 1800s in the French section of Antarctica, named Terre Adélie by Admiral Dumont d'Urville after his wife.

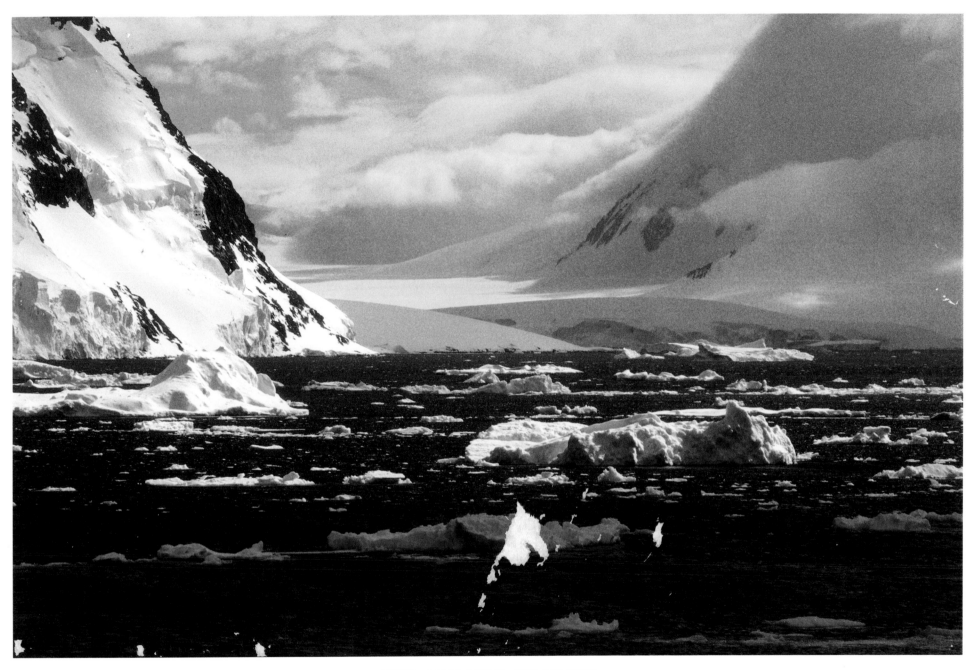

THE LEMAIRE CHANNEL

Still partly frozen by a thick layer of ice, the Lemaire Channel, a narrow waterway barely two kilometres wide and 11km long, is awash with giant splinters of 'brash ice', remnants of the melting ice. The channel, which freezes over in winter, wends its way between the towering, snow-covered cliffs of the Antarctic Peninsula and Booth Island, along the northern reaches of the continent. Only two per cent of the Antarctic is ice-free, mostly along the northern periphery of the Antarctic Peninsula and surrounding islands. The coastal regions of north and west Antarctica are regularly battered by fearsome katabatic winds – the result of heavy, cold air, which gallops down the icecap at speeds of up to 200km/h.

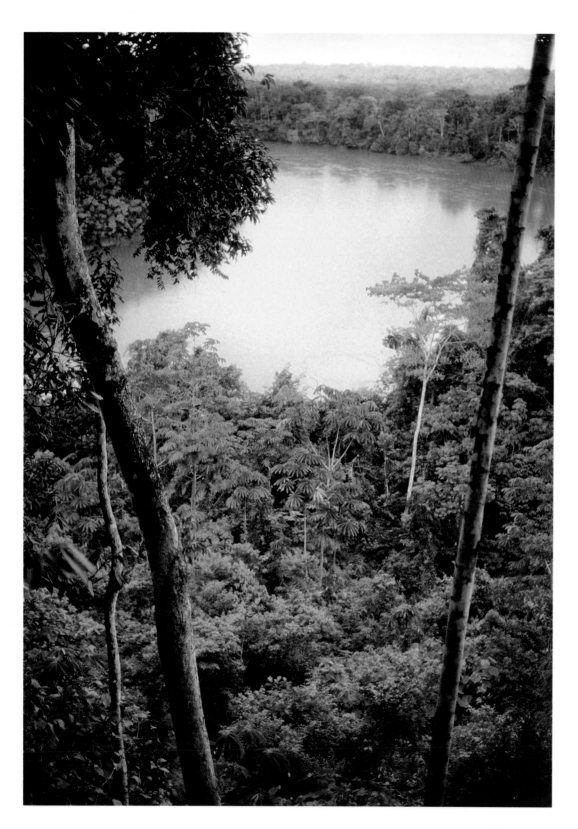

The Amazon

THE AMAZON RIVER

Beginning as a small stream in the snow-streaked central Andes in Peru, the Amazon's mother river, the Huarco, frolics down mountain slopes, skips down cliffs and gorges and hops across ravines and over boulders, in the process dropping 4,450m in altitude. Emerging at the base of the Andes, it thunders eastward, joined along the way by more than 1,000 tributaries flowing from the Guyana highlands in the north and the Brazilian highlands in the south. The acid and nutrient-deficient waters that rise from these crystalline highlands are referred to as the 'black rivers'. The best known is the Negro River, which stains the Amazon with a flourish of black swirls at their confluence near the jungle city, Manaus. The 'white rivers' – heavily laden with silt – gather nutrients as they scour the relatively youthful granite rocks of the tectonically active Andes in the west.

The Amazon River, the world's second longest river after the Nile, flows for 6,400km before discharging its heavy burden – 1.3 million tons of sediment – into the Atlantic Ocean. The Amazon drains about one-fifth of the world's annual runoff: at the height of the annual floods this means that fresh water pours into the sea at 175,000m^3 per second, driving the saline waters more than 100km from the shore.

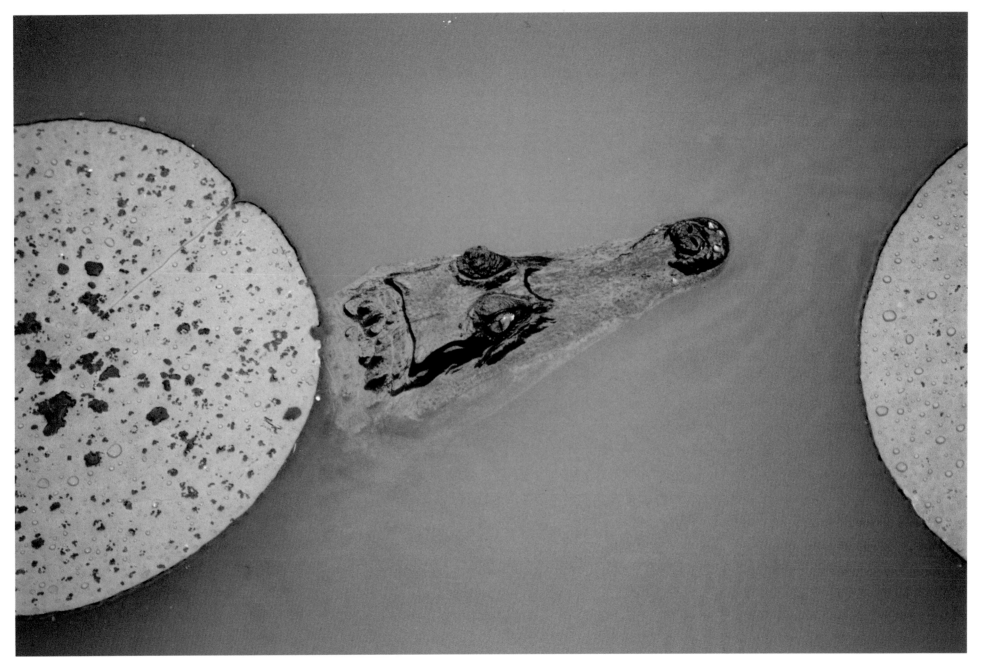

THE COMMON OR SPECTACLED CAIMAN, *Caiman crocodilus*

Gliding inconspicuously in the Amazon River, a spectacled caiman keeps vigil over its waterlogged surroundings. The silt-laden river, and the flooded forests around it, sustain a unique aquatic life. Floating plants (water hyacinth, water lilies and aquatic ferns) cover parts of the river like a vast tablecloth. Under the water's surface a network of drifting roots provides nourishment and shelter for invertebrates – from larvae to shrimps – and the fish that prey on them. In turn, the vertebrates, including the ferocious piranha, are fodder for the spectacled caiman and the larger black caiman (*Melanosuchus niger*), a rare species hunted to the brink of extinction for its hide.

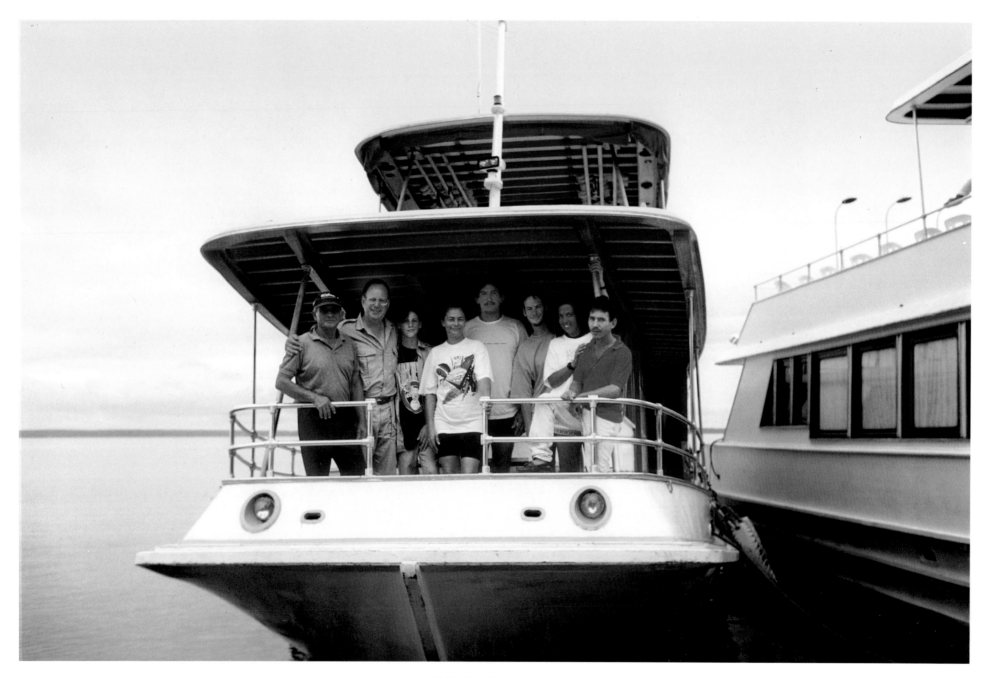

A LEAP OF FAITH

"My long-cherished dream to explore the Amazon was about to become a reality, and, to top it all, my sons, Richard and Marc, decided to come along. I had hired a boat and crew in Manaus, a port city on the banks of the Negro River, the Amazon's largest tributary. Where the rivers meet, their contrasting colours create a swirling spectacle, noticeable for 25km downstream (facing page, top left). Our guide for this trip was a Brazilian zoologist, a woman well acquainted with the river and adept in the ways of the jungle (facing page, top right). At times, though, she really tested my spirit of adventure. My first anxious moments came soon after our departure. For days I had been enquiring about ways to

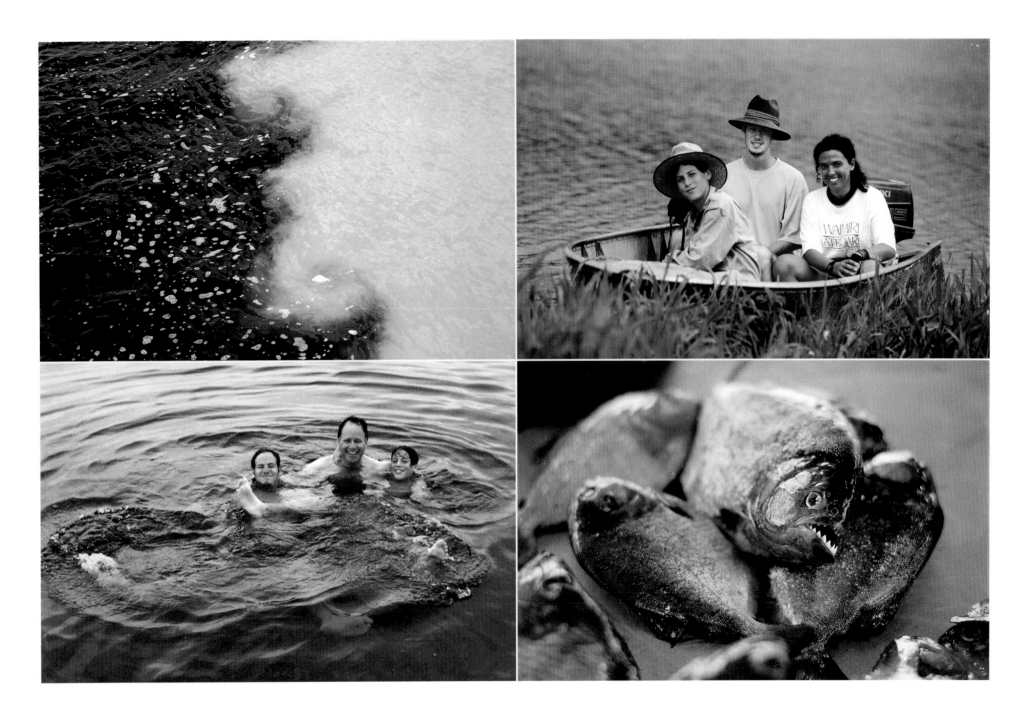

avoid the flesh-eating piranha – some species can devour an entire ox in minutes – and the dreaded anaconda, but in the absence of any satisfactory answers I had decided to keep out of the water. It was with absolute horror then that I watched our guide dive off the edge of the boat for a swim in the Amazon. She was quickly followed by Richard, then Marc. What would I tell my wife? How would I explain what happened to the boys? I looked down at them cavorting in the river. And then I took a leap of faith – diving, head first, into the mighty Amazon (bottom left). And the piranha? I photographed them in the marketplace, grateful to have escaped the fury of these rapacious fish (bottom right)."

WEEPER CAPUCHIN MONKEY,
Cebus nigrivittatus

No other monkeys are as clever as the capuchins of Central and South America. Intelligent, alert, dextrous and cunning, the four capuchin species, including the weeper capuchin, are the New World's equivalent of the Old World's smartest ape, the chimpanzee.

Capuchins live in troops of between 10 and 35 monkeys, but their fission-fusion lifestyle means that they seek food in sub-groups or, occasionally, alone. They are manipulative foragers, employing a high level of eye-hand coordination to find food that is hidden or otherwise inaccessible. Looking for tasty titbits, they'll tear off tree bark, unroll leaves, dig into rotten wood, and rifle through the debris found at the base of palm fronds or epiphytes. Tools come in handy when foraging. Twigs are used to poke around in holes, hard fruit and nuts are smashed against anvils (rocks and trees), and nuts are cracked by bashing them together. These sophisticated skills make the sharp-witted capuchins the most advanced tool-using monkey species in the New World.

Capuchins also display an astonishing range of communication signals, indicating a high level of intelligence. Their repertoire includes vocalisation, facial expressions, body movement, smell and touch. A multitude of calls – harsh barks, screams, growls, caws, trills and warbles – deliver messages associated with, among others, mating rituals, warning systems, threat behaviours and defensive action.

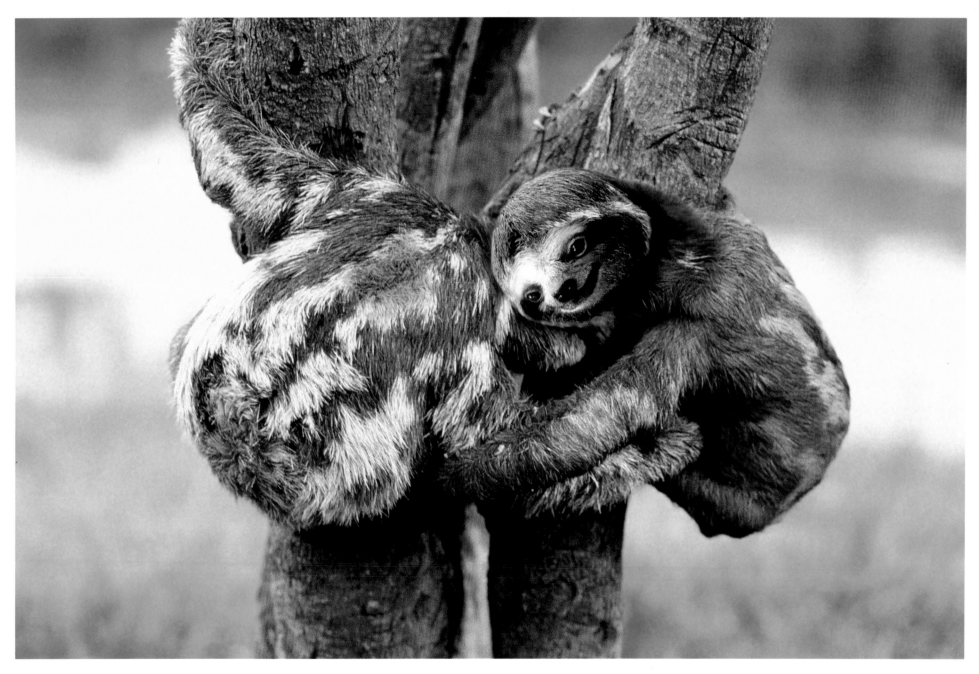

THREE-TOED SLOTH, *Bradypus tridacylus*

In what must be the slowest cuddle in the world, two sloths seems to find comfort in a hairy embrace. But the sloth's legendary slowness is only one of many adaptations to its jungle home. It spends its life clinging upright to tree trunks or hanging upside down, its movement so deliberately slow that it easily escapes the eyes of predators. Its upside-down existence also keeps it out of their clutches. Green algae growing in its fur provides additional camouflage, helping the tree-dweller to blend with the surrounding vegetation. Sloths are indiscriminate vegetarians – an advantage in the Amazon Basin, where trees of the same species seldom occur in close proximity.

"I had imagined the rain forest to be teeming with wildlife, most of it not seen anywhere else in the world. But in idealising the image, one doesn't always consider or know the details of this untamed wilderness, and no matter how well one prepares, one should expect the unexpected!

I had done a great deal of preparation for the trip and had read what I could about the problems associated with taking wildlife photographs in tropical regions. But I was to learn firsthand that taking photographs in the Amazon is a difficult and ardent task, rather different from my romanticised image of life in the jungle.

The first problem I encountered was the humidity. The air is so moist that everything, including ourselves, was constantly damp, and the rate of evaporation is virtually nil. The oppressive humidity is not only a source of personal discomfort; it also damages camera equipment and film. I tried in vain to keep my equipment dry while working, but the cloths I used quickly became sopping wet.

The humidity also causes lenses to fog. The result is that photographs acquire an unwanted soft-focus look. One might also end up with images that seem to be blurred in parts, even though the initial focus would have been pin-sharp. This is due to partial fogging of the lens. Sometimes, one is unable to focus at all.

These conditions inevitably shorten the lifespan of the equipment. As a result of the moisture, the rubber light trap on the inside of one of my cameras started to disintegrate. This created a light leak, and fogging of some of my images. I've since had to replace those particular cameras.

A well-known method of protecting camera equipment from humidity is to use silica gel. These hydroscopic silica crystals absorb moisture, helping to protect the equipment. Before I left on my expedition, I bought copious amounts of the gel and stored it in handy, neat muslin sachets. These I spread liberally among my equipment.

But I found these bags were of little force and effect in the Amazon jungle, as the humidity was so high that they soon became saturated.

The lack of light was another problem. Initially I thought that the light meter of my camera was faulty. I tested my second camera, and again I got light readings that were not within the normal range according to my experience.

Consider the Amazon rain forest though. Trees in parts of this hothouse soar to heights of 30–40 metres, spreading their foliage like gigantic treetop umbrellas. The canopy effectively blocks out most of the light; only about ten per cent of sunlight reaches the forest floor.

Given the prevailing conditions, very little oblique light, which we take for granted under normal circumstances, is able to filter through. Oblique light is important to give definition to the subjects being photographed. I realised then that my light meter readings were indeed correct and that I would have to make the most of the prevailing conditions.

Notwithstanding the difficulties, I soon adapted to working within these constraints.

An unexpected encounter with three-toed sloths restored my enthusiasm. Hanging from branches, these delightful creatures move at a painfully slow pace. Although they are tough animals,

there was something endearing about their slow-motion style of climbing trees (page 95).

The conditions on that particular occasion were perfect for taking good photographs. The delightful sloths were clearly visible, clinging tenaciously to a tree trunk.

Standing on the river bank, instead of a rocking boat platform, was also an advantage. I was so close to the sloths that in this instance I was able to use my macro lens.

During the days that followed I recalled an article written by a wildlife photographer in a well-known American photographic magazine. Writing about photography in the Amazon, he advised: 'Folks, don't go.' I was bemused. Once in the Amazon, I understood his sentiments."

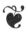

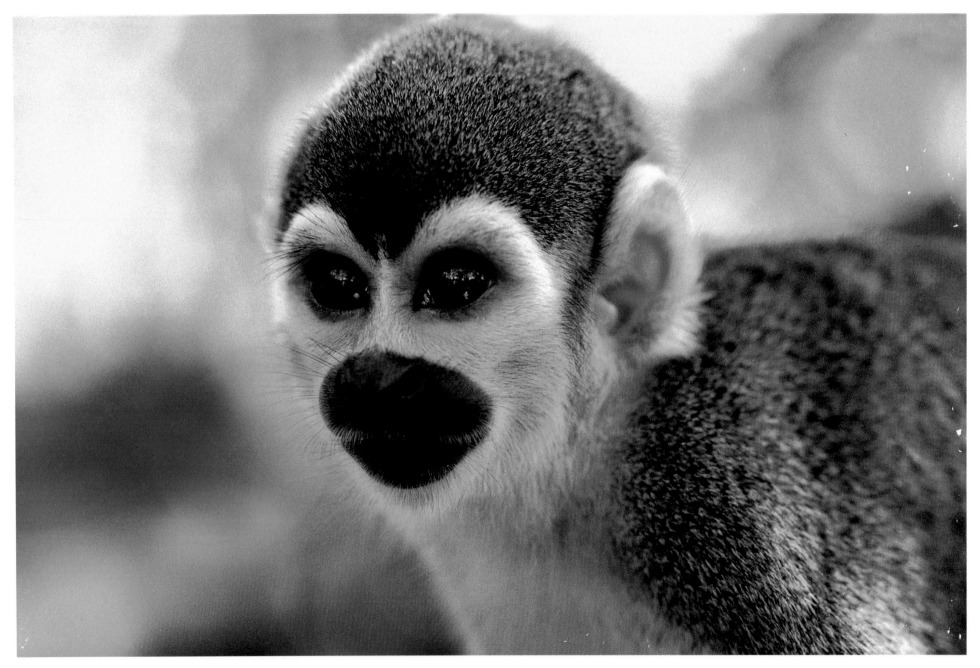

SQUIRREL MONKEY, *Saimiri sciureus*

The squirrel monkey is one of the smallest members of the family *Cebidae*, or true monkeys. But size can be a disadvantage when competing with the family's other 29 species for food. As a countermeasure to being evicted from fruit trees by stronger primates, the squirrel monkey has evolved a 'safety in numbers' lifestyle: troops of more than a hundred monkeys forage together, sometimes descending to the ground to look for food. The monkey's small size has forced other adaptations: requiring less energy and protein, it feeds on easily digestible ripe fruit, while its sharp, narrow teeth rapidly grind down insects. A small stomach, about one-sixth of its body volume, is all that is needed to digest this food.

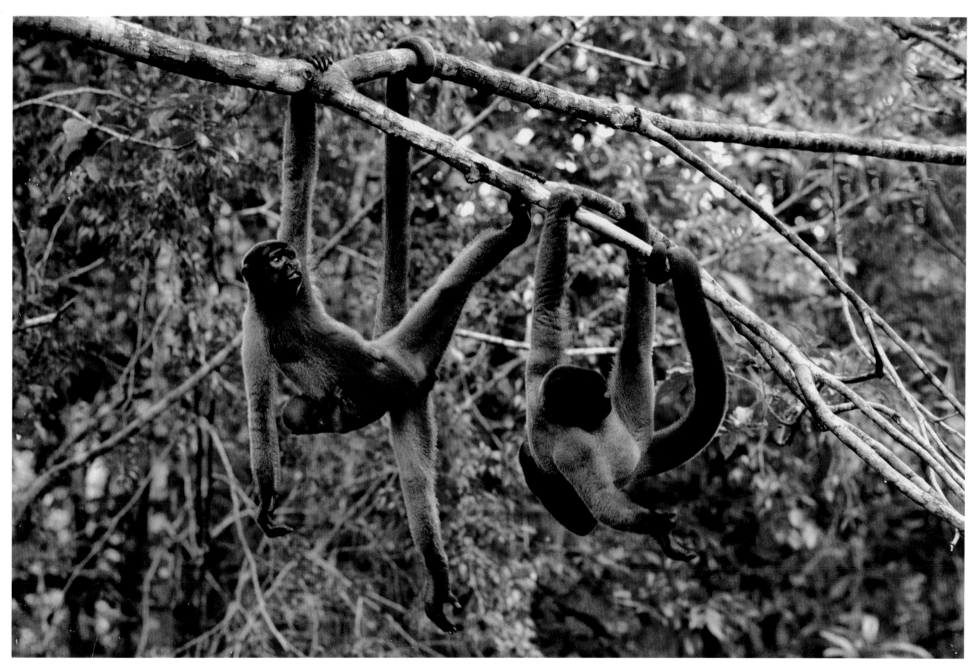

WOOLLY MONKEYS, *Lagothrix lagotricha*

Using their long, muscular tails as a fifth limb, the striking and densely furred woolly monkeys clamber through the rain forest with great agility. A third of the tail's underside is hairless at its tip, exposing a layer of ridged skin sensitive enough to probe for objects and grab hold of branches. These New World monkeys are among the only group of primates, the cebids, to have a prehensile tail. Found in troops of 15–20 individuals, woolly monkeys are at home in the middle and upper canopies of mature forests in the northern parts of South America, including the Amazon Basin. They range in forests from sea level to altitudes of over 2,400m.

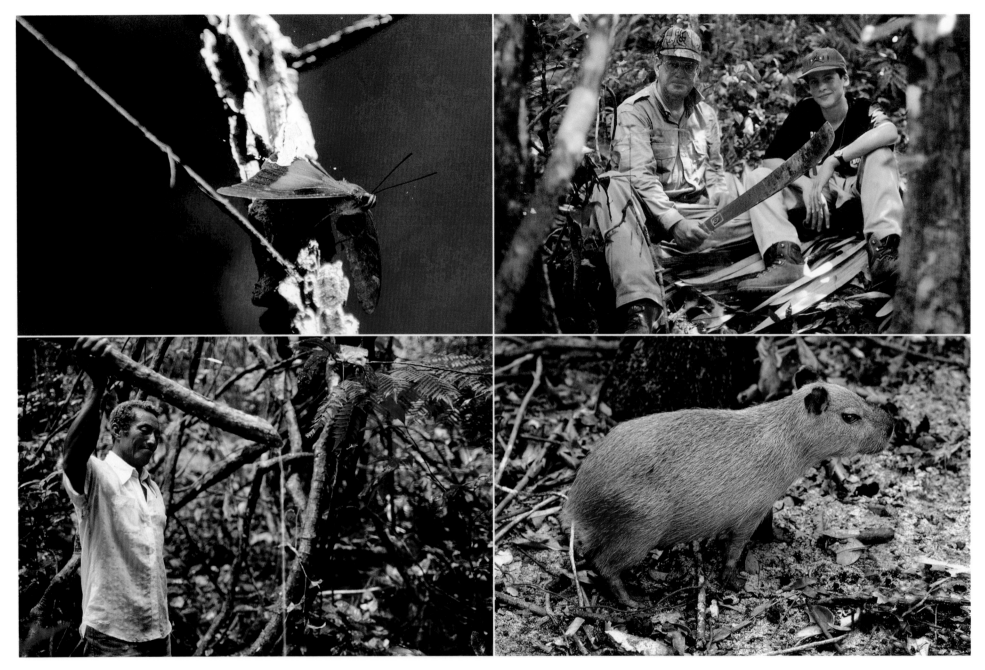

THE JUNGLE REVEALED

"It is an impressive sight to see morpho butterflies (top left) flash their large iridescent wings as they flit from tree to tree in the forest. Photographing them in flight is difficult, and the only reasonable opportunity comes in the millisecond after they've alighted and just before they fold their wings to reveal their dull brown underwings. Somewhat more robust than the morpho, the capybara (Hydrochoerus hydrochoeris), the world's largest rodent (bottom right), immerses itself in the river to escape its predators. Another discovery was that of the water vines. My son Marc and I (top right) were surprised to learn that one species of the ubiquitous liana (woody creeper) yields fresh drinking water (bottom left)."

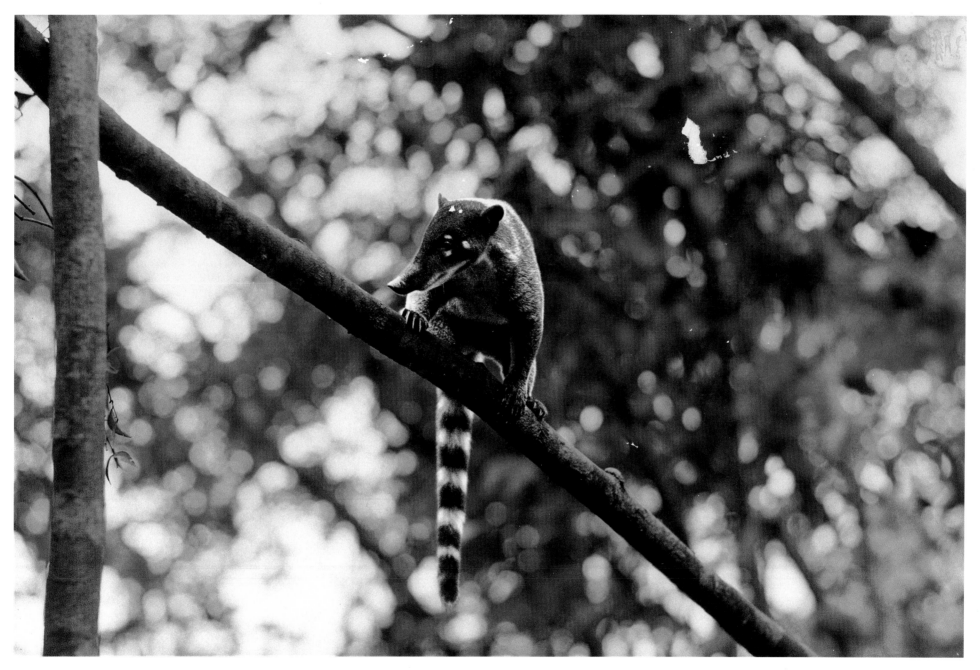

CAOTI, *Nasua nasua*

One of the most intelligent mammals in the Amazon jungle's menagerie is the versatile caoti. Primarily a ground-dweller, this omnivore is equally adept at climbing trees, using its sharp claws to scuttle up the highest of evergreens. A distant cousin of the racoon, the caoti's stylish ringed tail and sensitive, elongated and flexible nose sets it apart from the rest of the family. Caotis feed on nuts and fruit, and use their mobile noses to sniff out small animals on the forest floor. Aggressive when threatened, a pack of caotis can easily kill an animal the size of a domestic dog. Males are loners, while the more social females travel with their offspring in bands of 8–20 animals.

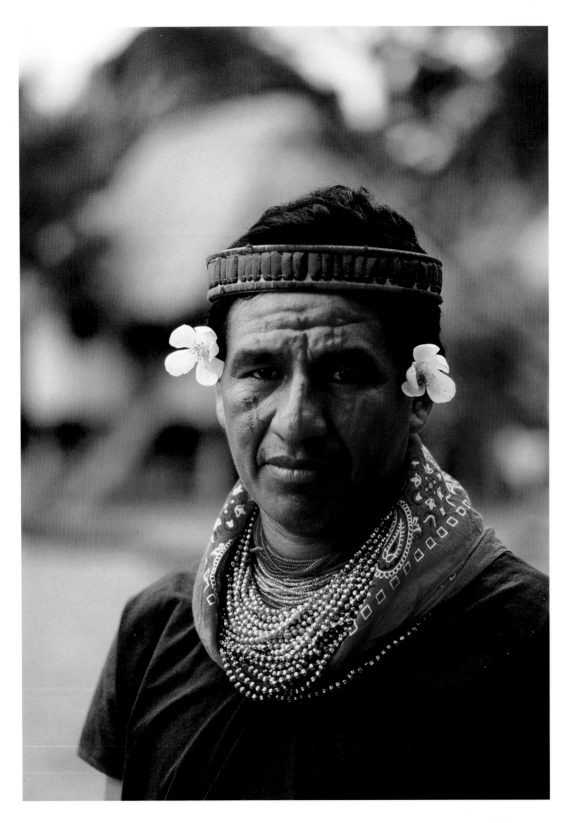

LIVING IN THE JUNGLE – THE COFAN INDIANS

For most of the estimated 15,000 years that humans have been known to inhabit the Amazon jungle, hunger has been the most persistent threat. With only about four per cent of fertile land in the Amazon Basin, the jungle's diverse communities have for centuries depended on fishing, hunting and gathering the fruits of the forest for their survival. Food scarcity forced the Amazon Indians to live in small villages and wage warfare to protect their meagre resources. Life was no different for the migrant Cofan ('the men who navigate') of Ecuador's Amazonian low-lands. Descendants of the Chibcha, who migrated to the lowlands from the northwest of South America approximately 2,000 years ago, nearly 1,000 Cofan now live in several discrete communities settled on 250,000 acres of near-pristine rain forest, much of it along the Aguarico River. However, this land constitutes only half of the Cofan Indians' former territory and their dispossession of much of their realm signifies a new threat to the existence of the people of the Ecuadorian jungle: oil exploitation. Faced by a new breed of conquistadors – mostly foreign oil companies – the Cofan have been campaigning to protect the rain forest and its rivers from deforestation and contamination from oil spills. Their efforts have inspired other Amazon communities to tackle issues of land use, development and conservation.

My then 12-year-old son Marc and I flew from Quito airport in a giant Hercules aeroplane as fare-paying passengers of the Ecuadorian airforce. This was the first leg of our journey to reach the Cofan Indians in the steamy Amazon jungle in Ecuador.

We had planned to penetrate the deep jungle, guided by the Cofan Indians, who were to lead us to a salt-lick frequented by tapirs, howler monkeys and various other creatures of the jungle, in order to photograph them.

The Hercules aircraft was cavernous, but spartan, and the majority of the passengers appeared to be civilians. Across from us sat some tough-looking hombres with droopy moustaches. The aircraft shuddered and shook and droned its way to Lago Agrio, a petroleum town reminiscent of what the Wild West may have looked like. At Lago Agrio we were met by an English-speaking driver who took us on a hair-raising ride down a narrow jungle road covered with black oil. Huge trucks seemed to bear down on us, yet miss us all the same.

After a few hours we reached a clearing on the bank of the Aguarico River, a tributary of the Amazon. At a makeshift jetty next to a half a dozen small river boats was the most rudimentary of open-air shops, whose sole proprietor, a plump, middle-aged lady with a bored expression on her face, was surrounded by the most basic trading post items. We were somewhat bemused to see a relatively new, full-sized billiard-table – larger in size than the shop itself – standing outside in the open and surrounded by mean-looking, cue-wielding dudes.

We were each handed a coke and a sandwich – our only sustenance for many hours. Leaving behind civilisation as we knew it, we set off downriver. There was no turning back!

Our home for many hours was a small river boat with an outboard engine. Its only passengers were my son and I, and a lone boatman who spoke only Spanish. It also carried several large plastic drums filled with petrol and secured with rope. After about an hour, our engine coughed and splattered to a stop. Our boatman lifted the outboard motor and removed the spark-plug. From his back pocket he produced three or four old spark-plugs, selected one and banged it on the side of the boat. He then blew on it, whistled through it, inspected it and, finally, installed it. After several false starts he coaxed the engine to life. This was to be the first of several of these spark-plug rituals during our river journey into this formidable frontier.

At one stage while drifting without power in the wide, muddy Aguarico, our boatman, skillfully dodging flotsam and jetsam and large logs, I prayed that we would not collide with anything substantial. Surely, if we had, we would have left the world's wildest jungle in a spectacular petrochemical fireball.

Still drifting, we passed a lone boatman – the only sign of humanity. Help at last, I thought. The two men exchanged pleasantries and then the stranger continued in the opposite direction, leaving our boatman to repeat his spark-plug routine.

The sunset was dramatic, then night fell. Unable to understand each other, we tried in vain to learn from our boatman how much further we had to go. When will we get there? We literally remained 'in the dark'.

Our boatman produced a powerful searchlight and with this in one hand he scanned the river in regular sweeps, while with the other he deftly navigated his craft between obstacles. The river was dark, very wide and dangerous. There were no life support

systems, no signs of humanity, no flotation vests. What lurked within? Shakespeare's Macbeth came to mind: 'Hell is murky.'

I remained outwardly calm and reassuring. Young Marc was just fine. Our boatman displayed remarkable skill, dexterity and focus and after what seemed like eternity, we were heralded by a flicker of light in the distance. We were warmly greeted in an excited tongue we didn't understand and helped out of the boats by several of the Cofan Indians. Carrying our photographic equipment, we clumsily slipped and squelched our way up the muddy river bank. We had reached our destination – a tiny village from where we would penetrate the deep jungle.

By pre-arrangement, Alex, a young Spanish-speaking American, joined us as our interpreter, as one of the Cofan villagers could speak Spanish. Conditions were spartan. Our lodgings consisted of reed huts on stilts with open sides for ventilation – a welcome respite from the extreme humidity of the day. Scratching sounds in our lodgings belonged to rodents seeking shelter, we were told. 'But not to worry,' our interpreter said. Anaethetised by the long arduous day we awoke at cock crow to a sun-drenched dawn heralded by birdsong and optimism.

There were no ablution facilities and Marc was coaxed into the river by Alex. 'The last one in the river is an old fart,' he said. I remained behind. I was very uneasy as the currents were visibly strong and dangerous. What of piranhas and anacondas? I immediately ordered Marc out of the river. Our sense of survival prevailed over our sense of smell and we remained unwashed until we returned to relative civilisation again.

Food at the village was simple 'free-range chicken' – the best I've ever tasted (or were we just very hungry?). Liquid refreshments consisted of boiled river water. Toilet facilities were very rudimentary. A single, communal 'long drop', with reed walls, reminded me of my army days during national service.

On our first evening, around twilight, some villagers came to our hut and sat down, uninvited and uninhibited. They had come to observe us. I guess we were as fascinating to them as they were to us. I had brought some colour proof pages of my wildlife photographs with me as people I meet during my expeditions often ask to see examples of my work. I showed them to the villagers. Imagine their wide-eyed, spellbound fascination on seeing images of animals they had never encountered before – tigers, polar bears and lions. Soon there was a cacophony of excited chatter and the people in our hut were soon joined by a throng of villagers. Visual communication transcends all languages and cultures.

Early the next morning our party of Cofan Indians, Marc, Alex, our interpreter, and I set off in dugout canoes with all our equipment. After some time we beached the dugouts under bushes on the river bank and started our journey on foot. We were dwarfed by the tallest and widest trees I had ever seen, anchored by a tangle of spectacular root systems and home to upwardly mobile forest foliage, formidable thorns, fascinating parasitic creepers and intertwined monkey ropes.

The Cofan, small of stature, were friendly, kind, considerate, very strong and jungle wise – ideal companions in an unfamiliar, hostile environment. They walked in single file, each with a heavy pack. I smiled at Marc and said: 'Dr Livingstone, I presume.'

We were warned, through our interpreter, not to touch or grab anything in the jungle. Dodging root systems, I stumbled, fell and instinctively grabbed onto what seemed like a branch. The sensation was like the severe jolt of an electric shock. I had grabbed what they called spina – spines, formidable thorns, some of which were left embedded in my hand. The Cofan lopped off one of the spina with his machete and using it as an instrument, he proceeded right then and there to 'operate' on my hand and removed the non-toxic thorns, some 30mm in

length. Grateful and somewhat relieved, we continued our journey.

The next 'initiation rite' was an unexpected series of river crossings. Balancing precariously as we walked across fallen trees over water, we inched our way across green algae-covered pools, with unknown creatures, perhaps caiman and the like, lurking below. This was serious stuff. For the longer crossings, the Cofan made makeshift balustrades – wooden poles spliced together with monkey ropes – for us to steady ourselves on.

The Indians' ingenuity and creativity were displayed again at supper time. In a matter of minutes, the men assembled chairs and a table out of woody vines and other vegetation. A green tablecloth of gigantic leaves completed the homely arrangement. All this was a prelude to a spartan meal of lentils and fish shared with persistent insects. Supper was complemented by boiled river water.

Our second night's entrée of fresh fish was caught at a spot in the river where a warm current forces fish to momentarily surface for air. With lightning speed, the Cofan men speared the fish with a running gaff. The gaff – a wooden stick with a barbed spear attached with sinew wound tightly around the end of the stick – functioned simultaneously as a spear and a fishing rod. Once speared, the fish would put up a vigorous fight, unravelling the sinew. As it struggled towards freedom our deft fisherman would 'reel' it in. Cooked over an open fire, the fish (yellow with purple fins) was the tastiest I had ever eaten.

Exhausted by the arduous day and the excitement of it all, we settled down to a good night's sleep, Marc in his tent and me in mine. Then, in the dark, in the middle of nowhere, with the unfamiliar sounds of the jungle all around us, parental anxiety overcame me. What had I done bringing my young son to this place? I called out to him: 'Marc, are you okay?' 'Yes, dad,' came his reply from inside his single berth canvas tent. And then again I

called: 'Marc, are you sure you're okay?' 'Yes, dad,' he said. And then, finally: 'Marc, are you sure you're sure your okay?' 'YES, DAD,' came his final exasperated reply. I went to sleep.

In the middle of the night there was a violent storm of thunder and lightning. A deluge of rain ensued. Nature called and I needed to leave my tent for a few minutes. In that brief time, it was besieged by giant ants. Torch in my mouth, I sat crushing these formidable looking interlopers, one by one, until I had regained my space. On another occasion I was suddenly covered with black bees. I thought my time had come, but Alex offered some consolation. 'Hold still and don't worry. They only want your salt.'

We spent the following day walking to the salt-lick. Unlike the salt-licks one finds in Africa, this one was a muddy quagmire – marshy and wet, with nowhere to sit and no place to rest one's camera equipment. Camera in hand, I waited patiently for an animal to arrive, but to no avail. There was not a creature in sight, save for the hundreds of droning insects of every description.

Extricating ourselves from the situation we headed back. As the old saying goes, the journey was more important than the destination. Marc, though asthmatic, experienced no problems. To my relief the special injection kit from our family doctor went home intact. Perhaps it was the absence of city pollution or the nebulising effect of the steamy jungle that kept him asthma-free.

Marc acquitted himself so well that a Cofan Indian placed a special necklace of Amazon jungle seeds and pods around his neck to honour him. I learned a great deal about Marc and he learned a great deal about himself. It was a great bonding experience between father and son and nature – a rare privilege we still consider one of the most important of many adventures we shared together in the wild.

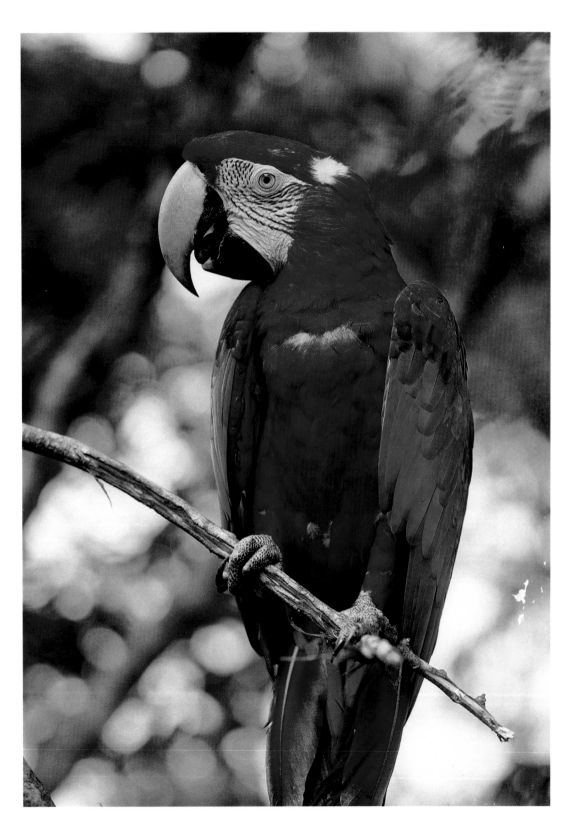

MACAW, *Ara chloroptera*

The red-and-green macaw occurs in the lowland forests of Central and South America from Panama south to Paraguay. It is a popular cage bird, and the combined effects of trapping and human settlement of the forests have had a severe impact on the population in several areas. Extinction has occurred in southeastern Brazil and in Argentina. Two other South American macaw species have been brought close to extinction through uncontrolled trapping, and a third species, the Glaucous macaw (*Anodorhynchus glaucus*), is almost certainly extinct: a possible sighting in Paraguay in 1997 has not been confirmed.

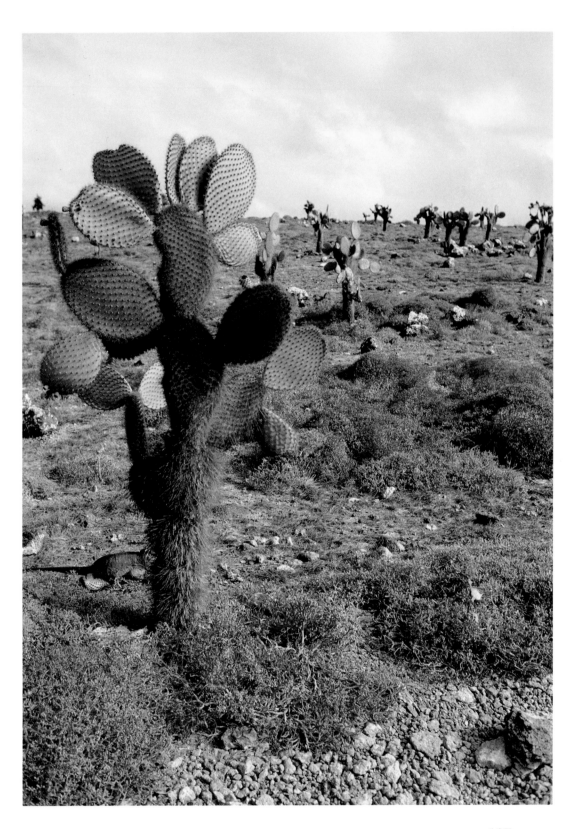

The Galápagos Islands

THE PRICKLY PEAR CACTUS – A SOURCE OF LIFE

In 1535, en route to Peru, the Spanish Bishop of Panama, Tomás de Berlanga, found his ship becalmed in the Pacific Ocean. Nudged by sea currents, it eventually came to rest on the semi-desert shores of the hot, dry Galápagos Islands. Stranded without water, the Bishop and his remaining crew (two men had already died) were forced to drink water from the fleshy pads of giant cactus trees *(Optunia sp.)*.

They had only to follow the example of the land iguanas and giant tortoises, who for thousands of years have obtained sustenance and precious water from the prickly pear cactus and its thirst-quenching fruit. The iguanas occasionally rise on their hind legs to reach drooping pads, but mostly they feed on fallen ones. The coastal-dwelling giant tortoises have evolved long necks and limbs and raised carapace entrances to reach the cactus pads. Doves, mockingbirds and two finch species also feed on the fruit of the cacti.

The cacti, which can grow to tree size, are surrounded by *Sesuvium sp.*, a perennial, salt-loving herb which changes from green in the wet season to yellow and red during the dry season.

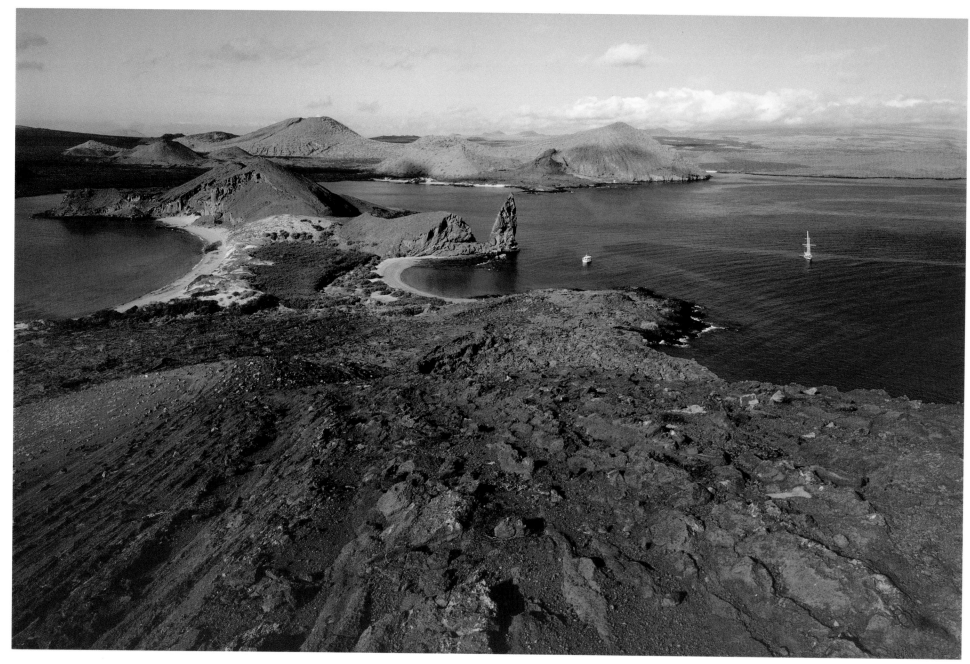

THE GALÁPAGOS ARCHIPELAGO

It seemed as if 'God had showered stones', wrote Bishop Tomás de Berlanga about the Galápagos Islands, after discovering them accidentally in 1535. But though islands such as Bartolomé (above) appear desolate, the Galápagos chain hosts a variety of wildlife found nowhere else – a fact that influenced Charles Darwin's theory of evolution. The archipelago of 19 islands and over 40 islets straddles the equator almost 1,000km west of Ecuador, near the junction of three tectonic plates. The island chain is moving southeast, at approximately seven centimetres a year, over a stationary hot spot. This feeds magma to the younger, western islands where volcanic eruptions still occur.

"A thousand kilometres west of the Ecuadorian coast lie the Galápagos Islands, a remarkable chain of volcanic islands, reefs and islets straddling the equator in the northern Pacific Ocean. As oceanic islands they have never been attached to any land mass, and most wildlife in this lava-strewn land originate from species that flew, swam or drifted there on rafts of debris. Plant seeds were probably carried in the digestive tracts of birds or in mud clinging to their feet.

The Galápagos Islands were annexed by Ecuador in 1832 and small settlements were established on several of the islands. In 1934 a few islands became wildlife sanctuaries, and in 1959 ninety percent of the archipelago was declared a national park. The sea in which the islands are located is also protected. The Galápagos Marine Resources Reserve, created in 1986 by the Ecuadorian government, constitutes 50,000 square kilometres of ocean surrounding the islands.

The only way of getting around the islands is on board a passenger boat registered with the authorities, which travels from one island to another. Another option is to stay on land and take day trips to some of the 50 demarcated visitor sites. I decided to charter a schooner, which enabled me to plan my own itinerary. I generally prefer to work in the first few hours of the morning and the last few hours of the day when the quality of the light, with a wide tonal range, long defining shadows and warm hues, is most conducive to photography.

At first the islands appeared to be desolate and inhospitable, but once I had stepped off the boat I discovered the astounding beauty of the Galápagos. Cacti, spiny acacias and palo santo trees have taken root amid the hardened black lava of the coastal regions. In the elevated zones, where cooler, moist air prevails, ferns grow, along with scalesia trees – giant relatives of sunflowers. The highlands are carpeted with low-growing ferns, herbs and grasses.

There is much evidence of the islands' volcanic origins. Underfoot, abrasive lava flows form exquisite patterns and shapes and some are lightly brushed with metallic reds and yellows. One can almost hear the bubbling lava, yet these rocks are mercifully ancient and cold. Even here, on the rocky, hostile surface, nature triumphs. Growing in cracks and crevices is the hardy lava cactus – an indomitable and tenacious species.

The island beaches are also most unusual. Depending on which island you are on, the sand is typically red, black, green or white. Beaches are mainly formed through wind erosion, and in the Galápagos the beaches take their colours from the surrounding volcanic rock.

What fascinated me the most, however, was the apparent absence of fear displayed by the land and marine animals. Imagine walking among land iguanas or swimming with marine iguanas, propelled through the water by their muscular tails. Reminiscent of giant chameleons or little dragons, they seemed to be unperturbed by our presence or that of any other animal. The ubiquitous Sally lightfoot crabs quite happily live side by side with these swimming iguanas. It was a privilege to be able to see the animals up close and observe them in their own habitat.

The Galápagos Islands are dominated by reptiles. Twenty-two species of reptiles – and several subspecies – coexist there. Endemic species of marine iguanas, land iguanas, tortoises, marine turtles, snakes, geckos and lava lizards can be found across the archipelago, although some are found only on specific islands.

Amongst the unusual animals on the islands are the Galápagos tortoises, famous for their immense size. A giant tortoise can weigh up to 250kg. Researchers have estimated that there were originally 14 subspecies on the islands, of which only 10 remain. Different subspecies reside on the different islands and they can be identified by, among other characteristics, their size, the shape of their carapaces and their coloration.

Coming face to face with these giant reptiles is an amazing experience. Although they also showed no fear, some withdrew into their cavernous shells when we got too close for their liking. As they did so, the sound they made dispelling the air in their cavernous shells was reminiscent of the closing of a pneumatic door.

It is not only the reptiles that exhibit such ease in the presence of humans. The birds, too, appear to be relaxed. This was aptly demonstrated by our naturalist guide. He clapped his hands and, as if conjured up by a magician, a Galápagos hawk appeared. The bird hovered above us, allowing me enough time to photograph it.

The islands are a birdwatcher's paradise. Frigatebirds, petrels, red-billed tropicbirds, blue-footed boobies, gulls and albatrosses are some of the thousands of birds found on the islands. The 1,350 kilometres of coastline is also home to several species of shore birds, including the striking Galápagos oystercatcher. The islands are an important winter stopover for some North American bird species, while others stay for the entire winter.

The bird that caught my attention was the beautiful red-billed tropicbird. I was captivated by the way its long, lyrical tail gracefully trailed behind it as it darted through the air. An opportunity to photograph it came during an early morning walk. As our party reached the top of a towering cliff overlooking the sea, we noticed several tropicbirds flying in and out of crevices in the rocks of the cliff face. I was able to photograph them from a height above their flight path, with the aquamarine sea forming the backdrop.

The fascinating marine world of the islands still remains relatively unexplored. However, more and more divers are visiting the islands for a chance to see its underwater kingdom. The waters teem with hundreds of species of fish from temperate and tropical zones. One can also swim with the sea lions, fur seals and turtles that cavort in these waters. From the deck of the schooner, we were able to observe turtles mating while stingrays and sharks swam past in the crystal-clear waters.

I remember sitting on the deck one balmy night. A light breeze created gentle waves on the surface of a phosphorescent sea, while above a star-studded dome arched across the heavens. Marc and I marvelled at the wonder of it all."

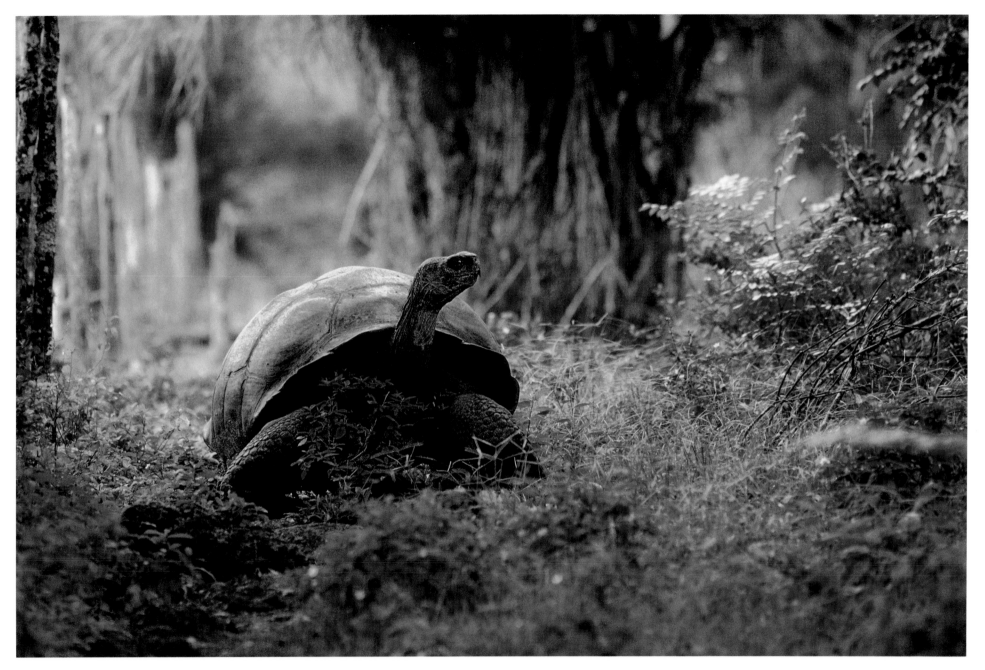

GIANT TORTOISE, *Geochelone elephantopus*

Together with the Aldabra tortoise of the Seychelles, the Galápagos giant tortoise is the largest living tortoise: it can weigh up to 250kg. Once a thriving tortoise haven, the Galápagos Islands – Spanish for saddle, referring to the saddleback tortoises – now hold a fraction of the estimated original population of 250,000. Four of the 14 subspecies that evolved on the islands are extinct. Of the survivors the big, dome-shaped races live in the lusher regions, while the cactus-eating saddleback tortoises inhabit drier areas. Favoured by passing sailors, more than 150,000 tortoises were captured for food between the 17th and 19th centuries. Easy to stockpile on board ship, they could survive without food and water for a year.

THE SURFACE OF A VOLCANIC ISLAND

A volcanic eruption at the turn of the 20th century on San Salvador Island left much of Sullivan Bay on the eastern side of the island covered in intricate shapes and patterns of solidified lava. The rope-like shape seen here is a common sight on the island. Called *pahoehoe* (the Hawaiian word for rope), the tightly folded lava tubes are formed when the outer crust of the magma cools down while molten lava continues to flow beneath the surface. This causes the skin to shrivel and contract into these distinctive shapes. Pahoehoe lava can also be seen on the volcanic islands of Hawaii, situated northwest of the Galápagos in the Pacific Ocean.

ISLANDS OF LAVA

The Galápagos chain of islands was born of successive layers of lava flows. Erupting from under the earth's crust, the fiery basaltic magma was initially laid down as submarine mountains but surged above the ocean surface to become volcanic islands. Wind and water erosion helped convert some surfaces into soil and made the islands more hospitable for plants and animals. Evidence of the archipelago's volcanic history is everywhere: from the black rocks jumbled along the shorelines to the tranquil crater lakes, and from the vapours escaping from vents in volcano rims to the spectacular patterns of the once liquid lava. These all offer clues to the geological history of *Las Encantadas* (the Enchanted Islands).

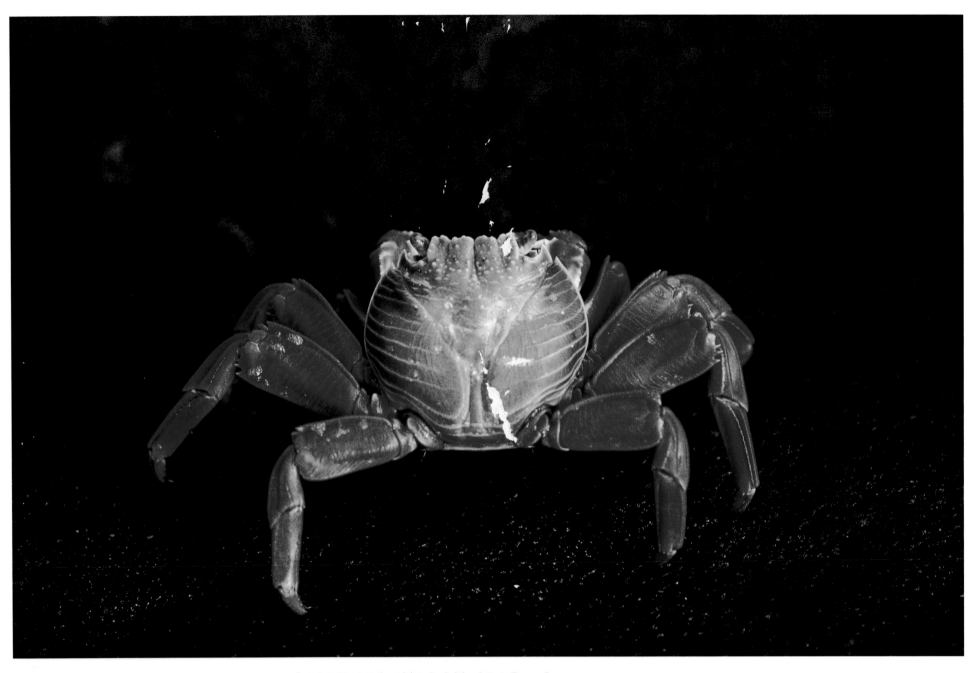

SALLY LIGHTFOOT CRAB, *Grapsus grapsus*

The coral-coloured Sally lightfoot crab is aptly named for its athletic ability to skip across short expanses of water. Even more fleet of foot is the juvenile, whose drab, black external skeleton is replaced, after several moults, with a new colourful exterior. Underneath the red and yellow upper body lies a blue belly, while a sprinkling of yellow completes the transformation to adulthood. Also called red lava crabs, these crustaceans are found on the black lava rocks along the shores of the Galápagos Islands. They regularly venture into the sea where they feed on algae, or become prey to moray eels and hawkfish. On land the Sally lightfoots are tasty fodder for herons.

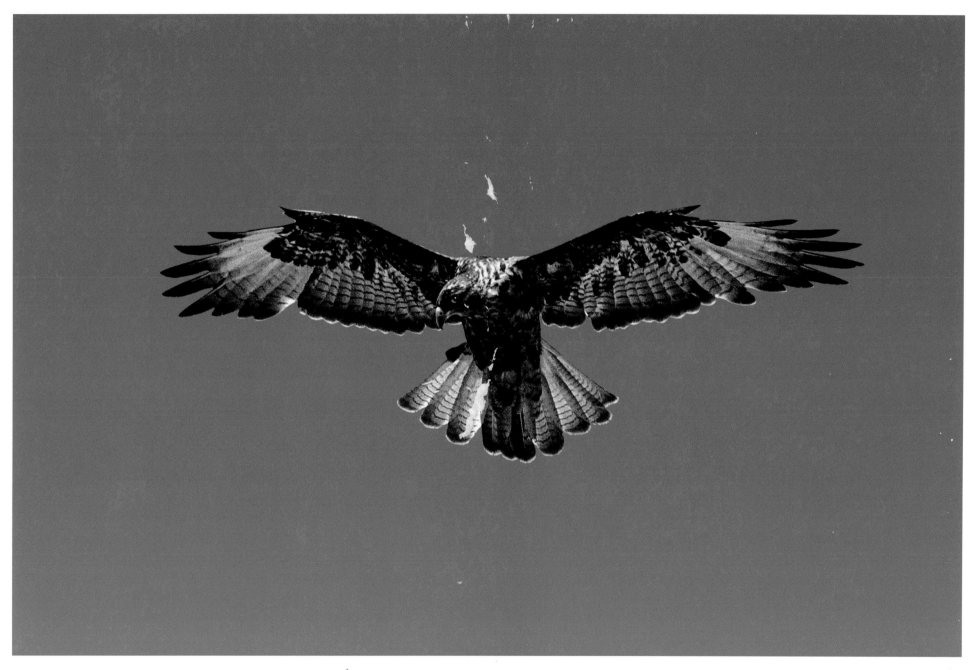

GALÁPAGOS HAWK, *Buteo galapagoensis*

As the name implies this hawk is unique to the Galápagos Islands. It is the only bird of prey to breed there and, perhaps because of the lack of competition, it enjoys a richly varied menu. The many courses include small birds, rats, iguanas and centipedes. Sadly, settlers have persecuted the bird so much that it has had to be included in the International Red Data Book of endangered species, and has dwindled to extinction on several of the islands. Even Santa Cruz Island, where up to 250 pairs used to breed, now hosts a mere handful.

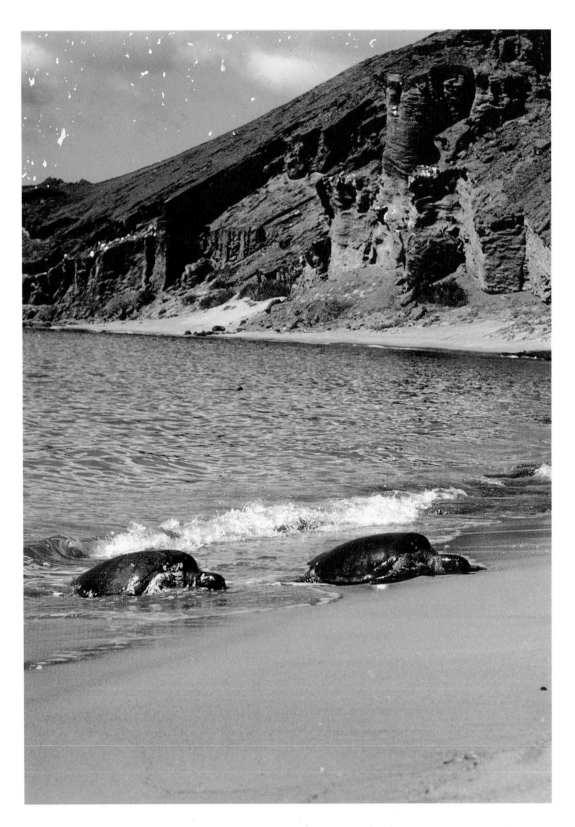

PACIFIC GREEN SEA TURTLES,
Chelonia mydas agassisi

Although not endemic to the Galápagos Islands, the Pacific green sea turtles are its only resident breeders, choosing to mate and feed in its calm waters and to nest on its narrow, sandy beaches.

During the nesting months (from December to June), females go ashore to lay their eggs. In one season they may make the nocturnal trip from surf to sand as often as eight times, each time depositing between 70 and 80 eggs in a nest hollowed out in the sand above the high tide mark. The nesting process takes about three hours to complete, after which the female returns to the sea. Recent studies have shown that sand temperature determines the sex of the embryos. The colder the sand, the more likely it is that the hatchlings will be male.

Life is treacherous for the hatchlings. They usually emerge at night, but when they don't, they may fall prey to birds and crabs. Life in the sea is also perilous: hatchlings are easy prey for sharks and large fish, and, as they grow older, for fishermen.

Sea turtles are renowned for their ability to migrate vast distances – as far as 3,400km – between their feeding and breeding grounds. Equally remarkable is the fact that adults always return to their hatching beaches to breed and nest.

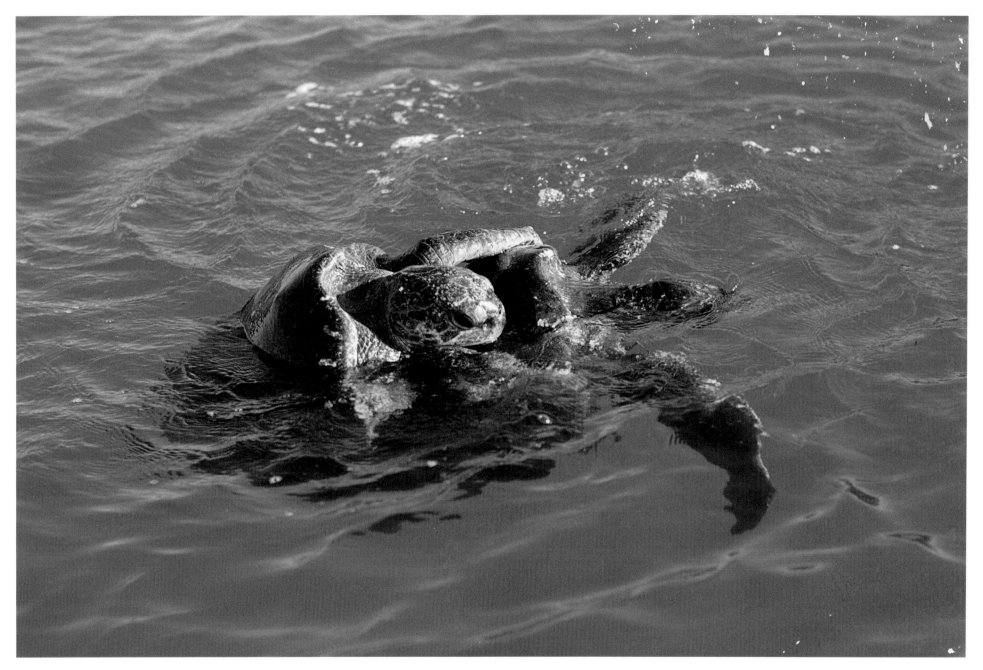

MATING TURTLES

Clinging on for dear life, a male sea turtle uses his flippers to stay on top of his partner while mating. By doing all the swimming during copulation, the larger female keeps herself and her partner afloat in their watery love-nest. November to January are breeding months in the shallow waters of Black Turtle Cove off Santa Cruz Island in the Galápagos. A flurry of activity takes place as males compete for the attention of females. For sea turtles mating is a promiscuous affair and males can often be seen waiting for their turn as a copulating pair completes its ritual.

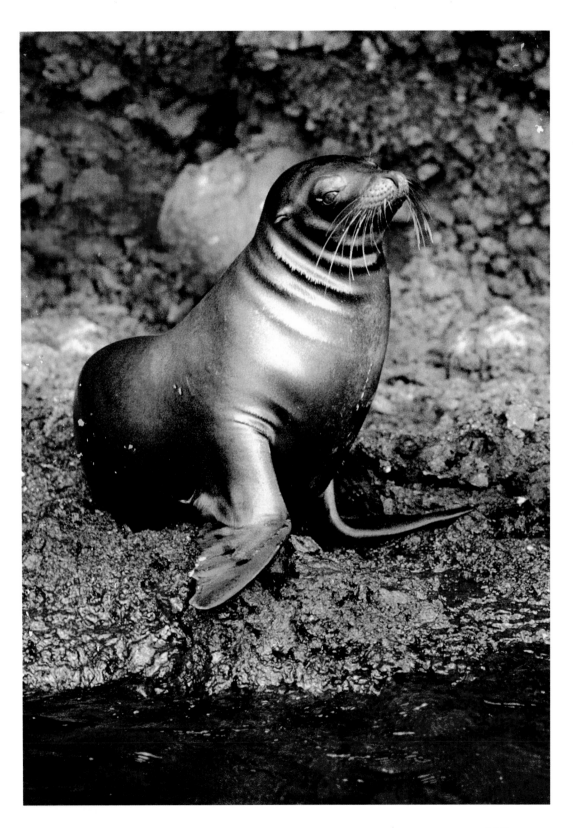

GALÁPAGOS SEA LION,
Zalophus californianus

Together with fur seals, the Galápagos sea lions are the only pinnipeds that live on the equator. While the southern-dwelling fur seals probably arrived there on the cool, north-flowing Humboldt current, the sea lions – relatives of the larger California species – emigrated from temperate, northern waters. Their passage, which would have involved swimming in warm equatorial currents, remains something of a mystery. Scientists estimate that they must have crossed the equator during glacial intervals some time in the last two million years.

The archipelago is a superb home. Its waters teem with more than 300 species of fish, many of which feed on nutrients freed from the bottom of the ocean by cool upwelling waters. From June to September prevailing easterly winds sweep surface water away, bringing up nutrients such as algae and plankton – the first link in a rich marine food chain – in the upwelling currents.

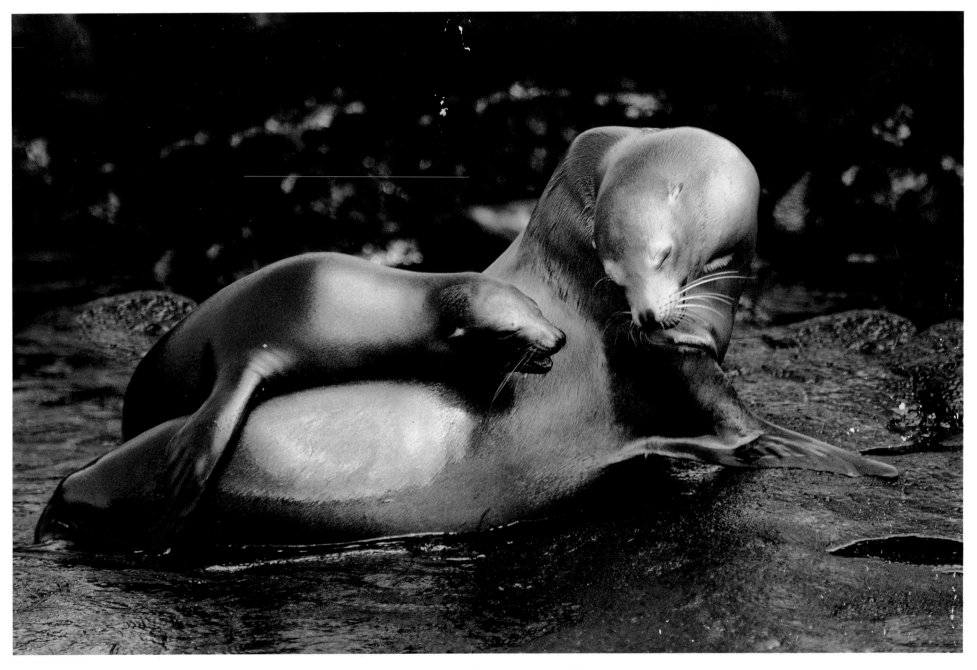

A TENDER MOMENT

Mother and pup are inseparable as they get to know each other during the first few days of the pup's life. The attentive mother returns to fishing at the end of the first week, but will suckle her pup for as long as three years. It is not unusual for mothers to suckle two pups born singly during successive years. Although territorial males spend much of their time guarding their properties, they keep an eye on their pups, emitting a warning bark when a shark is nearby. Sea lions live in harems dominated by a single bull, although the noncommittal cows freely migrate between territories. Weighing 250kg, bulls are nearly three times the size of the cows.

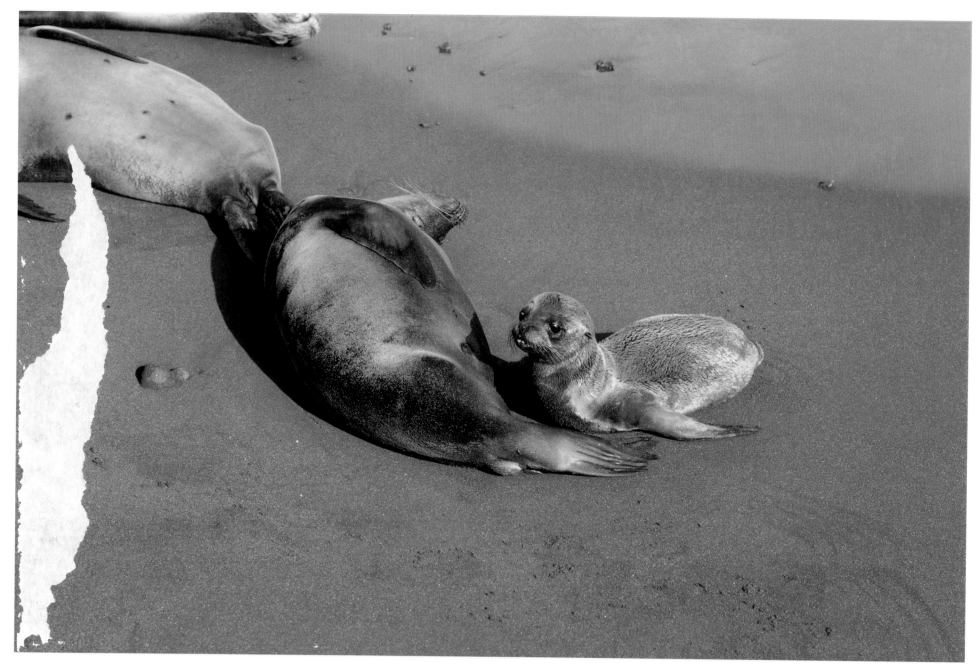

TAKING A BREAK

Lazing around on the beach is not only a pleasurable pastime for sea lions: it's a way of repaying an oxygen debt acquired by diving for food. Before plunging into the sea, these marine mammals expel air from their lungs to avoid problems associated with buoyancy and pressure. Sea lions can descend to depths of 40–180m, holding their breath for long periods while using oxygen stored in their blood and muscles. Like all marine mammals, their oxygen-carrying capacity is boosted by generous blood volumes – higher than those of terrestrial mammals – and high levels of myoglobin, an oxygen-carrying protein in muscles. Until their first dive at five months, pups are only allowed to play in shallow waters.

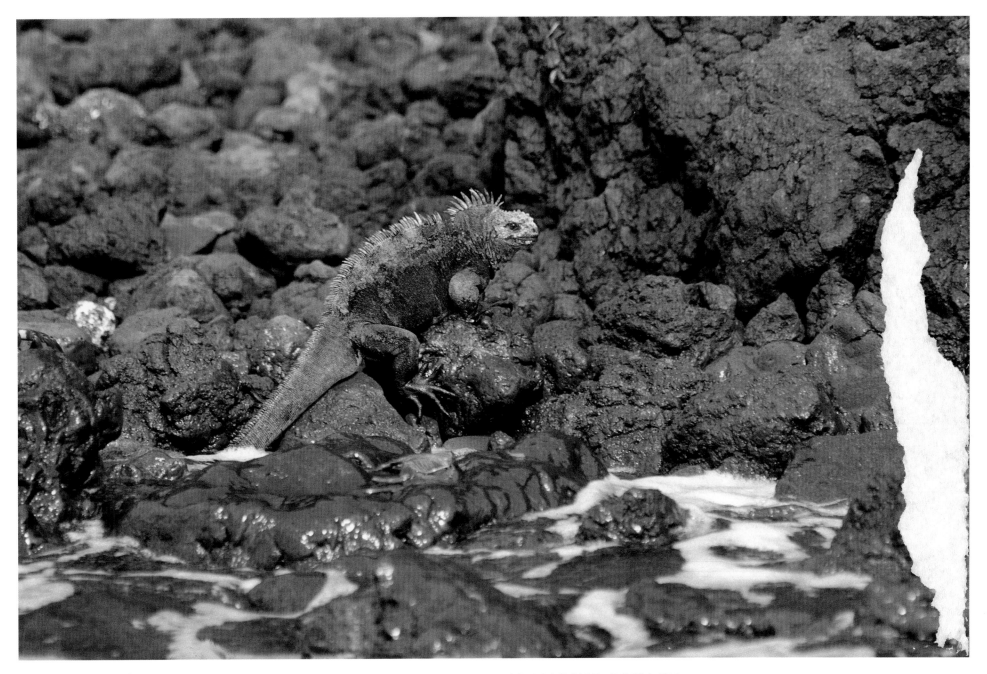

THE CASE OF DARWIN'S MARINE IGUANA

Charles Drawin described the marine iguanas he saw basking on jagged basaltic rocks as 'hideous-looking' creatures. But though unsentimental about the animal's appearance, he was greatly intrigued by the behaviour of an iguana who returned to the shore each time he threw it into the ocean. To what extent this experience informed his thinking we will never know, but today the iguana's behaviour is easily explained by Darwin's theory of natural selection – in the absence of terrestrial predators, there was no evolutionary selection pressure to be wary on land. This also explains the apparent tameness of the islands' animals and their vulnerability to man and the predators he introduced.

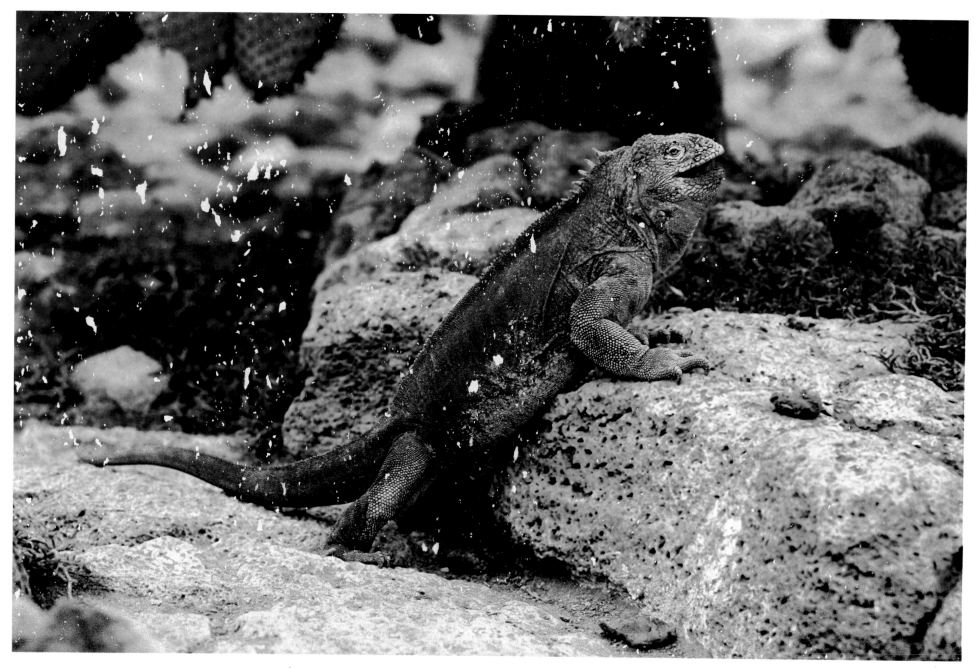

GALÁPAGOS LAND IGUANA, *Conolophus subcristatus*

A land iguana greedily gulps down the last bite of its favourite food – a succulent cactus pad. The cacti also provide the lowland iguanas with a year-round supply of water. Other food includes prickly pears, leaves, shoots and bark. Once abundant on most of the central islands, the iguana population on several islands has become extinct as a result of human occupation and the introduction of feral animals. The Charles Darwin Research Station on Santa Cruz Island runs a captive breeding and repatriation programme for iguanas and other island animals. It has managed to save the Isabela and Santa Cruz populations from extinction, and has repatriated iguanas to Baltra Island after a 40-year absence.

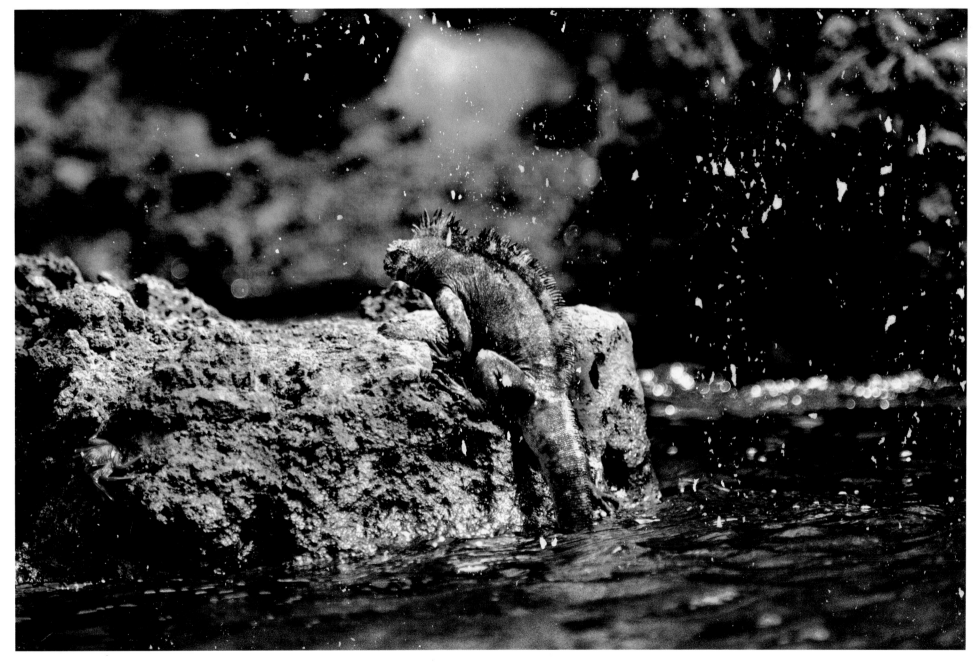

MARINE IGUANA, *Amblyrhynchus cristatus*

Hoisting itself out of the water, a marine iguana returns from a seaweed lunch at the bottom of the ocean. The only sea-going iguanas, these remarkable reptiles can dive as deep as 12m and stay underwater for nearly an hour. Although all iguanas nibble on red and green algae found along the shore at low tide, it is only the males who plummet to the ocean depths in search of a meal. Preparing for submersion, the iguanas bask in the sun until their temperatures reach 36°C. Once in the water, they can lose about 10 °C of body temperature. Iguanas sneeze regularly to get rid of excess salt that accumulates in the salt glands above the eyes.

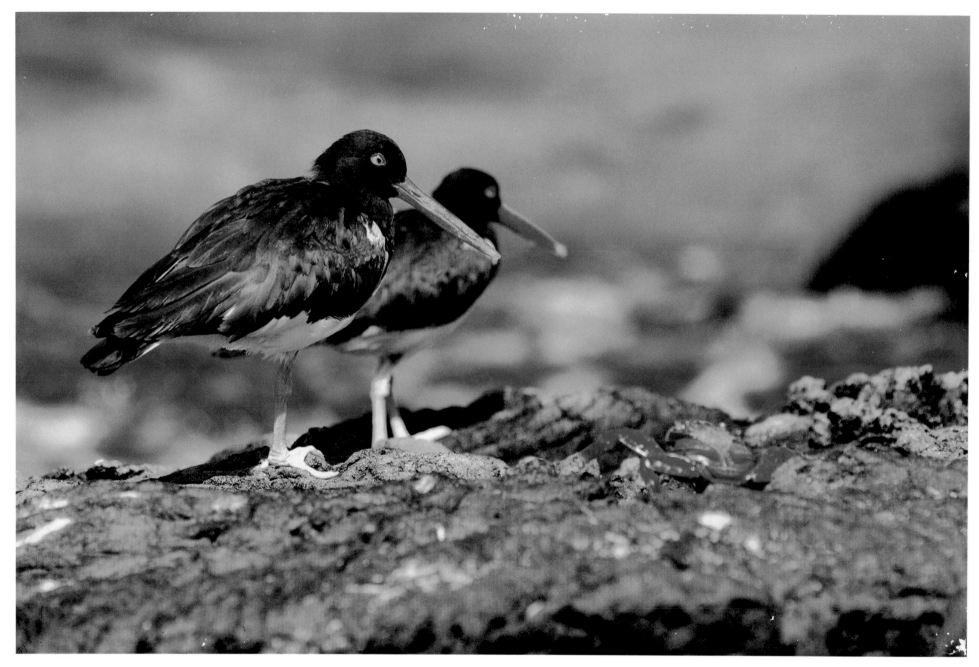

OYSTERCATCHERS, *Haematopus palliatus*

This Galápagos Islands species of oystercatcher was thought to be the American pied oystercatcher *Haematopus palliatus*. However, scientists now suspect that it could be a distinct species, since it differs slightly in plumage and has unusually large, fleshy feet – an adaptation to life on sharp lava shores. If it is a different species, it will instantly enter the Red Data Book on endangered birds, because the world population, entirely confined to the Galápagos, is thought to be under 100 pairs. These birds live in scattered pairs around the coasts of the larger islands, where they eat mostly shellfish.

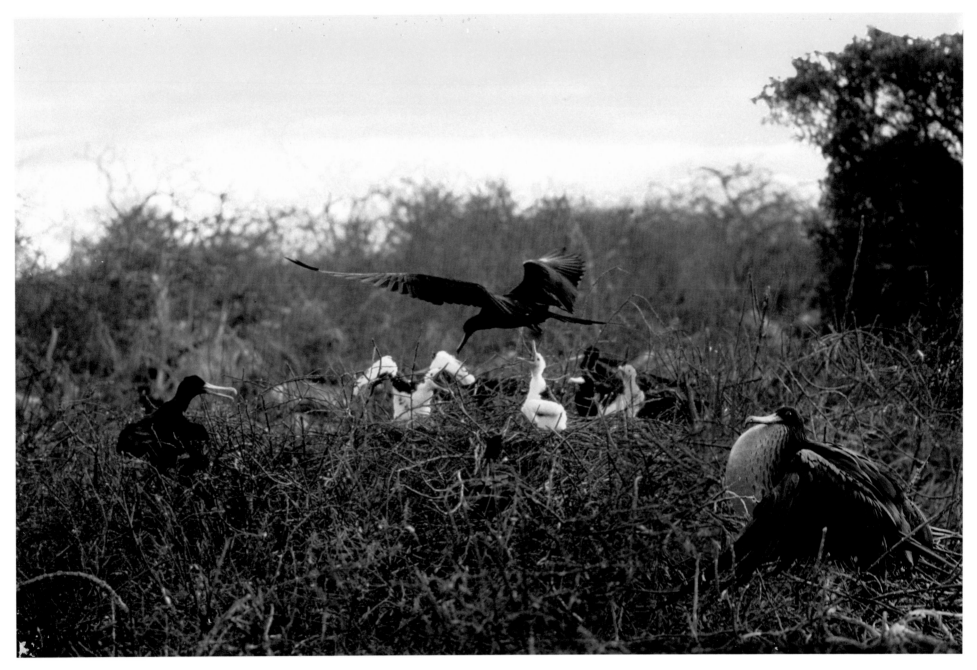

GREATER FRIGATEBIRDS, *Fregata minor*

'Creative license gone mad' was how seabird biologist Bryan Nelson described the enormous, red, inflatable throat sac of the male greater frigatebird. This bizarre love-token, which takes the bird 20 minutes to inflate, is but part of an impressive courtship display which also features extended, shaking wings and a high-pitched, warbling call. Often, several males display together, creating a noisy crowd of outrageously adorned suitors for the females to choose from. Little wonder that at first all they can do is to stand and stare. Later they join in the dance, waggling their heads and intertwining their necks with those of the males.

RED-BILLED TROPICBIRD, *Phaethon aethurus*

The graceful red-billed variety of tropicbird is one of only three species in the world, and the most rare, with only about 10,000 pairs remaining. As the name implies, tropicbirds inhabit the tropical oceans, the red-billed species occupying the smallest range. The remote, pristine Galápagos Islands are its prime breeding grounds. When not breeding, these birds fly up to 1,500km away from the islands to hunt the offshore waters of Peru and Panama. Despite the apparent encumbrance of its long, lythe tail, this bird deftly snatches up its prey of fish and squid after plunge-diving from the air, sometimes plummeting from as high as 25m onto its hapless target.

The Sub-Arctic: Canada & Alaska

GLACIER, ALASKA

Forced by its own weight and mass of compacted crystallised snow, a massive glacier creeps down a valley near Haines in south-eastern Alaska. At its snout ribbons of meltwater trickle down the mountain slope, depositing debris ranging from large boulders to fine grains as they flow across the outwash plain.

The world's glacial ice, including ice sheets and an estimated 70,000–200,000 glaciers, cover approximately 11% of the earth's land mass and contain nearly three-quarters of all its fresh water.

WINTER'S STARK BEAUTY – RIDING MOUNTAIN NATIONAL PARK

A white winter wonderland blankets the highlands of Canada's Riding Mountain National Park. Situated in western Manitoba, the park consists of nearly 3,000km² of jagged escarpment, boreal forest and gentle meadows. Stands of balsam fir and tamarack grace the mountain slopes and rolling hills, while forests of oak, elm and maple blanket the Manitoba escarpment. The park is a sanctuary for bison, elk, moose, black bears and beavers. It is also a port of call for 233 different bird species.

GRAY WOLF, *Canis lupus*

In solitary splendour, a wolf surveys the snow-covered wilderness around him. Resilient and tough, gray wolves have roamed the earth since the Pleistocene period, and, until the early 20th century, were the most widely distributed mammals on the planet. Over time the pack has evolved an efficient social system, working together to take care of the young and ensuring harmony through a complex series of dominance and submission behaviours – forms of communication designed to ensure that each member learns its place in the hierarchy. The pack functions as a finely honed killing machine, hunting cooperatively to down the biggest possible prey, especially in winter when more calories have to be burnt to keep warm.

MUSKRAT, *Ondatra zibethicus*

Sometimes mistaken for a beaver, the small, flat-tailed muskrat usually lives alone in lakes, ponds and streams. In swampy areas its grass and mud home is built on top of roots or mud, towering three feet above the water. Muskrats also dig multi-chambered lodges along water banks, using their sharp claws and protruding incisors to tunnel through the soft earth. Underwater entrance tunnels allow them to dive for food under the ice. They feed on the roots and stems of water lilies, grasses, sedges and cattails, occasionally eating shrimp and small fish. In winter they remain in burrows below the snow and ice for prolonged periods, living off aquatic plants stockpiled in summer and hoarded for sustenance through the long winter.

BROWN BEAR, *Ursus arctos*

"*I went to Riding Mountain National Park in Canada to photograph brown bears, desperately hoping that I would find one ... and, ambivalently, hoping that I wouldn't. Bears are big and formidable, and can cause serious injury or death if provoked or frightened. The important thing with bears, as with most animals, is not to surprise them. Though one could, of course, get as much of a surprise as them, by then it could be too late. The trick, I was told, was to rattle a tin filled with stones while walking along. This would alert the bear to one's presence, and hopefully it would trundle off. This photograph of a brown bear was taken with a lot of luck, a great deal of patience and a rush of adrenaline.*"

CONIFEROUS FOREST – RIDING MOUNTAIN NATIONAL PARK

The boreal forests of North America are dominated by conifers. Ironically, it is their adaptation to dry conditions 286–246 million years ago that allows them to survive in the cold taiga of Canada's Riding Mountain National Park. Their needle-shaped leaves are covered by a thick waxy cuticle and their stomata are sunk well below the surface, reducing water loss. This is essential, as for a large part of the year water in the soil is frozen, and the deciduous trees are forced to live in a 'cold desert'. Lone guardians of the edge of the treeline, the conifers of the northern forests endure through winter to make the most of a short summer.

THE COLOURS OF AUTUMN

Seasons intermingle on a forest floor in Canada. Fresh grass shoots and clover-like plants intimate the sun's tenacious grip on the vegetation, while the warm colours of discarded autumn leaves hint at colder weather to come. In a timeless cycle of regeneration, glistening drops of water will begin to work their magic to decompose the fallen foliage. Ice, snow and bacteria will do the rest, turning the honey-gold and russet coloured leaves into nutrient-rich humus.

PHOTOGRAPHING FOXES

"This photograph is the product of my first thrilling encounter with Arctic wildlife. We were making our way in a special hybrid vehicle from the airport in Churchill, en route to the Hudson Bay shoreline when I spotted this Arctic fox (Alopex lagopus). I instinctively ran to the front of the vehicle, asked our surprised expedition leader to stop the vehicle, gained his permission and then charged across the tundra, camera in hand. I had anticipated such a situation, and had my f2.8/280mm lens fitted with a 1.4x extender at the ready. Oblivious to the apparent danger of polar bears and the encumbrance of my Arctic clothing, I dashed after the fox across the tundra. Like most animals when they are being

pursued, the fox ran for some distance and then stopped to assess its pursuer. At that moment, it turned its face and momentarily stared straight into my lens. My motordrive whirred at four frames a second. I managed to get detailed shots of the fox set against a wonderland backdrop of rust-coloured sedges and summer grasses. The next opportunity I got to photograph the fox, it was way in the distance, scampering across its vast, icy natural habitat. Foot pads covered with thick hair give these foxes superb traction on the sea ice, where they feast on the remains of seals killed by polar bears. It was a good start to the trip!"

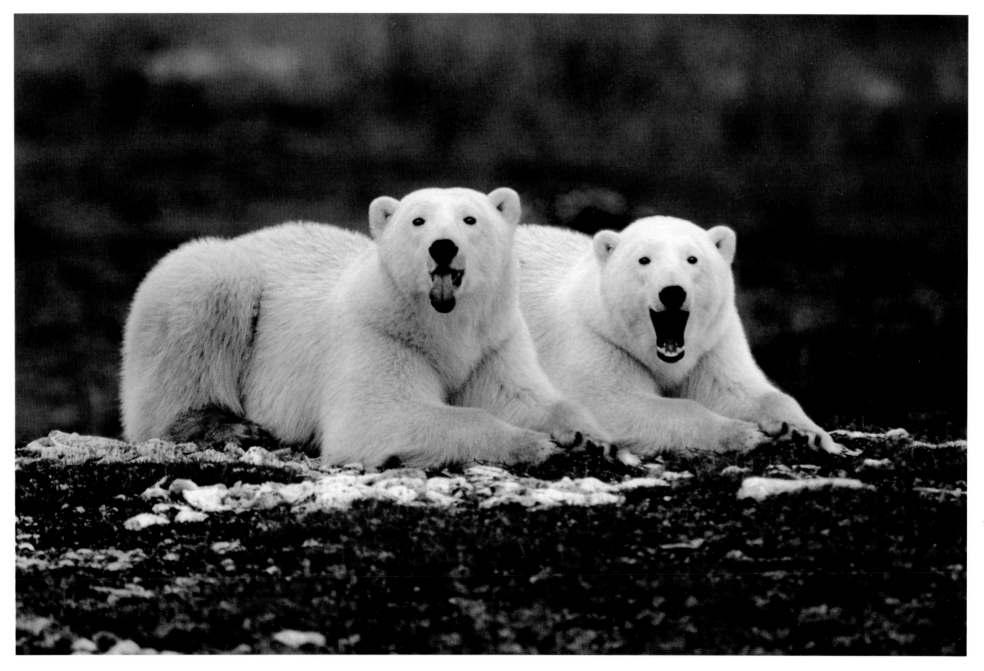

POLAR BEARS, *Ursus maritimus*

It's a bear's life out on the tundra in summer. In Churchill, Manitoba, the temperature rises to a maximum of 10°C making life almost intolerable for the ice-loving polar bears. Churchill calls itself the 'bear capital of the world', for it is here, on the western shore of northern Canada's famous Hudson Bay, that the Arctic royalty come to spend their summers. Forced onto land when the sea ice, their traditional home, begins to melt, the earth's largest predators spend just over three months, from mid-July to early November, on the moss and snow-covered tundra. Biding their time until the bay freezes over again, they rest, play and occasionally amble into town.

"I had read a great deal about the Arctic and was intrigued by a world of ice and snow, frozen seas, and unique wild animals adapted to climatic extremes. But the principal reason for going to the Arctic was to observe and photograph polar bears in their natural habitat. The world's largest predator, it is one of the most impressive creatures on earth.

As I began to plan a trip to the region, I realised that it would be imperative to join an organised expedition rather than undertake the journey on my own. The 16-person expedition I joined set out for Churchill via Winnipeg in Canada, led by a naturalist guide and other support personnel.

The small frontier town of Churchill on the western shores of Hudson Bay in the sub-Arctic is an ideal place for photographing polar bears. Every summer the melting ice forces the large carnivores to come ashore, where they spend much of their time inland on the tundra. During the summer months the bears feed on berries, grasses and, occasionally, birds, but mostly they burn their fat reserves to survive. By the end of September, when the ice starts to form again, the bears gather at the shoreline and wait patiently for the bay to freeze over so that they can go north to their winter feeding grounds.

It was during this lull before the winter freeze that our small expedition landed in Churchill in early October 1989.

For the next few days we observed and followed the bears, foxes and other wildlife in 'tundra buggies'. These hybrid all-terrain vehicles are fitted with enormous tyres to allow for travelling over the rocky shoreline and icy tundra. The giant wheels elevate the buggies high above the ground, keeping the passengers relatively safe from the clutches of the bears, which can stand up to three metres tall on their hind legs.

Our accommodation was in a self-contained bunkhouse – a large cabin on wheels – stationed near the Hudson Bay shoreline. Comfortable, but spartan, the bunkhouse consisted of sleeping quarters for 16 people and a small kitchen and dining area. We slept in single berths stacked like shelves one on top of the other. To get into bed one had to hoist oneself up past several other shelf-like berths.

The moment just before going to sleep was one of the highlights – gazing through the porthole just above my bed, I would watch the polar bears sleeping, dotted about the shoreline, typically lying low with their heads resting on their paws to minimise the effects of the Arctic chill. Their silvery fur shimmered in the moonlight.

Polar bears have an excellent sense of smell. Attracted by our food, they would wander across and sniff around the bunkhouse. Occasionally they would get up on their hind legs, raise their massive bodies against the bunkhouse wall, and stick their wet, black noses against it to peer through the titanium bars. They were as curious about us as we were about them. I wondered whether it was the bears that had come to observe us in our cages, or us observing them through the bars.

The desire to stroke them is almost overwhelming, but succumbing to the temptation is tantamount to signing one's own death warrant. Paradoxically, polar bears appear to be cuddly and friendly, but in reality, they are massive and powerful, and with a paw the size of a man's face, they are capable of ripping your arm off at lighting speed. Our guide repeatedly reminded us of this fact.

The light during the late summer is relatively weak, and, when taking photographs, I was forced to work with near-maximum

apertures and slow shutter speeds to compensate for the low intensity of the prevailing light.

Riding in armoured tundra buggies, we tracked polar bears, foxes and other wildlife. Most of the nearly 200 bird species that nest here in the early summer had flown south, but some, such as the snowy owl, gyrfalcon and ptarmigan, could still be seen.

The Arctic was not only the white wonderland I had dreamt about: I was amazed to see the beautiful rich colours of orange and red wild flowers and berries. I was also fascinated by the colours of the sedges that grow along the shore and on the tundra. Their dust-green and russet tones were accentuated by streaks of white snow.

Still, it was the polar bears that had captured my imagination. Although the tundra vehicle was ideal for viewing bears, I found it restricting to photograph them from the elevated angle of the buggies. My chance to photograph the bears at eye level came when, with two American photographers, I hired a vehicle of normal height and headed out onto the tundra for a morning. This was a valuable opportunity to photograph the bears at ground level in their natural environment from fairly close up, especially when they were play-fighting."

"The residents of Churchill are passionate about their bears, but they are also acutely aware of the power of these lords of the Arctic. Occasionally a bear, lured by the smell of food or garbage, wanders into town. Residents, together with police and government authorities, keep a close watch on them during the summer months from September to November. A 24-hour bear alert system has been established, and when the bears do lumber into town, they're trapped in baited cages. Once trapped, the bears are carted off in the mobile cages to the town's 'polar bear jail'. Bears kept in these holding pens are granted amnesty and released when the jail is full."

"On my last morning in Churchill, after I had packed my bags, I found myself with some time to spare before my flight departed. I braved the cold – average daily temperatures were -1°C – and decided to stroll through the town before heading for the local shopping centre in search of a cup of hot coffee.

Standing on the first floor of the centre, I was marvelling at a huge stuffed bear towering above me, when all of a sudden pandemonium broke out. 'There's a bear. There's a bear,' people shouted as shoppers scattered in all directions. I saw someone pointing at a bear lurking around outside the building not far from the entrance. In no time members of the polar bear reaction unit had arrived, firing shots into the air to scare the bear off. The bear fled, running across the tundra at the edge of the town. This unexpected encounter with the polar bear was a fitting end to an unforgettable wildlife experience."

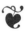

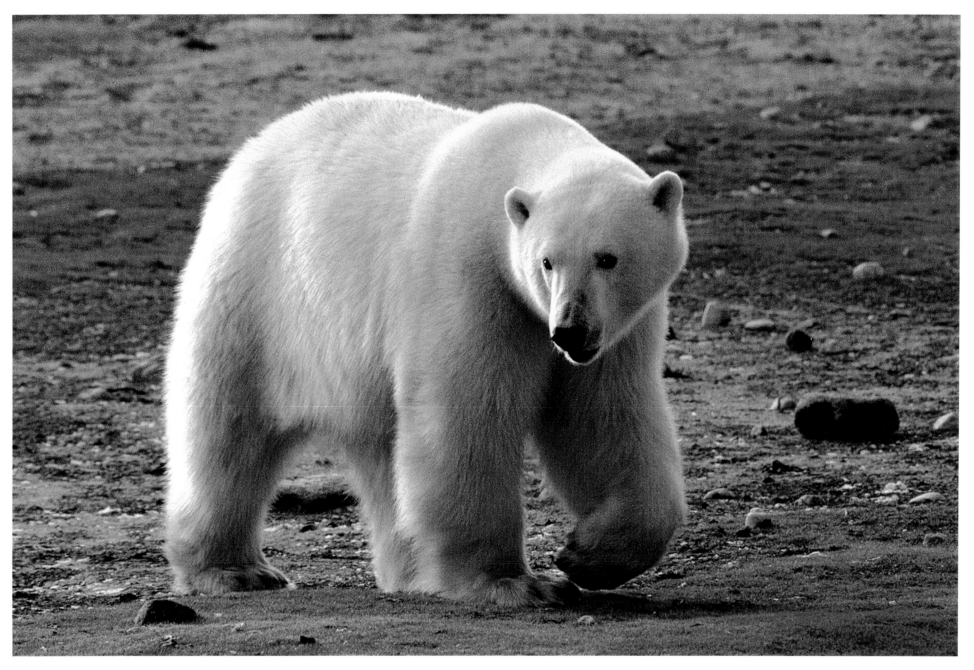

A SUMMER DIET

When summer arrives the soils of the tundra thaw, and for a brief eight weeks the desolate wilderness of the southern Arctic is transformed into a luxurious garden barely inches high. In some places, red and green mosses, free of the suffocating touch of ice and snow, cover the ground and hundreds of species of lichen spread their tentacles across rocks and stones. Flowering plants grow in sheltered spots and red and yellow sedges burst forth from the shallow soil covering the permafrost. But for the bears, summer is the leanest season. Depending largely on stored calories, they also nibble on the sedges, pick at the blueberries and cranberries, and savour lemmings, Arctic ground squirrels and eider ducks.

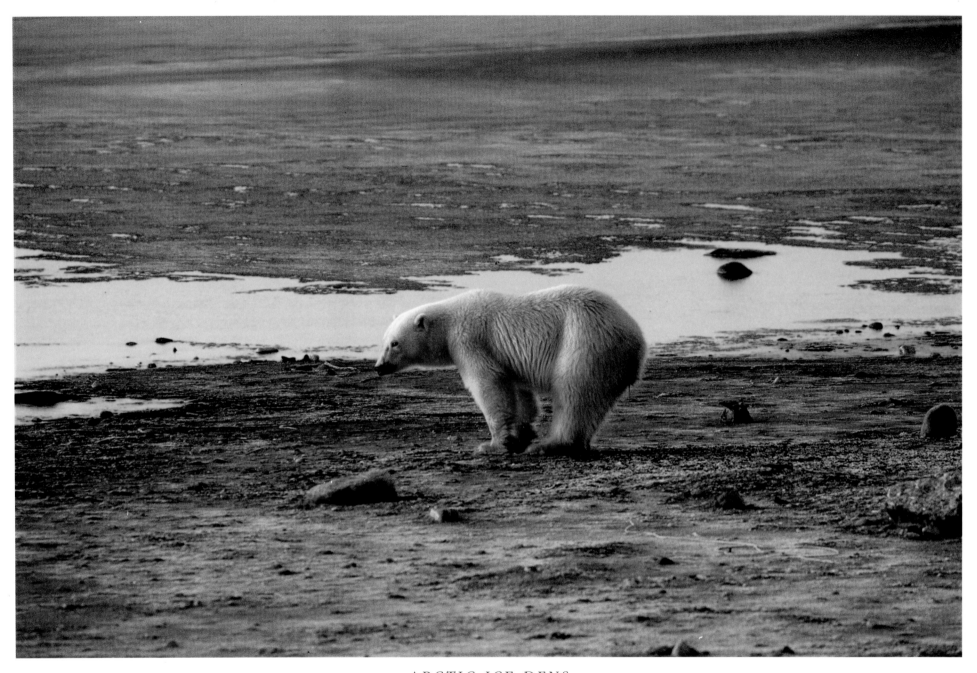

ARCTIC ICE DENS

In the high Arctic polar bears live in virtual darkness nearly all year round. The sun's rays hardly touch ground there, and in the endless winter night the bears find protection from blizzards in dens dug in snow banks on the sea ice. Down south, at Hudson Bay and James Bay, one of the largest and most unusual denning areas for polar bears was discovered in 1969. Unlike elsewhere in the Arctic, the dens here are excavated in river beds and peat hummocks. Male bears den for shorter periods than she-bears, and are often abroad hunting food. Some maternity dens – ingeniously incorporating roots of black spruce bushes as pillars – have been in use for over 200 years.

AURORA BOREALIS

"The aurora borealis is a spectacular phenomenon created by solar winds streaming through the earth's magnetic field in the northern polar region. I witnessed a dancing sheet of coloured light in the night sky and captured the splendour of its swirling vortex and its reflections illuminating the Hudson Bay shoreline."

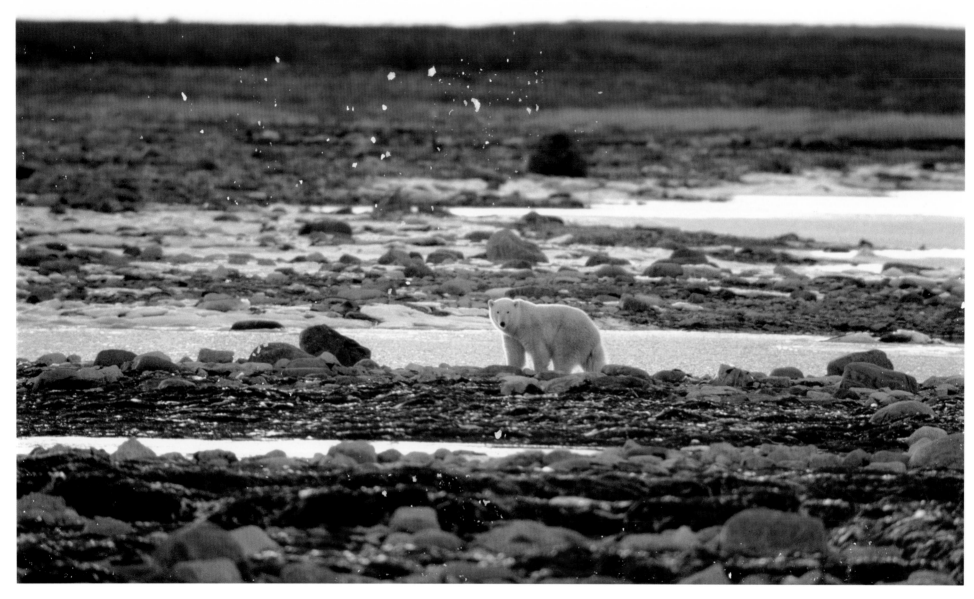

GREAT EXPECTATIONS

The pregnant bear starts building her den at the same time that the embryo begins to develop. Once she's taken up residence, she digs until the warm, snug den is as homely as an igloo, complete with entrance hall and raised chambers to retain the heat. Here she delivers and nurses her tiny offspring – born with no insulating fat – through their first winter. Containing 33% fat, the mother's milk is creamy; only the milk of seals and some whales is richer. By early spring, mother and cubs emerge famished from their hideout and their first stopover is on the pack ice, where they gorge themselves on young seal pups. Cubs remain with their mothers for $2\frac{1}{2}$ years.

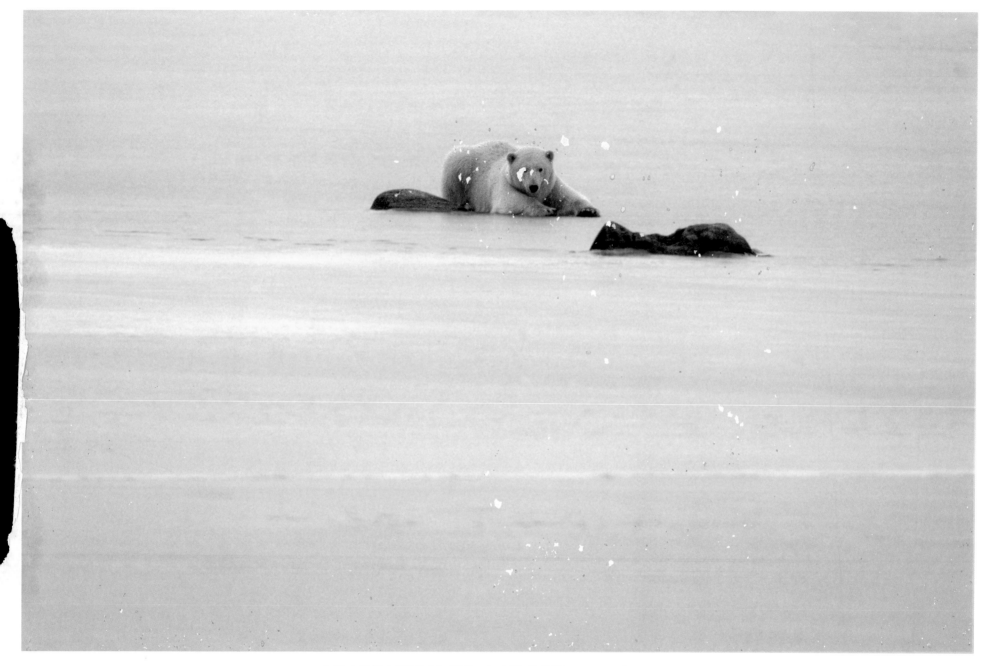

ADAPTATION TO A FROZEN KINGDOM

In a world where temperatures can plummet as low as -60°C, the polar bear's physiology is an astonishing feat of evolutionary engineering. Its waterproof fur, which appears white, is actually colourless, consisting of a forest of hollow fibres that trap solar energy and funnel ultraviolet light to the bear's coal black skin. Underneath the heat-absorbent skin, a 10cm layer of fat provides additional insulation in freezing conditions. Protected by fur and blubber, the giant's energy is further conserved by an internal cooling system: on hot days a blood-rich sheet of muscles, stretching from the shoulders to the small of the back, releases heat into the atmosphere, while on cool days the blood flow to the muscles is reduced.

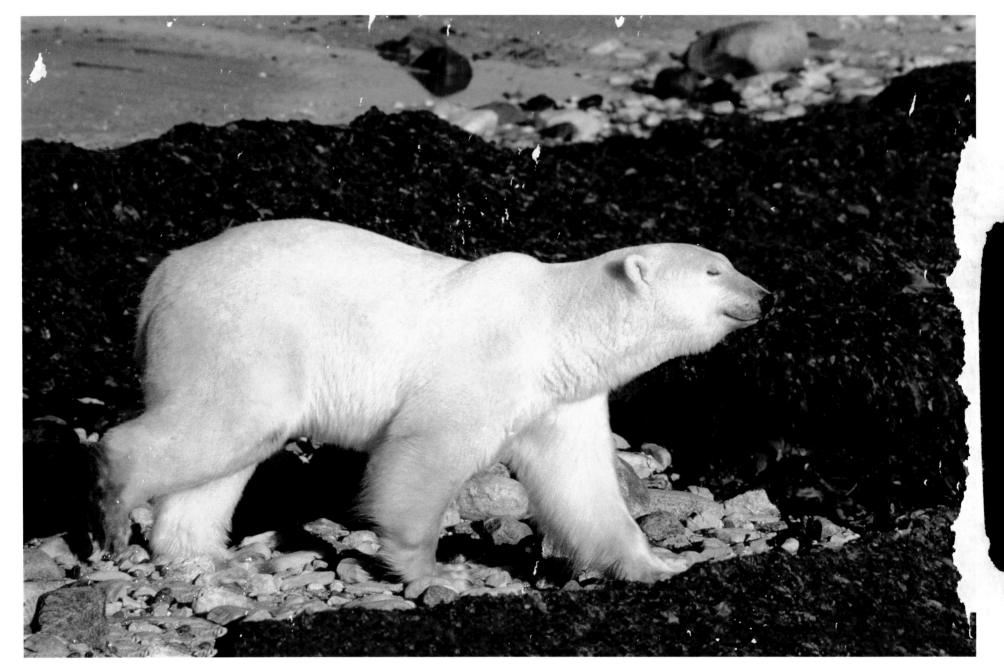

A PEERLESS PREDATOR

With a self-satisfied look on its sun-drenched face, a polar bear strolls along the seaweed-strewn shoreline. Though they occasionally eat kelp, polar bears prefer the skin and blubber of ringed seals – their staple food. The seal pups' birth in early spring ends the bears' long winter famine. For a few weeks, they gorge themselves on pups, bashing through the snow to extricate the seals from their birth lairs. They use their excellent sense of smell to track seals under the ice, and will wait patiently at a seal's snow-covered breathing hole until the moment it surfaces. The bear then smashes through the ice to grab the seal, often crushing its bones with this single action.

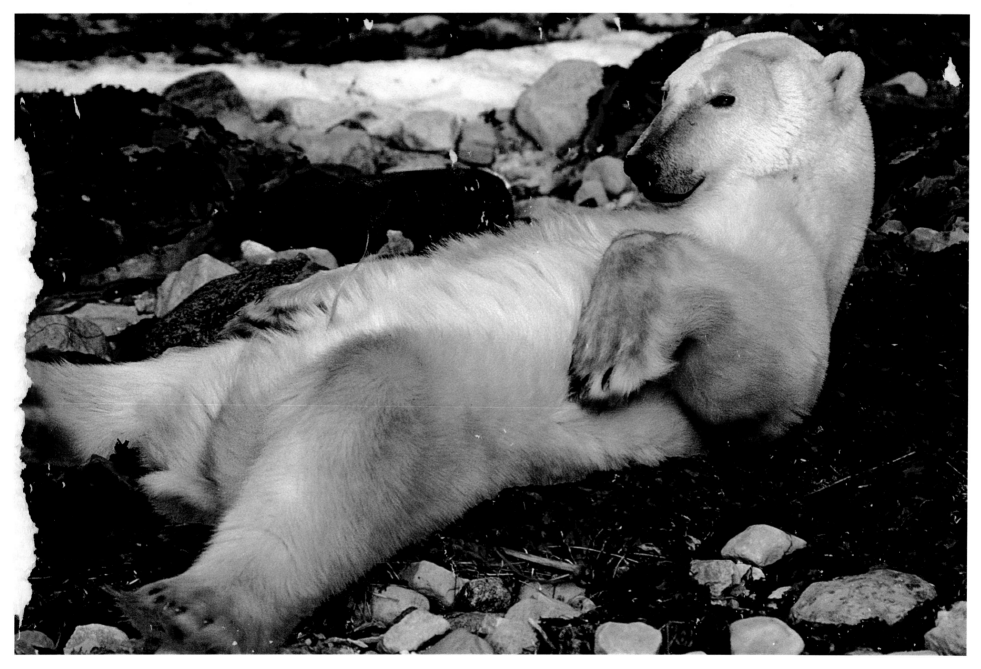

COOLING OFF

At ease in a frozen wilderness and perfectly equipped for life on the ice, it is in the heat of summer that the polar bear clan suffers the most: the bears quickly overheat when they exert themselves. So, although the half-ton giant can sprint nearly as fast as a racehorse, it prefers to pad along with a graceful, precise gait. Contemplating its navel is a favourite pastime too: to beat the heat, the polar bear lies on its back, paws in the air, or sprawls on the cool sand or in snow patches where it snoozes, belly down, with its arms, legs and neck outstretched. Bears also love to swim and use their enormous paws to paddle in the icy sea.

THE EDGE OF THE TREELINE

Along Canada's northern rim, the country's youthful forests of spruce, pine, fir and birch finally thin out. Only the last few stragglers, their trunks gaunt like flagpoles and devoid of branches on the side facing the fiercest winds, stand in spirited defiance. Beyond lies the Arctic tundra – an immense, treeless plain, buried under snow for almost nine months of the year. Abrasive winds, ice, low precipitation and the lack of sunlight inhibit the growth of trees here. Permafrost – the permanently frozen soil which begins at least 30cm below the surface and is thousands of years old in some places – is rock hard and impermeable, preventing trees from taking root on the tundra.

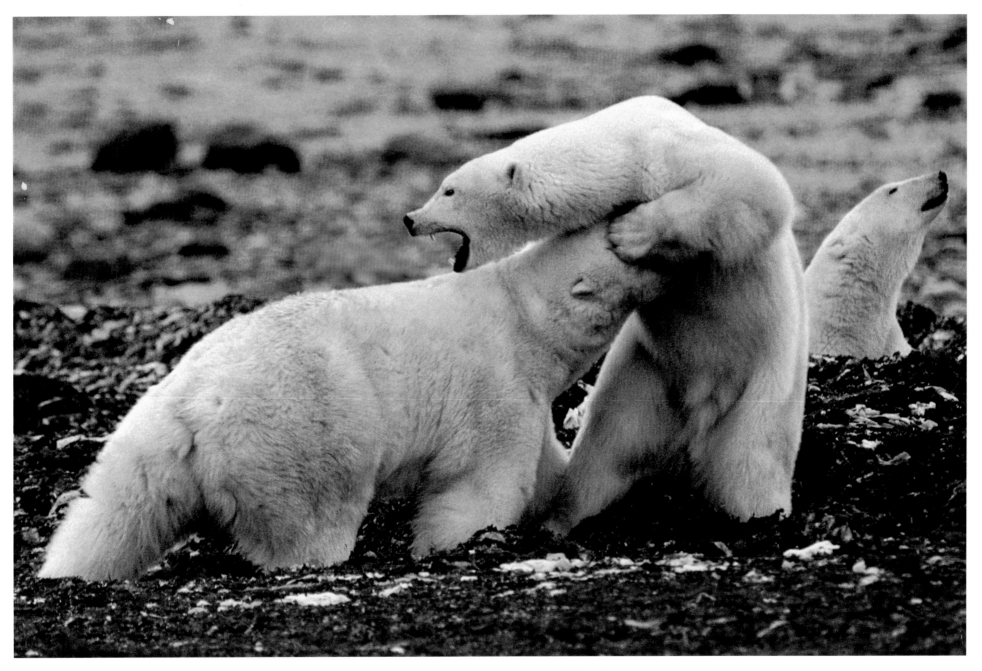

SPARRING AND FIGHTING

In autumn, during years when they have eaten well, male polar bears have enough energy to play-fight most of the day, taking breaks only to cool down or drink icy water. Standing some three metres high and weighing around half a ton, these behemoths could cause serious damage in these skirmishes but their play is remarkably injury free. However, in the spring mating season disputes over a female, whose scent attracts several suitors, can be deadly. Through a prescient feat of nature, fertilised eggs are only embedded in the uterus walls five months after mating, and cubs are born 12 weeks later. This timing allows exploitation of abundant food, in the form of seal pups, when the bear cubs start eating solids.

MALLARDS, *Anas platyrhynchos*

The native range of the wild duck, or mallard, encompasses much of North America and Eurasia. But the bird's striking appearance and size have made it popular as an ornamental waterbird and as a gamebird for shooting. So, over the centuries, it has been introduced to countries far beyond its natural range – places as disparate as Bermuda and the Falkland Islands, Hawaii and Tahiti, Kerguelen and Macquarie Islands, South Africa, Australia and New Zealand. Not all these introductions have been successful, and some have had devastating consequences, such as crop loss, competition with native ducks and hybridisation.

SNOWY OWL, *Nyctea scandiaca*

Most of the world's owls are nocturnal creatures. But what can an owl do if it breeds at high Arctic latitudes during the northern summer, on tundras bathed in the perpetual light of the midnight sun? Snowy owls have solved the dilemma by hunting at the darkest times. That's when their prey (and they're especially partial to lemmings) are most active. They also eat other young birds, especially in summer when lemmings are scarce, and Arctic hares, although these present a challenge to catch and subdue. On occasions, snowy owls have even been seen to catch fish, plunging into the water in a good imitation of an osprey.

BALD EAGLE,
Haliaeetus leucocephalus

"I travelled in a light aircraft to the beautiful Chilkat River in Alaska to take this photograph, drawn there by an extraordinary annual event: the gathering of America's national bird, the bald eagle. About 3,000 of these normally scattered birds flock there each November from hundreds of miles away, attracted by the late-fall run of sock-eye salmon. The fish, weighing up to five kilograms, come here to spawn and die in the natural upwelling of warm water that keeps the river from freezing. The eagles perch on nearby gravel bars or stumps, so intent on their epicurean treat that they are oblivious to the occasional vehicle – thus presenting a feast for photographers too!"

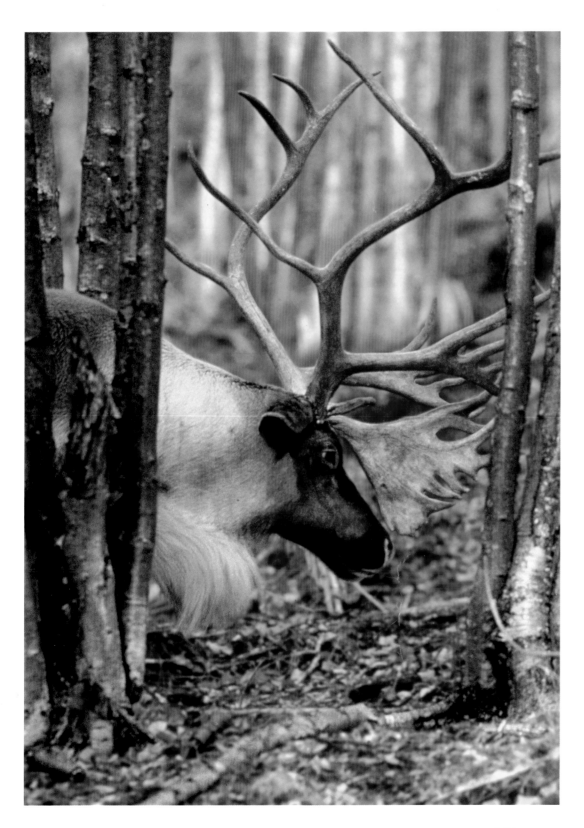

CARIBOU,
Rangifer tarandus

Caribou wear their magnificent antlers with panache, except in winter when they are shed, one by one, with a casual shake of the head. New antlers appear in summer and a velvet covering, which is rubbed off just before the autumn mating season, supplies blood for their growth.

Both sexes have antlers, although those of the females, or hinds, are less ornate. The caribou, known in Europe as reindeer, are the only deer species whose hinds grow antlers, though theirs are more delicate than those of the male.

To survive in a harsh region where the vegetation is covered by ice for most of the year, the plant-eating caribou live nomadically. They migrate over enormous distances – as far as 1,000km – from their summer range and calving grounds on the Arctic tundra to their winter shelter in the southern sub-Arctic forests. They mostly follow the same route, travelling around 15km per day. During these epic journeys their ranks may swell to between 10,000 and 100,000 animals as disparate herds, all following the same seasonal clock, band together. Unhurried, but always on the move, caribou stop only to sleep, chew the cud, drop fawns and herd temporary harems during the mating season. In summer, they feed on succulent sedges, grasses, mushrooms, twigs and fruit, but they like the pale yellow lichens, a winter staple, the best.

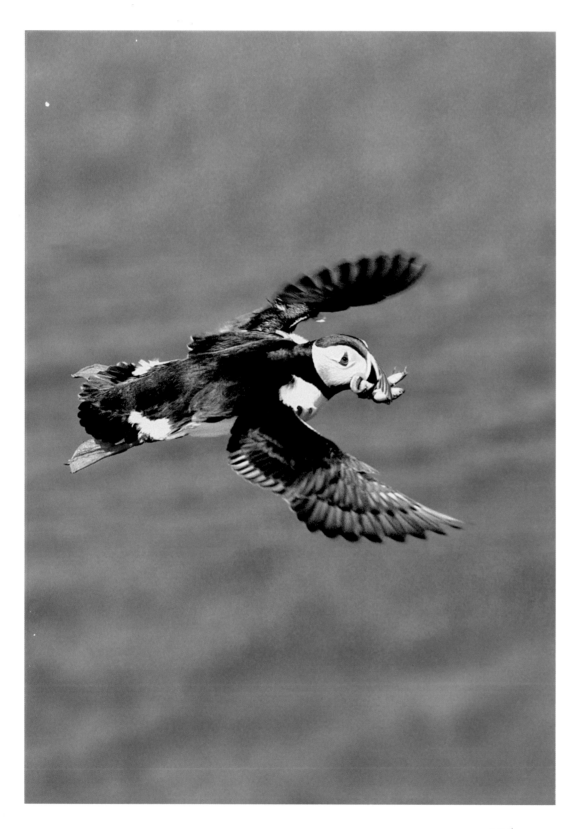

Scotland

ATLANTIC PUFFIN,
Fratercula arctica

See an Atlantic puffin flying ashore with fish in its bill and you know that its single egg has hatched and there is a hungry youngster somewhere awaiting a meal. These birds breed in burrows about a metre long, and there the chick remains until it is able to fly. Any youngster rash enough to go for a waddle outside its burrow would soon be snatched up by the waiting, ever-vigilant gulls. When the breeding season is over, puffins abandon the colony and head to sea for the winter. Shortly before they return the following spring, they undergo a rapid moult, which, for a short time, renders them flightless. It is then that they are particularly vulnerable to marine pollution.

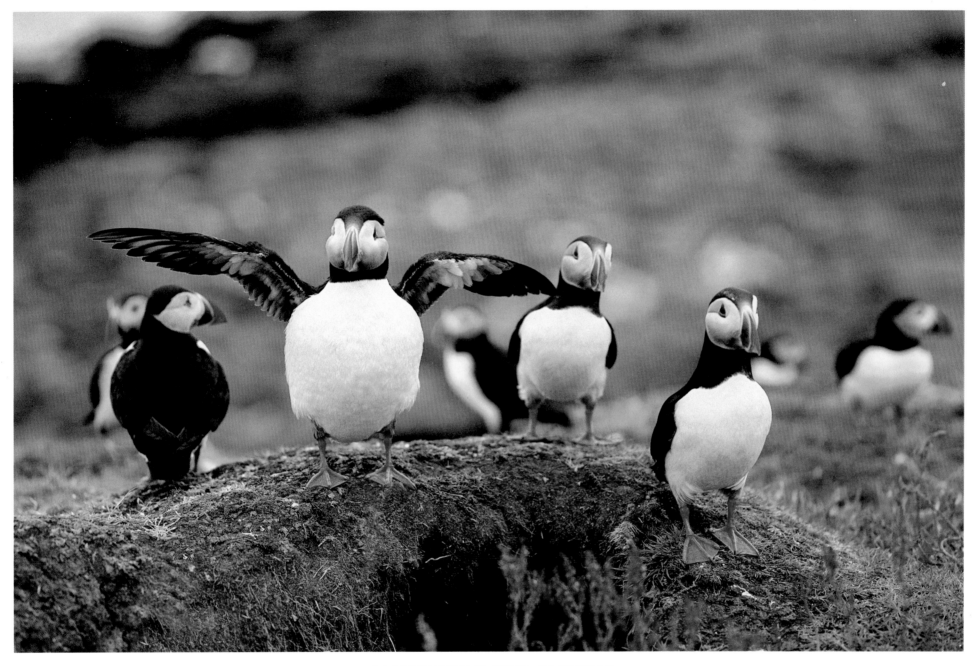

CONSERVING THE PUFFINS

Its comical and appealing appearance has not saved the Atlantic puffin from the predations of man, who has harvested their chicks and eggs for centuries. Between 1850 and 1920, 400,000 Atlantic puffins were killed each year in Iceland alone, for food, oil and other purposes. Fortunately, in recent decades the emphasis has shifted from exploitation to conservation, and puffin numbers are gradually recovering, especially in the south of their range – a recovery which is expected to continue. At least the Atlantic puffin is not threatened globally: the world has a breeding population of about six million pairs.

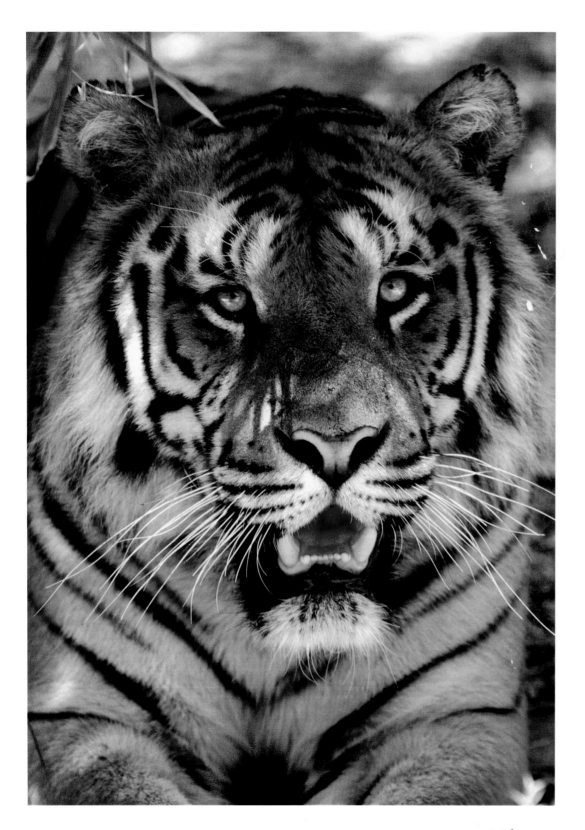

India

TIGERS ON THE BRINK

The tiger *(Panthera tigris tigris)* has enthralled and inspired humankind for centuries. Its timeless beauty, predatory prowess and elusive nature have helped turn the world's largest cat into one of its most enduring icons. A symbol of power through the ages, it has been worshipped in different religions, revered in legends and fables, and inspired poets across the world.

Tragically, tigers are on the brink of extinction. Their numbers plummeted in this century: only about 6,000 are estimated to survive in the wild, five per cent of the numbers counted in 1900. The prognosis in the East is dismal: the Bali, Caspian and Javan sub-species have been wiped out, and prospects for the survival of the remaining five range from bleak to cautiously optimistic. The destruction of natural habitats due to the pressure of human encroachment poses an increasing threat to the world's tiger population, as does poaching – the tiger's coveted striped skin can earn its seller nearly $15,000. They are further endangered by the illegal trade in tiger parts which are in heavy demand in southeastern Asia for use in traditional medicines.

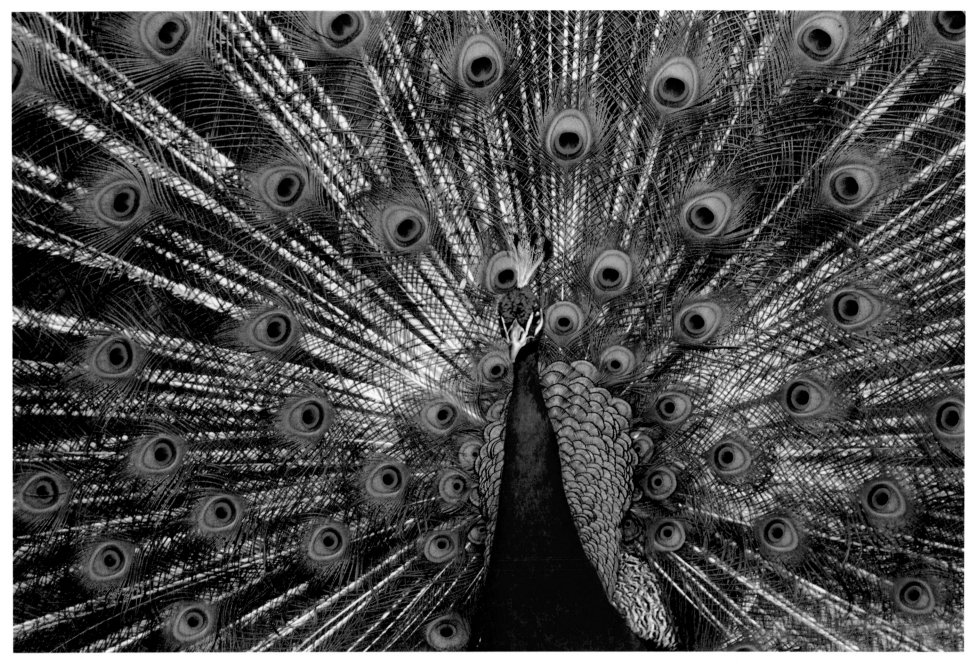

BLUE PEAFOWL, *Pavo cristatus*

In a magnificent dance of seduction, the peacock raises its tail coverts and unfurls the long train, revealing the brilliant plumage that never fails to impress both his mate and human beings. During courtship, he shakes his feathers ever so slightly, resulting in a dazzling display as the multihued, iridescent eyes of the plumes reflect the sunlight. Blue peafowls, common in India and Sri Lanka, have strong wings and roost in trees at night after spending most of the day on the ground. Associated with fertility in India, the peafowl is regarded as a destroyer of evil because of its liking for, and skill at, killing snakes. Peafowls are a bane to tigers as their loud alarm call alerts the entire jungle to the tigers' presence.

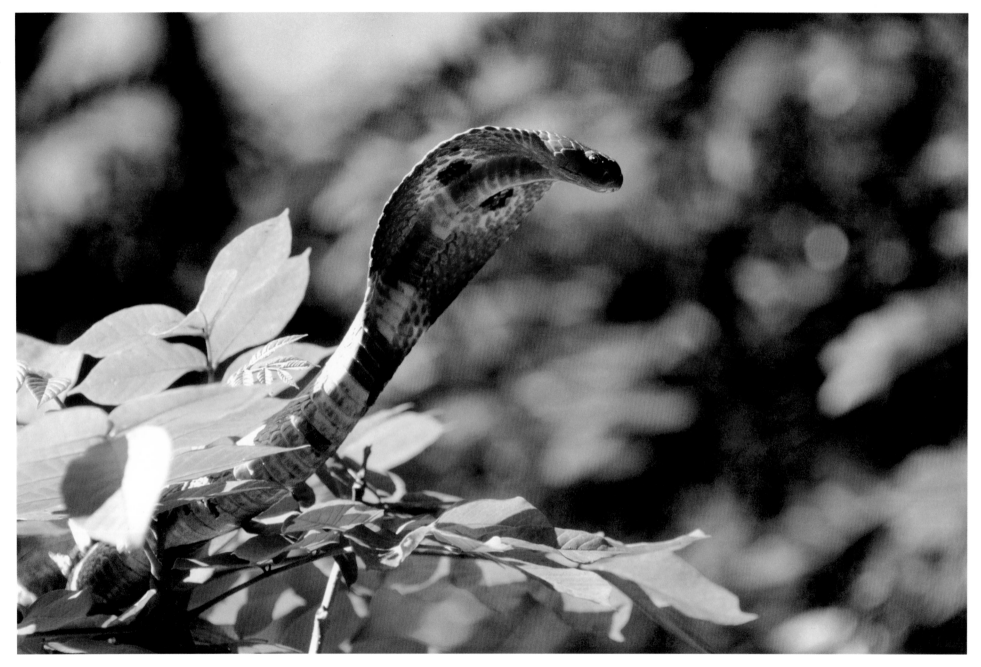

INDIAN COBRA, *Naja naja*

"A rustle of leaves close by distracted me. When I turned in the direction of the sound, an Indian cobra slithered and reared up, displaying its hood. The dappled light of the Indian jungle, falling on the hood, gave it a translucent quality and I could clearly see the two 'eyes' which are part of the intimidating face-like markings on the back of the snake's head. This photograph was published in Leica International. *On reflection, had I been better schooled in the ways of the Indian jungle, I may have run a mile on seeing the snake. Its bite can lead to a painful death and it can squirt its deadly neurotoxic venom into its victim's eyes, causing excruciating pain and blindness. The* naja naja *is the only true cobra found in India."*

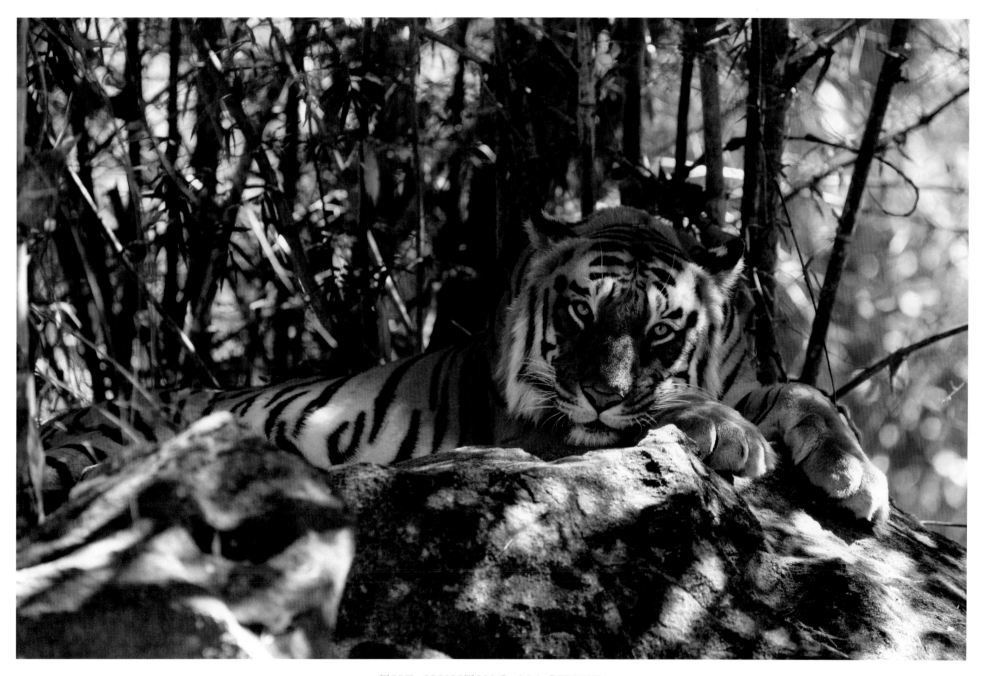

THE HUNTING MACHINE

Determination and might are powerfully combined in the tiger, who uses both to the utmost in the gruelling task of hunting. It needs to, for on average only one in 20 of its attacks are successful. With infinite patience and using all available cover, it slowly stalks to within 20m of its prey, crouching with its body grazing the ground, its shoulder blades jutting out like wings, and its muscles rigid with tension. Then follows an incredible burst of speed and the cat lunges and sinks its claws into its prey from the rear. Jerking the head of its prey backwards, its sharp canines and powerful jaw rips the prey's throat. The killing grip severs the prey's spine, and the clenched jaw suffocates it.

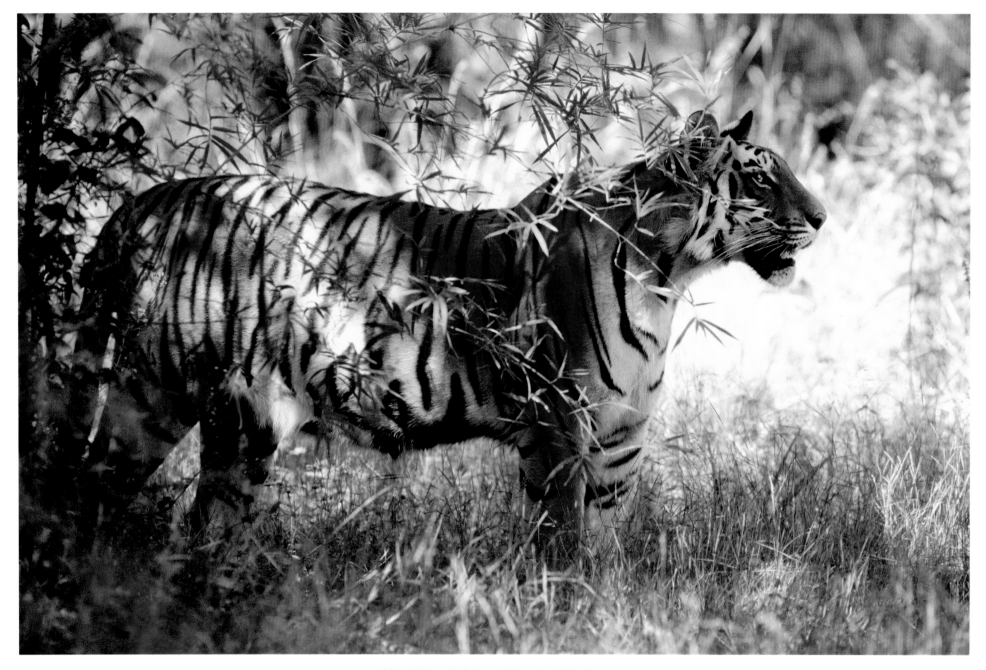

TIGER COMMUNICATION

While the tiger's thunderous roar strikes terror into the hearts of humankind, one of its lesser-known vocalisations, called pooking, has confounded both hunters and scientists alike. Emitted once or repeated in quick succession, the sound, a dull 'pok', is similar to the barking call of the sambar, the cat's favourite prey. Scientists differ on their interpretation of the vocalisation. Some suggest that it lures the deer, providing the tiger with an easy kill, others term it a sex call, and still others regard it as warning call designed to alert other members of the family of the tiger's presence.

"For me, the lure of India was its tigers. Not only was it my dream to observe and photograph these magnificent animals in their natural habitat, but my quest was to photograph them from a confrontational perspective, face to face. Most photographs of tigers are taken from a lofty height, usually with the photographer riding on the back of an elephant. The cats don't attack the great tuskers, so one of the more common ways of taking photographs of them is from the saddle on top of an Indian elephant.

When I first came face to face with a tiger, with its awesome presence, magnificent aspect and sheer size, it was love at first sight. I felt exhilarated and elated and bold. My patience and determination had been tested so often during my journey to India and through its vast interior, but at that moment, it was worth it all.

I had arrived in Delhi nearly a fortnight before, at four in the morning, expecting to be welcomed by the guide I had arranged from London. But the man who was to smooth my passage through India wasn't there. Outside the airport exit post a tall, moustached policeman with a stout stick kept guard, while a thousand hands summoned in the half-light, but there was still no sign of my guide. I had some difficulty persuading the policeman to allow me back into the airport building through the exit. Once inside I tried to summon help, but at that hour there was none. It was suggested instead that I check in at a hotel and wait until a respectable hour.

I did the opposite. I hired a car and driver and headed into the night, bound for Ranthambore National Park, a tiger haven in northern India. Approximately 400km² in extent, the park is also the site of the ancient mountain fortress of Ranthambore, built in the 10th century. The ruins of palaces, mosques, temples and hunting towers are still visible across the landscape and in this overgrown and disused battlement, tigers and leopards are sometimes seen.

Intrigued, and eager to see my first tiger, I joined a small group led by one of the park's rangers. The diesel-fuelled jeep was noisy. Surely the tigers would be wary of the chugging engine, I thought. We saw no tigers in Ranthambore.

Frustrated and somewhat disillusioned, after some days I headed south. I had spent nearly a week in India, searching for the elusive tiger, but to no avail. In the north, everyone kept telling me to go south, and, when I got to southern India, everyone kept advising me that the tigers were abundant and more easily observed in the north.

I was eventually to travel nearly 4,000km before having my first glimpse of a tiger in Bannerghatta National Park, south of Bangalore. Smouldering eyes looked down on me as the tiger surveyed the terrain around him, majestically enthroned on a large craggy rock in the shade of a bamboo thicket. Camera at the ready, I swung frenetically into action, majesty in the moment: tiger and photographer interacted as the motordrive whirred at four frames a second.

Sadly, time is running out for the jungle beast. Their numbers are dwindling fast. It would be a tragedy if future generations were denied the experience of seeing a live tiger in the wild. By portraying their beauty and magnificence, I hope that, in some small way, I can highlight the desperate plight of the tigers and the urgent need to save them from extinction."

"One of the places I visited to photograph the Indian tiger was Nagarahole National Park, a lush, forested wildlife sanctuary in Karnataka state, about 80km from Mysore city in the south of India.

Most of the park is clothed in moist deciduous forest, with dense undergrowth creating a miniature jungle on the forest floor. To the east, the landscape changes. Here the trees are not as imposing, the forest's ceiling is lower and savannah grasses play in the wind.

It is difficult to observe tigers in these conditions. The big cats are masters of disguise, and the dense cover afforded by the forest shrubs makes it an ideal environment in which they can conceal themselves.

Nevertheless, I arranged with the park manager to be allowed to visit one of the observation points where tigers had been seen on and off over the years. So, early one morning, I was dropped off at a treehouse in the middle of the jungle, with promises of being fetched at the end of the day.

I waited in my treetop den, hoping to see the powerful cat. I listened to the sounds of life around me, thinking that forests are also strangely quiet places. Still, I sat, waiting.

Soon I heard a rustle of leaves below me. Two men dressed in dhotis were ducking through the underbrush. They looked fearsome: one of them carried what looked like a long spear, while the other was holding a large, sharp machete.

Poachers, I thought. Afraid that they would see me, I hit the deck, where I lay motionless, holding my breath. My heart was beating wildly. I was terrified. 'What if they see me,' I thought. 'They might kill me.' I must have lain there for about half an hour; but it felt like an eternity. When I dared to look out, they had vanished.

In the late afternoon, without having seen a single tiger, I was collected by the ranger and I recounted my experience to him. 'Don't worry about them, they're only tuber-gatherers,' he said."

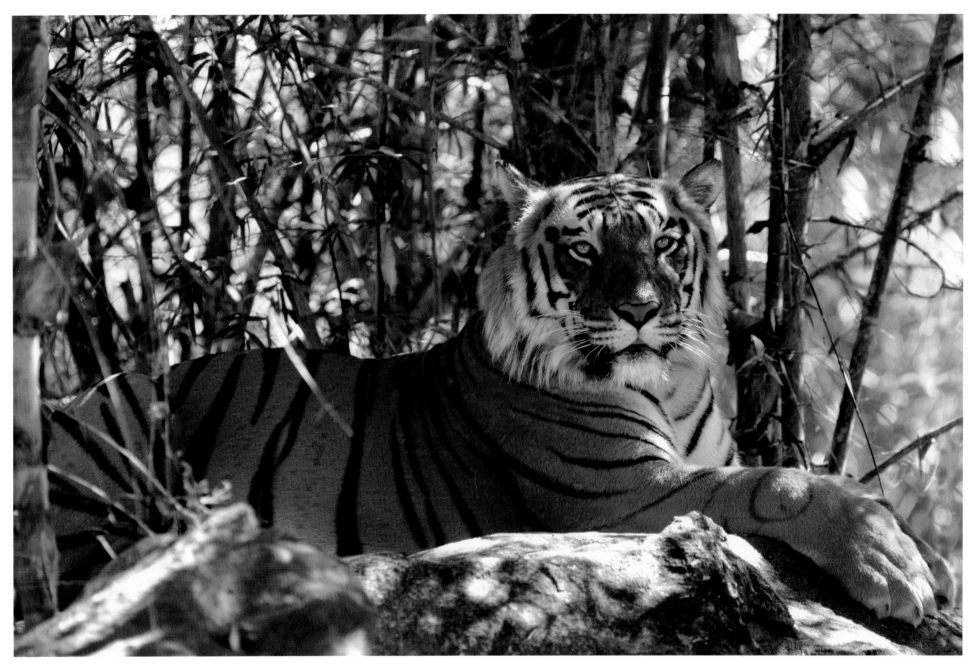

THE MAN-EATERS OF THE SUNDARBANS

In the steamy mangrove swamps of the Sundarbans, where India's great Ganges River runs into the sea, the country's man-eaters lurk. Their predilection for human flesh may have started centuries ago, but was first noted in 1515 when they ate the washed-up bodies of the victims of India's first recorded cyclone. It appears that the taste for human flesh has been passed on through the generations: on average, 36 people are killed each year in the Sundarbans. Locals appeal to Banabibi, the tiger goddess, to keep them safe while they go about their daily chores.

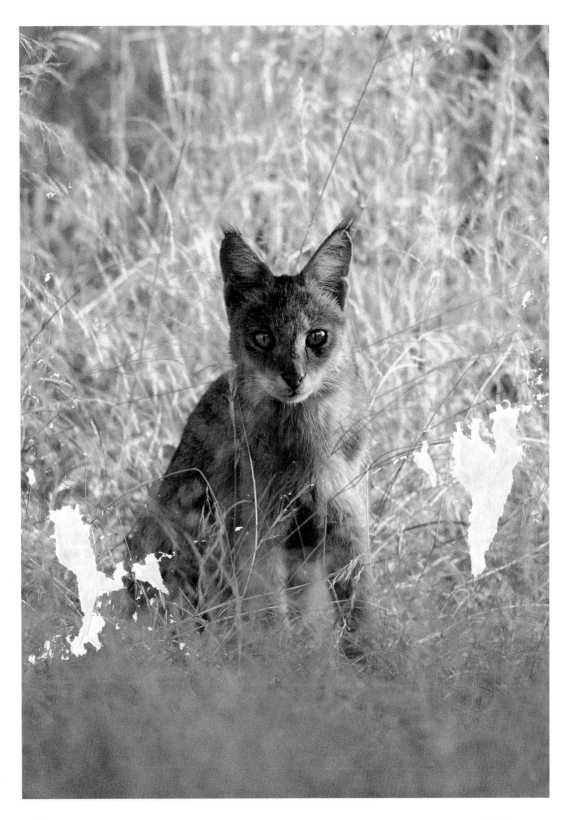

JUNGLE CAT,
Felis chaus

This highly adaptable feline roams the dense forests. Weighing only about nine kilograms, the long-limbed jungle cat is nevertheless a powerful hunter. It is mostly active in the day, stalking and killing rodents, frogs and occasionally chital fawns and birds. Its tawny coat bears dark stripes on the legs, and its ringed tail is shorter than those of other small cats. The jungle cat is widely distributed, found from Egypt, through the Middle East, to the Indian subcontinent.

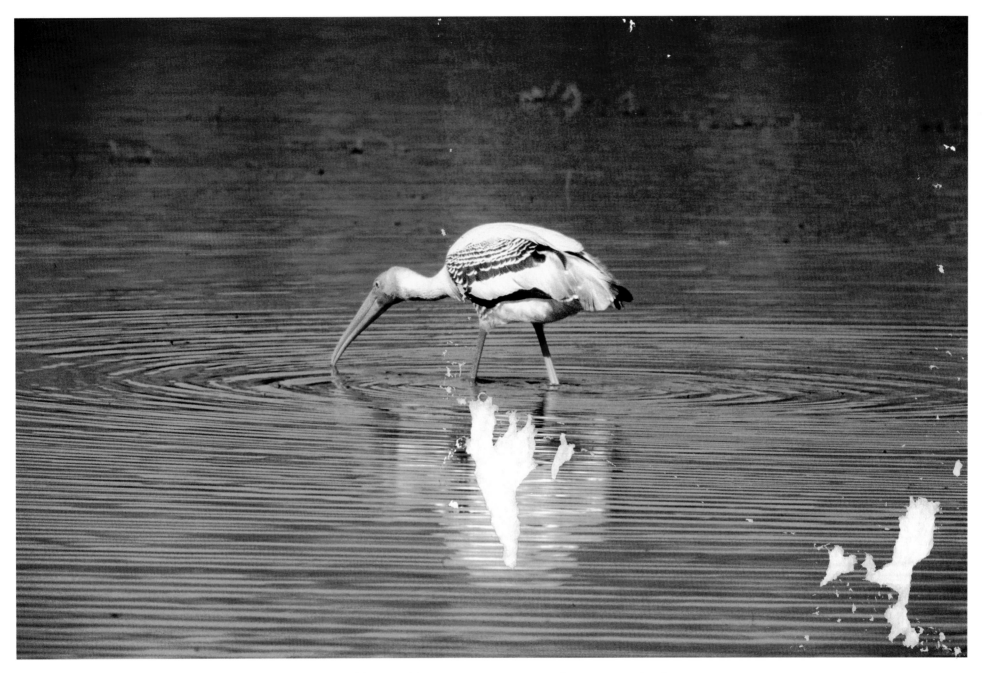

PAINTED STORK, *Mycteria leucocephala*

The painted stork is the Asian counterpart of the American wood stork (*M. americana*) and the African yellow-billed stork (*M. ibis*). It has a patchy distribution between northwestern India and southern China. Primarily a fish- and frog-eater, it searches for its prey in shallow freshwater wetlands. Like its African and American relatives, much of its hunting is done by touch, either by stirring the mud with one foot, or by scything its bill from side to side through the water. Breeding is triggered by the onset of the monsoons. Nests are built in colonies, usually in trees overhanging water and sometimes in association with other waterbirds such as herons and ibises.

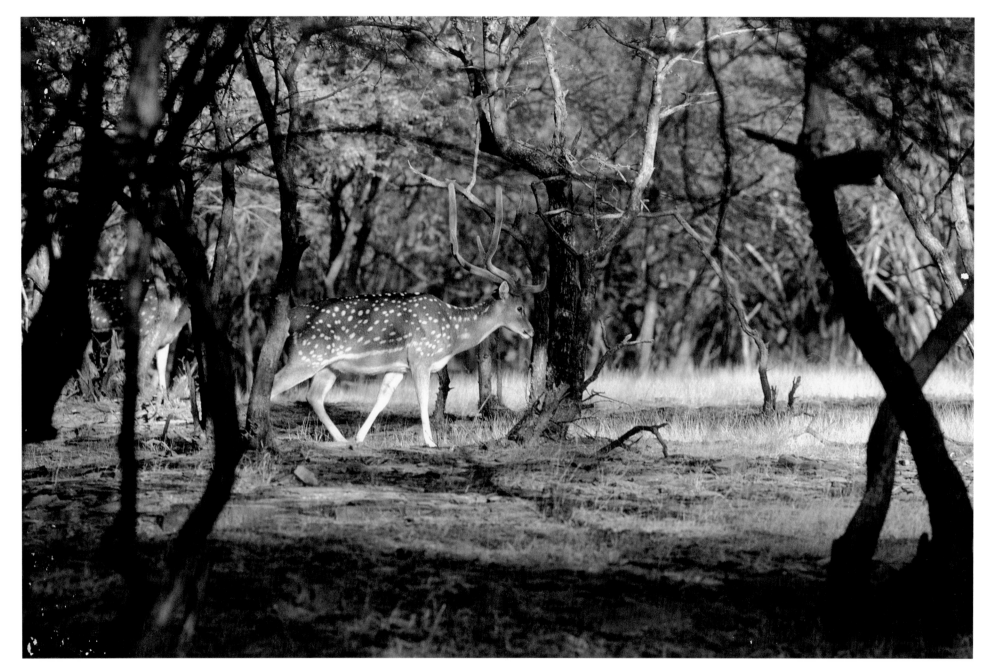

CHITAL, *Axis axis*

The dainty white-spotted chital is arguably the most beautiful of all deer. Generally placid, the bucks' tempers flare during the rutting season when they use a variety of displays to intimidate their rivals. A challenger may assert his claim by thrusting his head up aggressively, displaying the white patch on his throat to make himself look larger and more formidable. Not all aggression is directed at adversaries, though. When 'preaching' – a form of displaced aggression – the buck balances on its hind legs and thrashes its horns among the leaves of low-slung branches, eventually emerging with vegetation entwined round the antlers and looking somewhat ferocious. Bald patches on the ground mark preaching trees, shared by several males.

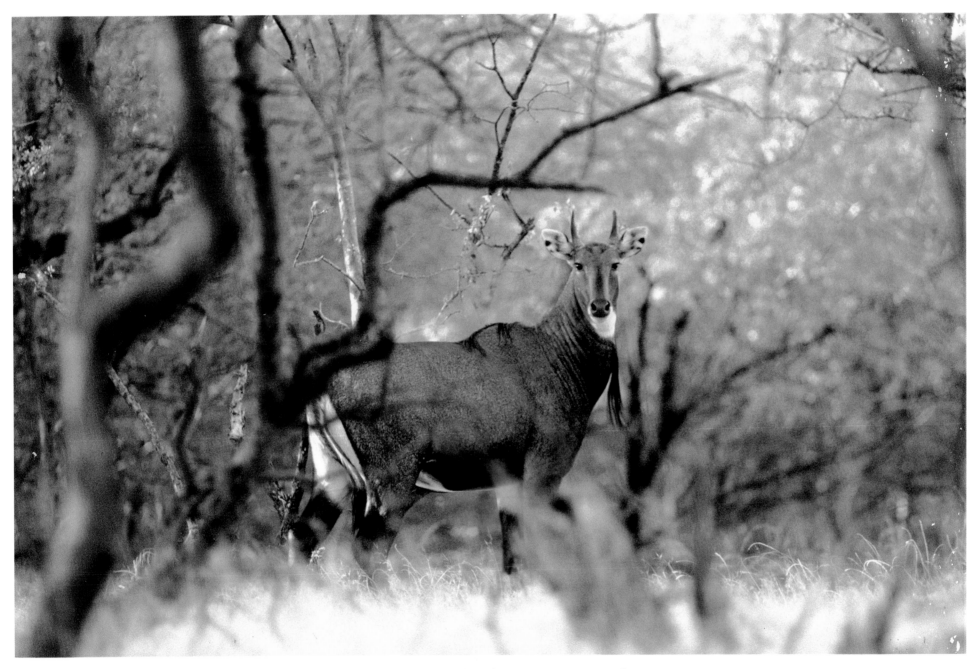

NILGAI, *Boselaphus tragocamelus*

Found only in India, the short-horned nilgai is Asia's largest antelope. It weighs up to 270kg and, although its high shoulders give it a somewhat ungainly look, it can gallop at great speed. The nilgai and its relative, the four-horned antelope (also indigenous to India) are the only survivors of the *Boselaphini* family, from which modern wild cattle evolved. Nilgai forage in herds in dry, deciduous forests. Primarily grazers, they also browse, sometimes by standing up on their hind legs to nibble the fresh leaves of shrubs and trees. While grazing, they constantly sniff the air, announcing the presence of a predator by tapping a hoof on the ground – an urgent signal to others to scamper.

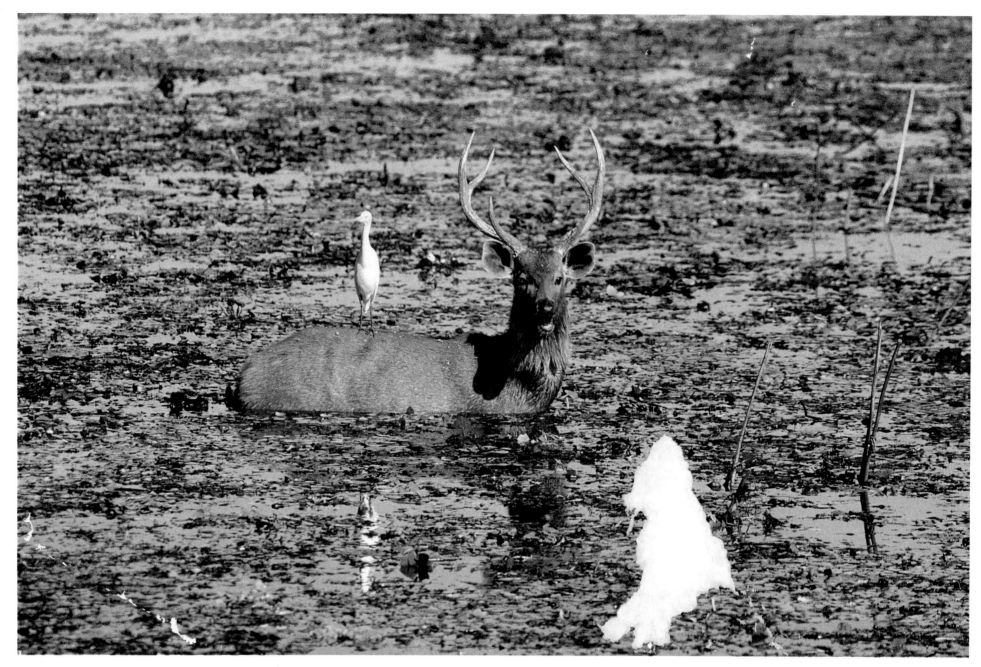

SAMBAR, *Cervus unicolor*

Asia's largest deer, the magnificent sambar, seen here with an egret on its back, immerses itself in lakes and rivers to nibble on water plants. The preferred prey of tigers, sambars are constantly on the lookout for any sign of the striped cat. Moderate vision means they can't easily see a motionless animal; they rely instead on their senses of smell and hearing to escape. Though generally elusive, sambars are more conspicuous during the rut. At the onset of the mating season, stags spray themselves with their own scent to make themselves more attractive to hinds and more intimidating to other males. Pounding hooves and locking horns at regular 'stamping grounds' possibly serves to communicate stags' presence to others.

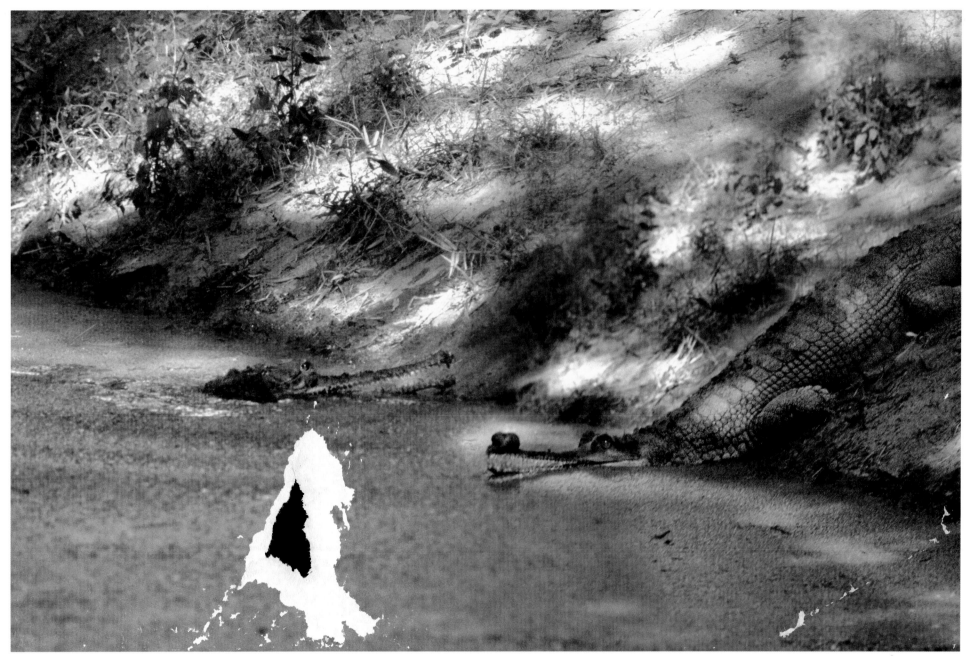

GHARIAL, *Gavialis gangeticus*

Indigenous to the rivers of northern India, the gharial characteristically has a slender body, long snout, and, in the case of the male, a distinct bulge on the tip of the upper jaw. Gharials feed mainly on fish, which they clench between sharp, interlocking teeth before manoeuvring them to the back of the mouth and swallowing with an upward jerk of the head. Though the jaw muscles used to open the mouth are surprisingly weak, the jaws close with deadly force. These aquatic predators are the only species of the crocodilian sub-family, *Gavialiae*. Brought close to extinction by hunting and shrinking habitats, they numbered a perilous 250 in 1974. Sanctuaries helped increase their numbers to 3,000 within 20 years.

KING COBRA,
Ophiophagus hannah

The king cobra's flared hood rightly inspires dread – its venom is deadly, attacking the nervous system and causing death from respiratory paralysis within hours. Its aggressive display is achieved by inflating its expandable rib cage and flattening its neck. As its name, *Ophiophagus,* implies, the king cobra survives on a diet of other snakes. It is the only snake in the world to lay its eggs in a self-made nest of leaves and soil. The king cobra is a favourite among Indian snake-charmers: though deaf like all snakes, it sways to and fro while following the movements of the snake-charmer's flute, or *tubric.*

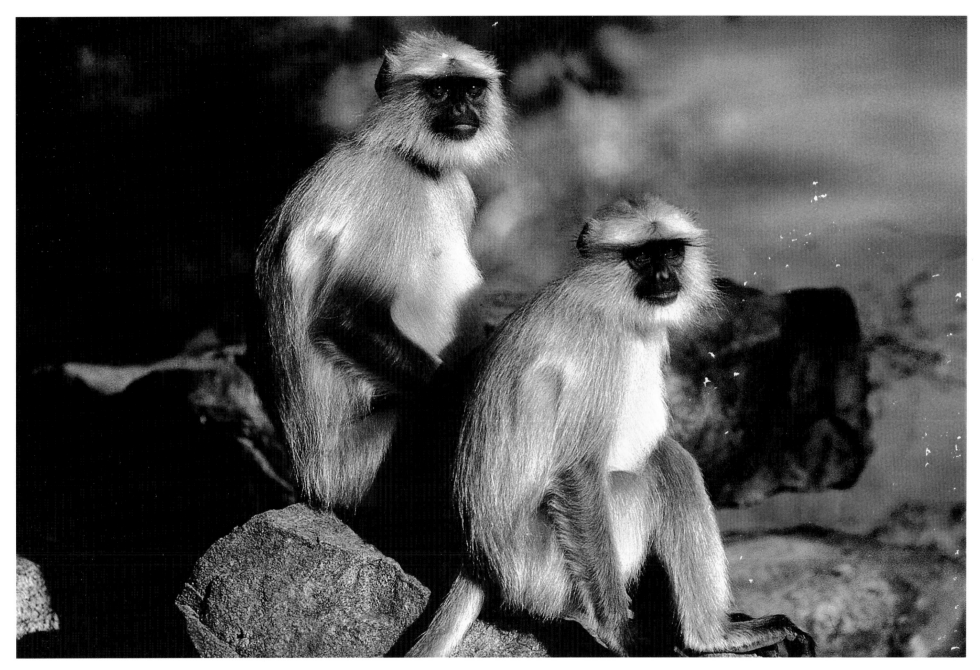

HANUMAN LANGUR, *Presbytis entellus*

Slender-bodied and long-tailed, the Hanuman langur takes its name from the monkey god who, with his monkey troop, helped recapture Sita, the bride of the divine prince Rama. The jungle's noisiest sentry, the langur has excellent vision and scans the forest floor for tigers and leopards on the prowl from its perch high up in the jungle's canopy. Its staccato alarm bark and frenetic treetop acrobatics provide an early warning system to other animals. One beneficiary is the spotted deer, or cheetal, which feeds on foliage dropped by the langurs. Obtaining moisture from a diet of shoots and leaves that are often too poisonous for other animals, langurs can survive throughout the summer without water.

SELECT BIBLIOGRAPHY

Africa Environment and Wildlife. 6(3). 1998.

Alderton, D. 1991. *Crocodiles and alligators of the world*. London: Blandford Publishing.

American Museum of Natural History. http://www.amnh.org/

Audubon Society. 1980. *The Audubon Society field guide to North American mammals*. New York: Alfred A. Knopf.

Berril, NJ and Berril, M. 1969. *The life of sea islands*. New York: McGraw-Hill Inc.

Bomford, L. 1993. *The complete wolf*. London: Boxtree.

Box, B (ed). 1993. *1994 South American Handbook*. Bath: Trade and Travel Publications.

Breeden, S. 1984. Tiger! Lord of the Indian jungle. *National Geographic*, 166(6).

Britannica Online. http://www.eb.com/

Brown, LH; Urban, EK and Newman, K (eds). 1982. *The birds of Africa, Vol. 1*. London: Academic Press.

Burton, M. 1981. *The new Larousse encyclopedia of animal life*. New York: Bonanza Books.

Centre for Integrated Study of Animal Behaviour. http://www.cisab.indiana.edu/

Chester, S. 1993. *Antarctic birds and seals*. California: Wandering Albatross.

Constant, P. 1992. *Marine life of the Galapagos: a guide to the fishes, whales, dolphins and other marine animals*. Paris: Pierre Constant.

Davids, R. and Guravich, D. 1983. *Lords of the Arctic: A journey among the polar bears*. New York: Macmillan Publishing Co.

Del Hoyo, J; Elliot, A and Sargataal, J (eds). 1992–1997. *Handbook of the birds of the world, Vols 1–4*. Barcelona: Lynx Edicions.

Estes, RD. 1993. *The safari companion: a guide to watching African mammals*. Johannesburg: Russel Friedman Books.

Fothergill, A. 1993. *Life in the freezer: a natural history of the Antarctic*. London: BBC Books.

Fourie, PF. 1989. *Kruger National Park. Questions and answers*. Nelspruit: SA Country Life.

Fry, CH. 1984. *The bee-eaters*. Calton, T. and AD Poyser.

Fry, CH; Keith, S and Urban, EK. 1988. *The birds of Africa, Vol. 3*. London: Academic Press.

Galimberti, D. 1991. *Antarctica – an introductory guide*. Florida: Zagier & Urruty Publications.

Getaway. 1997–1998. Cape Town: Ramsay, Son & Parker.

Ginn, PJ; McIlleron, WG and Milstein, P. Le S. 1990. *The complete book of Southern African birds*. Cape Town: Struik Winchester.

Godfrey, M; Barreto, R and Mrosovsky, N. 1996. Estimating past and present sex ratios of sea turtles in Suriname. *Canadian Journal of Zoology*, 74(2).

Goss, R. 1990. *Maberly's mammals of Southern Africa*. (Revised by R. Goss.) Johannesburg: Jonathan Ball and Ad. Donker Publishers.

Harris, MP. 1974. *A field guide to the birds of Galapagos*. London: Collins.

Hinde, G. 1992. *Leopard*. London: HarperCollins Publishers.

Insight Guides. 1988. *Indian wildlife*. USA and Canada: Prentice Hall Press.

Insight Guides. 1992. *Amazon wildlife*. Singapore: APA Publications.

IUCN Species Survival Commission Cat Specialist Group. http://lynx.uio.no/catfolk/

Jackson, M. 1993. *Galapagos: a natural history*. Alberta: University of Calgary Press.

Kavanagh, M. 1983. *A complete guide to monkeys, apes and other primates.* London: Jonathan Cape.

Kolinski, S-P. 1995. Migrations of the green turtle, *Chelonia mydas,* breeding in Yap State, Federal States of Micronesia. *Micronesica,* 28(1).

Lightbody, M; Talbot, D; DuFresne, J and Smallman, T. 1997. *Canada: a Lonely Planet travel survival kit.* Hawthorn: Lonely Planet Publications.

Long, JL. 1981. *Introduced birds of the world.* London: David Charles.

Lopez, B. 1986. Arctic dreams. *Imagination and desire in a northern landscape.* London: Macmillan London Limited.

Lucas, M. 1996. *Antarctica.* Cape Town: New Holland Publishers.

Macdonald, D (ed). 1984. *All the world's animals. Carnivores.* New York: Torstar Books Inc.

Macdonald, D (ed). 1984. *All the world's animals. Hoofed mammals.* New York: Torstar Books Inc.

Macdonald, D (ed). 1984. *All the world's animals. Primates.* New York: Torstar Books Inc.

Maclean, GL. 1985. *Roberts' birds of Southern Africa.* Cape Town: The Trustees of the John Voelcker Bird Book Fund.

Miles, H and Salisbury, M. 1985. *Kingdom of the ice bear.* London: BBC Books.

Miller, H. 1970. The cobra, India's 'good snake'. *National Geographic,* 138(3).

Morris, D. 1991. *Animalwatching. A field guide to animal behaviour.* London: Arrow Books.

Mutwa, C. 1997. *Isilwane. The animal.* Cape Town: Struik Publishers.

Nelson, B. 1968. *Galapagos: islands of birds.* London: Longmans.

Newlands, G. 1988. *Spiders. (Struik pocket guides for southern Africa).* Cape Town: Struik Publishers.

Newman, K. 1988. *Newman's birds of Southern Africa.* Johannesburg: Southern Book Publishers.

Palmer, RS (ed). 1988. *Handbook of North American birds, Vol. 4.* New Haven and London: Yale University Press.

Pearce, F. 1998. Too darned hot. *New Scientist,* 8 August.

Quammen, D. 1988. *The flight of the iguana: A sidelong view of science and nature.* Delacorte Press.

Quammen, D. 1997. *The song of the dodo.* London: Pimlico.

Rachowiecki, R. 1992. *Ecuador and the Galapagos Islands – a travel survival kit.* Hawthorn: Lonely Planet Publications.

Reader's Digest. 1992. *Book of the great South African outdoors.* Cape Town: The Reader's Digest Association South Africa.

Reader's Digest. 1997. *Spectacular world of Southern African birds.* Cape Town: The Reader's Digest Association South Africa.

Schaller, GB. 1967. *The deer and the tiger. A study of wildlife in India.* Chicago and London: The University of Chicago Press.

Smithers, R. 1983. *The mammals of the southern African subregion.* Pretoria: University of Pretoria.

Sterling, T. 1973. *The Amazon.* Amsterdam: Time-Life Books B.V.

Strange, J. 1992. *A field guide to the wildlife of the Falkland Islands and South Georgia.* HarperCollins Publishers.

Tidwell, M. 1994. Randy Borman: Cofan chief. *Earth Island Journal,* 9(3).

University of Michigan, Museum of Zoology. http://www.oit.itd.umich.edu/bio/

Woods, RW. 1988. *Guide to the birds of the Falkland Islands.* Oswestry: Anthony Nelson.

World Wildlife Fund. http://www.wwf.org/

INDEX

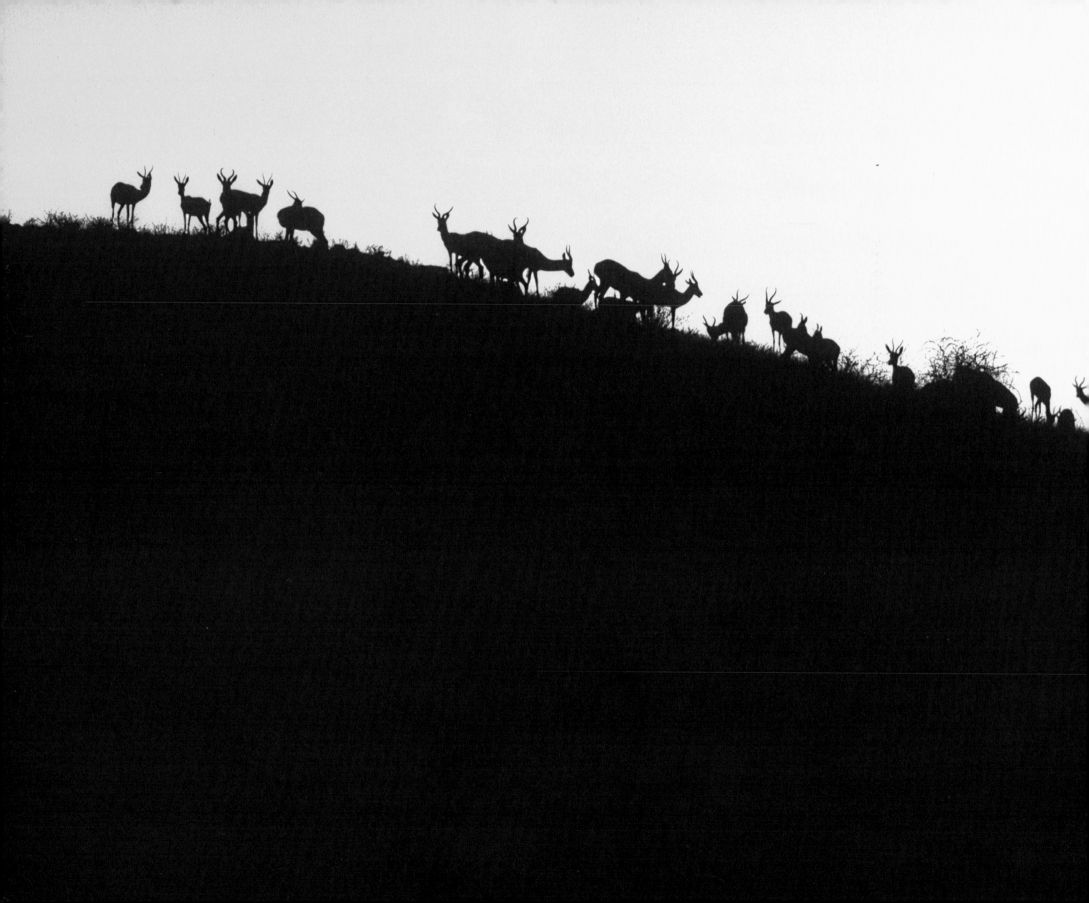